1416

RAPHAEL

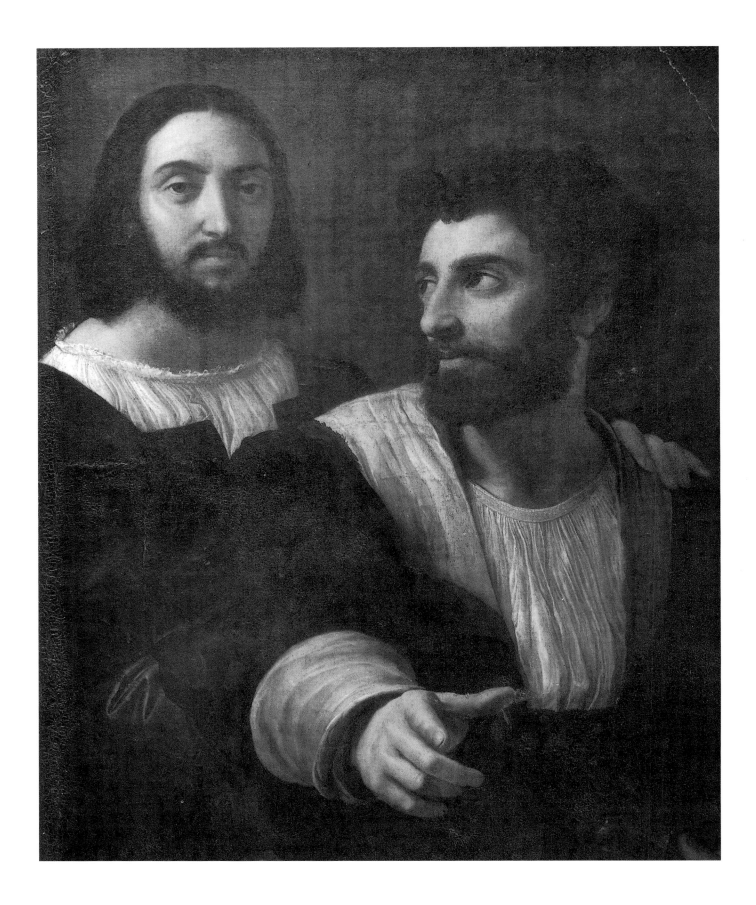

RAPHAEL

JAMES H. BECK

Professor of Art History, Columbia University, and
Director, ArtWatch International

HARRY N. ABRAMS, INC., PUBLISHERS

FOR

RUDOLF WITTKOWER

IN MEMORIAM

Frontispiece:
Detail of *Portrait of Two Men*
(so-called *Raphael and the Fencing Master*). 1518–19.
Oil on canvas, 39 × 32⅝″. The Louvre, Paris

Library of Congress Cataloging-in-Publication Data

Beck, James H.
 Raphael / James H. Beck.
 p. c.m.
 Includes bibliographical references and index.
 ISBN 0–8109–3777–8
 1. Raphael, 1483–1520. 2. Painters—Italy—Biography.
I. Raphael, 1483–1520. II. Title.
ND623.R2B363 1994 93–39102
759.5—dc20 CIP

ACKNOWLEDGMENTS

This book was largely written at Villa I Tatti, the former home
of Bernard Berenson in Florence and now the Harvard Univer-
sity Center for Italian Renaissance Studies, where I was able to
use the excellent library and study facilities. I am grateful to
Harvard University and to the staff of the villa, including the
then Director, Myron P. Gilmore; the sometime Acting Direc-
tor, Mason Hammond; Fiorella Superbi; Anna Terni; Nelda
Ferace; and Gloria Ramakus. Warm thanks are extended also to
the staff of the Kunsthistorisches Institut in Florence and to its
former Director, Ulrich Middeldorf, and its current Director,
Herbert Keutner. My friend and colleague Howard Hibbard gra-
ciously read parts of the manuscript, as did Jonathan Riess and
Paul Weis.

 The staff of Harry N. Abrams, Inc., has been very helpful, and
I wish to single out Mrs. Barbara Lyons, who saw to the pro-
curement of the photographs, and especially Joanne Greenspun,
who edited the manuscript with sympathetic attention.

New York City
June 1, 1973

I would like to thank Gordon Bloom, Deputy Director of
ArtWatch International, and Harriet Whelchel of Harry N.
Abrams, Inc., for their editorial and organizational efforts, as
well as designer Ellen Nygaard Ford and photo researcher
Catherine Ruello of Abrams, for their work in bringing about
this new, concise edition. Also, Leta B. Bostelman of Abrams
must receive a special mention for the rare consideration and
courtesy she gives her authors.

Lamporecchio
July 1993

PHOTOGRAPH CREDITS

Alinari, Florence: cpls. 4, 9, 10, 11, 14, 31, 33, 37; Artothek,
Planegg, Germany: cpl. 12; Ludovico Canali, Rome: cpls. 1,
13, 16, 19, 20, 27; Giraudon, Paris: cpl. 8; Oronoz, Madrid;
cpls. 23, 36; © Her Majesty Queen Elizabeth II: figs. 16, 30;
R.N.M., Paris: frontispiece, figs. 17, 18, 23, 25, cpls. 6, 7,
15, 35, 38; Scala, Rome/Art Resource, New York: cpl. 30.

CONTENTS

RAPHAEL *by James H. Beck* 7

Biographical Outline 46

Selected Bibliography 47

COLORPLATES

1. S. NICCOLO DA TOLENTINO ALTARPIECE *Capodimonte Museum, Naples* 49

2. THE CRUCIFIXION *National Gallery, London* 51

3. CORONATION OF THE VIRGIN *Pinacoteca, Vatican, Rome* 53

4. MARRIAGE OF THE VIRGIN *Brera Gallery, Milan* 55

5. THE MADONNA AND CHILD ENTHRONED WITH FIVE SAINTS (COLONNA ALTARPIECE)
 The Metropolitan Museum of Art, New York City 57

6. SAINT MICHAEL AND THE DRAGON *The Louvre, Paris* 59

7. SAINT GEORGE AND THE DRAGON *The Louvre, Paris* 61

8. THE THREE GRACES *Condé Museum, Chantilly* 63

9. PORTRAIT OF ANGELO DONI *Pitti Gallery, Florence* 65

10. PORTRAIT OF MADDALENA DONI *Pitti Gallery, Florence* 67

11. THE MADONNA OF THE GRANDUCA *Pitti Gallery, Florence* 69

12. THE HOLY FAMILY WITH SAINTS ELIZABETH AND JOHN (THE CANIGIANI HOLY FAMILY)
 Alte Pinakothek, Munich 71

13. THE MADONNA OF THE GOLDFINCH *Uffizi Gallery, Florence* 73

14. THE ENTOMBMENT *Borghese Gallery, Rome* 75

15. LA BELLE JARDINIERE *The Louvre, Paris* 77

16. THE MADONNA OF THE BALDACCHINO *Pitti Gallery, Florence* 79

17. THE FALL *Ceiling, Stanza della Segnatura, Vatican, Rome* 81

18. THE DISPUTATION OVER THE SACRAMENT (DISPUTA) *Stanza della Segnatura, Vatican, Rome* 83

19. THE SCHOOL OF ATHENS *Stanza della Segnatura, Vatican, Rome* 85

20. THE SCHOOL OF ATHENS (detail) 87

21. PARNASSUS *Stanza della Segnatura, Vatican, Rome* 89

22. THE GARVAGH MADONNA *National Gallery, London* 91

23. PORTRAIT OF A YOUNG CARDINAL *The Prado, Madrid* 93

24. THE ALBA MADONNA *National Gallery of Art, Washington, D.C.* 95

25. GALATEA *Villa Farnesina, Rome* 97

26. THE EXPULSION OF HELIODORUS FROM THE TEMPLE *Stanza d'Eliodoro, Vatican, Rome* 99

27. THE MASS OF BOLSENA (detail) *Stanza d'Eliodoro, Vatican, Rome* 101

28. THE LIBERATION OF SAINT PETER FROM PRISON *Stanza d'Eliodoro, Vatican, Rome* 103

29. THE SISTINE MADONNA *Gemäldegalerie, Dresden* 105

30. THE S. CECILIA ALTARPIECE *Pinacoteca, Bologna* 107

31. LA DONNA VELATA *Pitti Gallery, Florence* 109

32. THE FIRE IN THE BORGO *Stanza dell'Incendio, Vatican, Rome* 111

33. THE MADONNA OF THE CHAIR *Pitti Gallery, Florence* 113

34. THE MIRACULOUS DRAUGHT OF FISHES *Victoria and Albert Museum, London. Crown Copyright* 115

35. PORTRAIT OF BALDASSARE CASTIGLIONE *The Louvre, Paris* 117

36. THE WAY TO CALVARY (LO SPASIMO) *The Prado, Madrid* 119

37. PORTRAIT OF LEO X AND TWO CARDINALS *Uffizi Gallery, Florence* 121

38. THE HOLY FAMILY OF FRANCIS I *The Louvre, Paris* 123

39. THE CREATION OF EVE *Logge, Vatican, Rome* 125

40. THE TRANSFIGURATION *Pinacoteca, Vatican, Rome* 127

Index 128

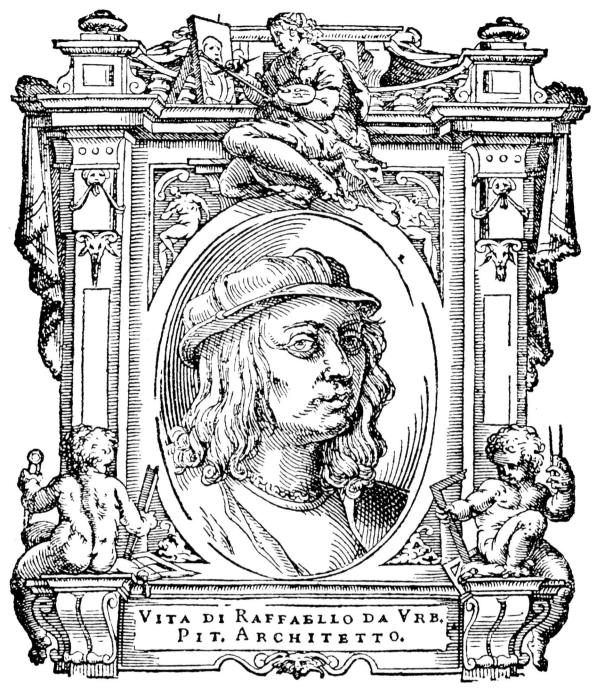

1. Portrait of Raphael from the *Vite* by Vasari. 1568

Three Italian imagemakers monopolized the visual arts during the Renaissance: Leonardo da Vinci, Michelangelo, and Raphael. Temperamentally worlds apart, they formulated so much that is deemed intrinsic to the nature of postmedieval painting, sculpture, and architecture that without their contributions it is virtually impossible to conceive, much less understand, the art of the past four centuries. All three giants were heirs to a vigorous tradition developed in the fifteenth century, as well as to the awakening passion for forms and modes invented by the Greeks and Romans, not to mention a still lively Gothic experience. In addition to the impulses from the near and distant past, significant cross-fertilization occurred. The interchange took two forms: first, there was direct borrowing from one another, and this was especially true for Raphael, understandably so because he was by far the youngest. Second, there were certain reinterpretations of one artist's work by another. More than once Leonardo pondered certain of Michelangelo's works and even made "corrections" in a drawing of what he must have considered short-

comings of the famous marble *David,* a sculpture Raphael carefully studied. Leonardo, born in 1452, was perhaps the most exceptional man of an exceptional age: his interests moved to every corner of the visual world. He was the universal man par excellence. Michelangelo, born nearly a quarter of a century after the notary's son from Vinci, was surely more the artist and less the scientist. His spirit was troubled by a constant search for some explanation of his own tormented being, whether it be in stone, paint, grandiose architectural projects, or tortured verse. During a long life stretching over nine decades, he never found a mode of expression that fully satisfied his artistic yearnings; his art was, rather, the search itself.

Raphael, born in 1483, eight years after Michelangelo and more than thirty after Leonardo, was temperamentally as decidedly unlike both his older contemporaries as he was of a different local origin. Florentine by training and in taste, Leonardo and Michelangelo had at easy reach the weighty innovations of their immediate Florentine predecessors who had, in effect, created the Renaissance in the visual arts—the architects Brunelleschi and Alberti, the painters Masaccio, Filippo Lippi, and Fra Angelico, and perhaps most profoundly of all, the sculptor Donatello. The soil of the Renaissance was home territory for Leonardo and Michelangelo, and its dialect, Tuscan, was their mother tongue. Not so for Raphael. He was born in the mountain town of Urbino, tucked in the Apennines at some distance south and east of Florence. It was entirely rebuilt in the second half of the fifteenth century under the patronage of the Montefeltro family, whose chief protagonist was Duke Federigo (fig. 2), a professional soldier who had fought at the pay of Florence. Raphael's father, Giovanni Santi, was one of the painters at the bustling provincial court and was also something of a poet. In the 1480s he wrote a long panegyric to commemorate the exploits of the duke, and in it he left a remarkable and extremely perceptive evaluation of the arts. Although Giovanni died when the boy was only eleven, the picture he painted in verse of contemporary artists is of more than passing interest for an analysis of Raphael's own development, since the commentary must have been one of the few memorabilia that the orphan—his mother had died when he was eight—treasured.

After making a number of observations about the nature of art and remarking that "excellent drawing [*disegno*] is the foundation of painting," Giovanni Santi proceeds to enumerate the best artists operating in the fifteenth century. His selection turns out to be much like our own, and he even mentions the chief sculptors of the period, including Donatello, Jacopo della Quercia, and Desiderio da Settignano. He singles out two young masters for high praise: Leonardo da Vinci and Pietro Perugino, both of whom will play such an important part in Raphael's evolution as an artist. But the highest praise of all is reserved for Andrea Mantegna, court painter for the Gonzaga at Mantua. One could justly wonder if Raphael had paid a visit to this aged painter on his North Italian journeys before Mantegna died in 1506. There are clear indications that Raphael was familiar with Mantegna's art, certainly through engravings but also in Mantua.

As a child, Raphael had direct acquaintance with many of Italy's leading artists who passed through the sophisticated court at Urbino, where his father was something of a factotum. Raphael must also have been impressed with the works they left in Urbino and with the Ducal Palace, itself a gem of Renaissance architecture. Its measured elegance and refinement reflect the contributions of Luciano Laurana and Francesco di Giorgio Martini. Paintings by important quattrocento masters located in Urbino and nearby include works by Paolo Uccello, Piero della Francesca, Melozzo da Forlì, Signorelli, and Perugino, and even a major panel by the Netherlandish painter Justus van Ghent.

It would be a mistake, however, to exaggerate the extent of Raphael's assimilation of all these diverse artistic experiences when he was very young. They formed, rather, the general cultural environment and visual underpinning that affected his development in relatively unspecific though basic ways. And further, he could hardly have learned more from his father than a bit of basic drawing and some notion of how to mix colors. His real training came in the next ten years, first locally in Urbino, possibly with the painter and friend of his father Evangelista da Pian di Meleto, with whom he shared his first known commission. When Raphael was about eighteen, in 1501, he began working for Pietro Perugino, born near Perugia, as his name implies, and probably the leading Central Italian painter of his generation. The connection with Perugino, himself experienced in the Florentine workshops, was a determining factor in the first phase of Raphael's art. The young painter

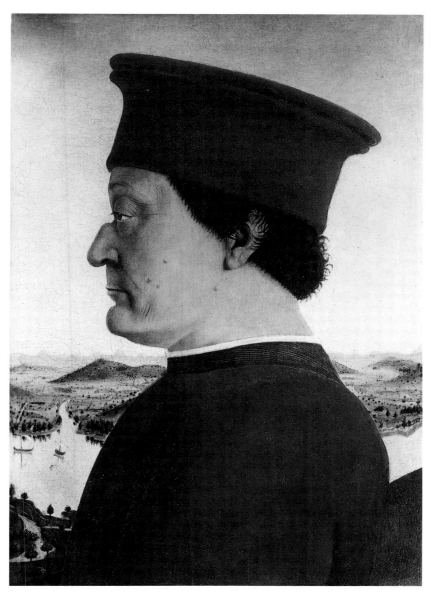

2. Piero della Francesca. *Duke Federigo da Montefeltro*. c. 1473.
Oil on panel, 18½ × 13″. Uffizi Gallery, Florence*

*When oil is indicated in the captions, the reader should bear in mind that very few chemical tests have been made on Renaissance panel pictures, and therefore the exact components of the medium have not usually been determined.

became so skilled at absorbing the manner of the older master that in very short order his style became virtually indistinguishable from Perugino's, and by the time Raphael was twenty-one, he seems to have surpassed Perugino within the context of the latter's own approach and aesthetic, much as the young Leonardo had surpassed, in painting, his teacher Verrocchio.

Perugino was an Umbrian who had been trained within the tradition of Piero della Francesca. He had a more lyric and attenuated figure style than Piero, however, and appeared to perpetuate certain conventions of Sienese painting, whose impact on Central Italian art was very great during the fourteenth and early fifteenth centuries. The delicate imagery, the refined, small-featured, thin-limbed figures, the deep, rich color, the adherence to the past characterize Perugino's language of forms. He had, at the same time, mastered many innovations of the early quattrocento, having set up shop in Florence in the 1470s, and he could use mathematical and aerial perspective efficiently. As a famous master of fresco, he was invited to paint in the Sistine Chapel along with the best painters of his day, including Botticelli and Ghirlandaio. He was also an astute portrait painter,

3. Pietro Perugino. *Vallombrosa Altarpiece.* 1500.
Oil on panel, 13′ 7⅞″ × 8′ ⅞″. Uffizi Gallery, Florence

4. *Saint Sebastian.* c. 1503.
Oil on panel, 17 × 13½″. Accademia Carrara, Bergamo

yet his reputation was built primarily on large altar-pieces where figures, landscape, and architecture were integrated within a luminous atmosphere. Perugino was one of the busiest painters in Italy by the time Raphael became associated with him, with commissions for the city of Perugia, where he maintained his shop, as well as for other centers.

Although the precise nature and length of Raphael's connection with Perugino are unknown, the surviving works, from the very earliest up to 1504 and even somewhat later, betray a close artistic reliance of the younger man upon the master. When Raphael was between the ages of seventeen and twenty-one, he executed four important altarpieces, three for churches in Città di Castello, a small but thriving center on the border between Tuscany and Umbria, and one for a church in Perugia. Whether these were obtained through the recommendation of Perugino, which seems likely, or obtained directly, Raphael's

stylistic dependence upon Perugino was pervasive.

The first of these paintings survives only in a few fragments. It is known that Raphael undertook the commission in partnership with Evangelista da Pian di Meleto. Very likely this joint venture represented the continuation of Giovanni Santi's old *bottega,* inherited by Raphael only when old enough and sufficiently skilled to revive the family business. The altarpiece, the *Coronation of S. Niccolò da Tolentino* (colorplate 1), provides a firm, established point in Raphael's early career since it was commissioned on December 10, 1500, and finished but ten months later. Stylistically there are clear parallels with Perugino's work of that very moment, including *The Assumption of the Virgin* (the so-called *Vallombrosa Altarpiece*) in the Uffizi Gallery, Florence, which is signed and dated 1500 (fig. 3). In fact, there are even those critics who already see in this painting by Perugino the collaboration of the youthful Raphael,

11

5. Raphael (attributed to). *The Madonna and Child with Book.* 1502–3. Oil on panel, 21¼ × 15¼ ". Norton Simon, Inc., Museum of Art, Los Angeles

6. Study for *The Madonna and Child with Book.* 1502. Pen on paper, 4½ × 5⅛". Ashmolean Museum, Oxford

who may also have assisted the master in the fresco decoration of the Cambio in Perugia. A possible contribution of the very young Raphael to some of Perugino's commissions of this period has often been suggested, although the singling out of an isolated figure or group here and there as having been painted by Raphael is a highly speculative activity that gives little insight into the early style of the master.

Because of the dismembered and mutilated state of the *Coronation of S. Niccolò da Tolentino* and the degree of collaboration with Evangelista, few dogmatic conclusions should be drawn about Raphael's art at this stage. It does appear clear, however, that at the age of eighteen Raphael was already sufficiently skilled to have undertaken a significant commission. A second large altarpiece for Città di Castello, entitled *The Crucifixion* (colorplate 2), was made for the Gavari Chapel in the Church of San Domenico. As the sixteenth-century biographer and artist Giorgio Vasari observed, if Raphael had not signed the altarpiece, people would have thought it was by Perugino. Such a statement, which to modern ears might indicate an absence of creativity and originality on the part of the young painter, actually stands very much to his credit. He had probably finished *The Crucifixion* in 1503 when he was only twenty, equaling one of the most respected and sought-after masters in Italy. (Raphael's patron-to-be, Agostino Chigi, had referred to Perugino in 1500 as the best master in Italy.)

Raphael located his Crucifixion on a slight rise overlooking an expansive, gently rolling countryside. The figure types and their stereotyped poses, saccharine expressions, and standardized gestures all belong to Perugino's vocabulary. What is most distinctive about the picture is the composition, and it is on this fundamental level that Raphael had already unconsciously begun to move beyond his master. Here the figures are distributed in such a way as to echo the arched form of the ancona itself: the circle and the ellipse are geometric forms that give authority to the total composition. Two scenes from the predella at the base of the altarpiece have been found, and they affirm the youthful Raphael's ability to work in a small scale. Thus the *Gavari Altarpiece* demonstrates a range from nearly life-size figures to minuscule images. Raphael's control and his natural sense for composition were already so strong that actual size was irrelevant.

A third effort of this Peruginesque Umbrian peri-

fresco that he painted in the papal chambers a few years later.

The overall plan has some affinities with Perugino's large altarpieces, for example the one for San Pietro in the same city, although Raphael has sought a more convincing arrangement for his figures in the lower zone. The figures are disposed around the sarcophagus in a splayed circular grouping, which is repeated above with the music-making angels who enclose the central figures where the actual coronation is taking place. Differing from the circular thrusts in the Gavari *Crucifixion,* which occur essentially on the surface, the movement here takes place convincingly in space. Furthermore, the heavenly scene with the coronation does not float unspecifically but has mass and weight within its sphere. The painting has been criticized for the unfortunate placement of the sarcophagus, which cuts off most of the figures, but with it Raphael begins a gradual rejection of Perugino's syntax and simultaneously a gradual evolution of his own. The tambourine player

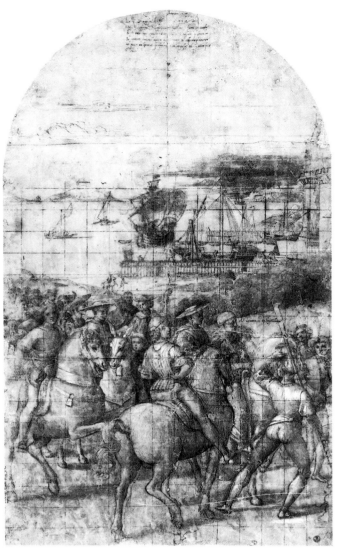

7. Preliminary cartoon for *The Departure of Enea Silvio Piccolomini for the Council of Basel.* c. 1505. Pen, bister, and white lead on paper, 27¾ × 16¼". Gabinetto di Disegni e Stampe degli Uffizi, Florence

od, when Raphael may well have had his headquarters in Città di Castello, was the *Coronation of the Virgin* (colorplate 3), now in the Vatican Pinacoteca, complete with predella scenes dealing with events in Mary's life. It was originally commissioned by Maddalena degli Oddi for the Church of San Francesco in Perugia and was probably painted largely during 1503. The commission to Raphael must have had at least the support of Perugino, if it was not actually arranged by the older master for his younger associate. Also an altarpiece of considerable dimensions, the *Coronation* is a far more ambitious composition than the previous pictures. With two distinct and separate zones, it represents an early statement and in some ways prefigures the far more famous *Disputa*

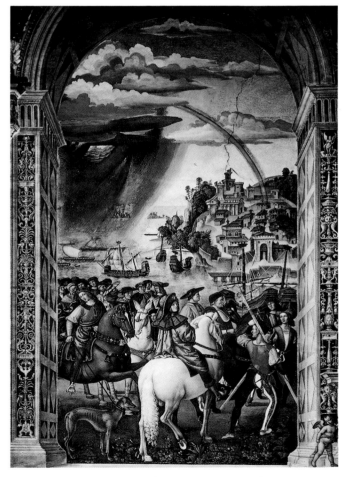

8. Pintoricchio. *The Departure of Enea Silvio Piccolomini for the Council of Basel.* c. 1506. Fresco. Piccolomini Library, Cathedral, Siena

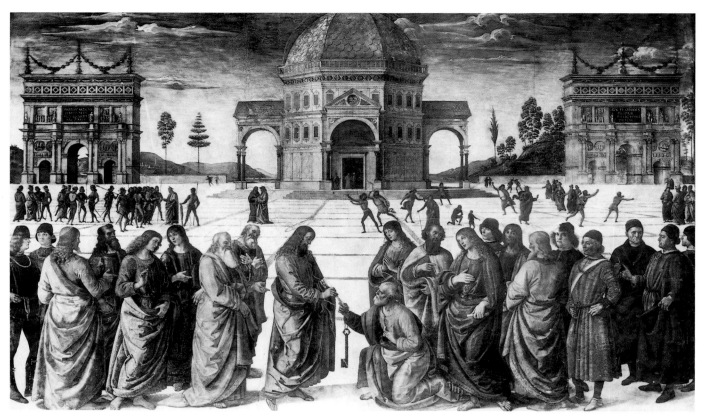

9. Pietro Perugino. *The Delivery of the Keys to Saint Peter*. 1482. Fresco, 10′ 11⅞″ × 17′ 11⅞″. Sistine Chapel, Vatican, Rome

10. *Marriage of the Virgin* (detail). 1504. Oil on panel. Brera Gallery, Milan

from the upper zone, derived from a sculptural prototype, has a physical amplitude that is unknown in Perugino and points to Raphael's subsequent style. About twenty-one years old when he finished the *Coronation,* he was able, once he had absorbed Perugino's approach, to alter and eventually discard it. Such a rejection did not come about all at once; to be sure, strong reflections of Perugino continue to be found in his work for the next several years.

After making a processional banner painted on one side with *The Creation of Eve* and with *The Crucifixion* on the other, he executed the last of the works in this period for Città di Castello, the *Marriage of the Virgin* (colorplate 4). It represents the end of this first phase of Raphael's development, where he still follows a program and uses a figure style delineated by Perugino. The *Marriage of the Virgin* is a smaller, more intimate and refined work than the altarpieces discussed above. It is signed and dated—Raphael of Urbino, 1504—thereby offering another firm point in his career. The composition is related to one enunciated by Perugino in *The Delivery of the Keys to Saint Peter* (fig. 9), which was executed in fresco for the Sistine Chapel some twenty years before, and which reoccurs in a painting by Perugino commissioned in 1499, also depicting the Marriage of the Virgin (Musée des Beaux-Arts, Caen). Raphael has made his composition more logical and easier to read; at the same time he softened the rigid central thrust of Perugino's examples. But the greatest differences lie in the handling of figures: Raphael's figures have weight, they stand convincingly. But for all this, Raphael's language remains very much Perugino's, and perhaps this fact explains the prominent position he gives to his signature, on the temple in the background (fig. 10); thus no one could fail to recognize Raphael as the author. Michelangelo had earlier done a similar thing when he boldly signed his name to the *Pietà* (fig. 33). Painted immediately preceding Raphael's extended residence in Florence, the *Marriage of the Virgin* demonstrates that upon his arrival there he was a highly skilled, if somewhat provincial, young painter who worked closely, and with great success, in the manner of Pietro Perugino.

His Florentine experience was rapidly to upset or severely recast a good deal of what he had learned, offering new, broader avenues of an infinitely more robust character than he had contemplated before. As if by some stroke of destiny, Raphael went to Florence soon after Leonardo had returned from an extended

11. *Connestabile Madonna.* c. 1505.
Oil on canvas, diameter 7″.
Hermitage, Saint Petersburg

12. *Dream of a Knight.* 1505–6.
Oil on panel, 6¼ × 6¼″.
National Gallery, London

stay in Milan and a military expedition with Cesare Borgia. Michelangelo was also there, having but recently finished the marble *David*. Echoes of heated discussions about the monumental statue and its proper placement must still have been very much in the air on Raphael's arrival in Florence, presumably in the fall of 1504. In October Giovanna da Monte-

13. *Agony in the Garden* (one of the predella panels of the *Colonna Altarpiece*). c. 1505.
Oil on panel, 9½ × 11″. The Metropolitan Museum of Art, New York City

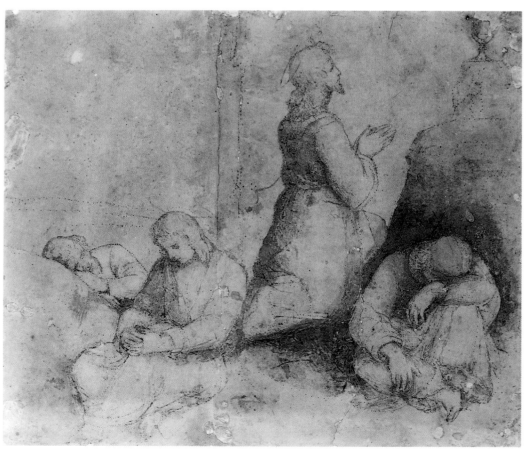

14. Study for *Agony in the Garden*. c. 1505. Ink and wash on paper,
8⅞ × 10¼″. The Pierpont Morgan Library, New York City

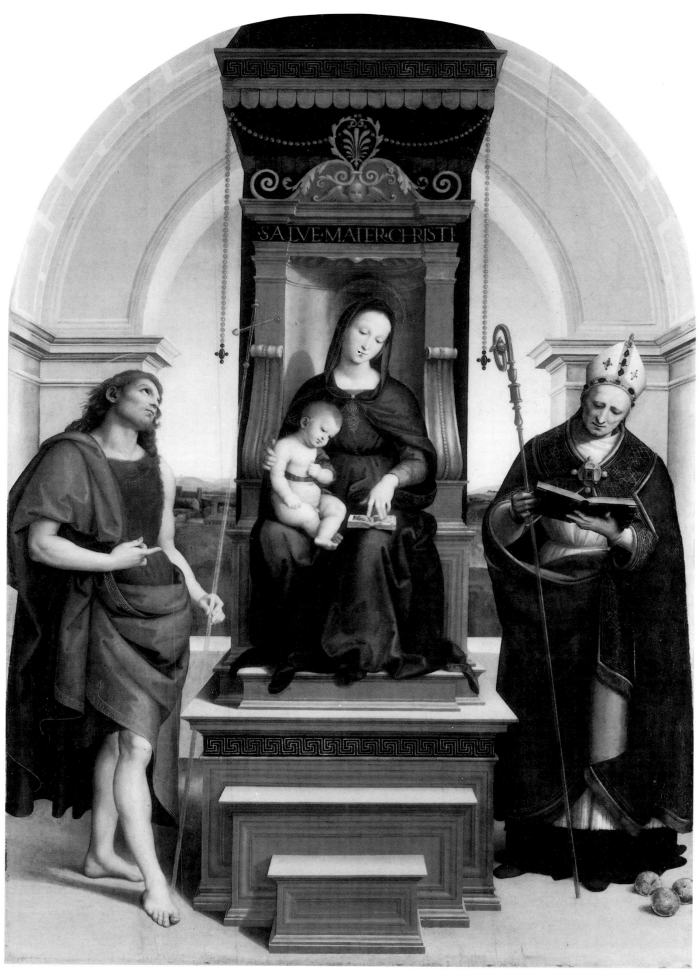

15. *The Madonna and Child Enthroned with Two Saints (Ansidei Altarpiece).* 1505–6.
Oil on panel, 8′ 11¼″ × 5′ 1½″. National Gallery, London

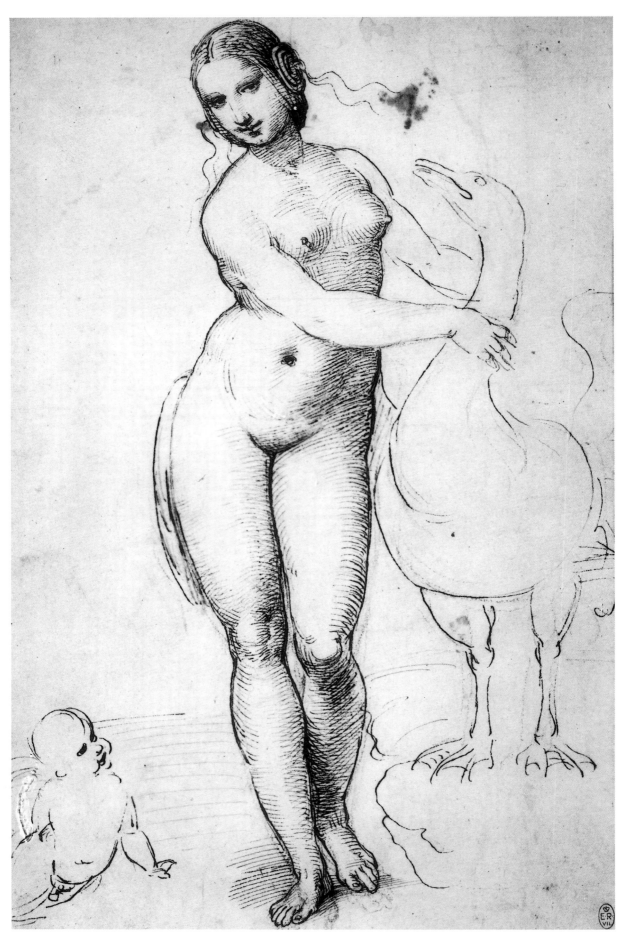

16. *Leda and the Swan* (after Leonardo). c. 1507. Ink on paper, 12½ × 7½″. Royal Library, Windsor.
Reproduced by gracious permission of Her Majesty the Queen

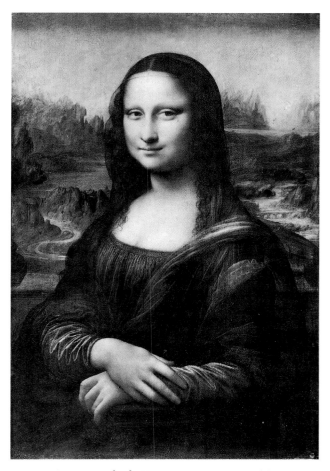

17. Leonardo da Vinci. *Mona Lisa.* c. 1503.
Oil on panel, 38½ × 21″.
The Louvre, Paris

18. *Half-Length Study of a Woman.* c. 1506.
Ink on paper, 8⅝ × 6¼″.
Cabinet des Dessins, The Louvre, Paris

feltro, the influential daughter of Federigo and sister-in-law of Pope Julius II, wrote a letter from Urbino recommending Raphael to Piero Soderini, the head of the government, in order to perfect his study of art. This information should by no means exclude the likelihood that Raphael had been in Florence before—undoubtedly he had, probably traveling there on various occasions with Perugino—but this date marks Raphael's more permanent stay in Florence, where he remained for about four years; nor was he entirely unaware of Florentine art before this period. But the time was only now ripe for Raphael, having mastered his craft, to register the full meaning of the Tuscan heritage and make an irreparable break with the stylistic precepts of his teacher.

The two *giganti* of Florentine art, Michelangelo and Leonardo, were locked in competition during these years, each entrusted with an important mural for the Great Hall of the Palazzo della Signoria: Michelangelo was developing the cartoon for the *Battle of Cascina* (now destroyed), Leonardo the *Battle of Anghiari* (also destroyed). These two historical cartoons—the paintings were never executed—had an immeasurable impact on the young Raphael, as they did on generations of painters. By the time Raphael had completed the *Marriage of the Virgin* he was prepared to conquer new horizons, and the electrified atmosphere that was then characteristic of Florence with the presence of Leonardo and Michelangelo, as well as representatives of the older tradition, Lorenzo di Credi, Piero di Cosimo, and Botticelli, quickly had its effect.

During the next four years, while the center of his activity was in Florence, Raphael produced a large number of private commissions encompassing several genres, and he was able to benefit on almost every level from solutions of his older contemporaries in the process. In portraiture, for example, both the husband and wife likenesses of the Doni (colorplates 9, 10) bespeak a new elegance, especially in the pose and in the bearing of the sitters, that can be directly related to Leonardo's *Mona Lisa* (fig. 17). This work

19

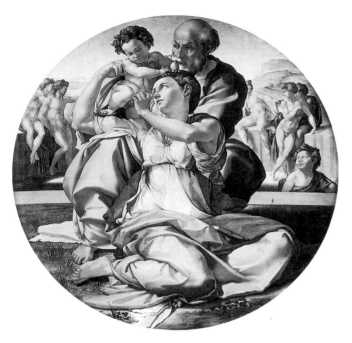

19. Michelangelo. *The Doni Holy Family.* c. 1503.
Oil on panel, diameter 47¼".
Uffizi Gallery, Florence

continued to serve Raphael as a model even after he left for Rome in 1508, although by the second decade of the sixteenth century Raphael's portraiture has a more illustrious quality, and the subjects have greater monumentality, as exemplified by the *Portrait of Baldassare Castiglione* (colorplate 35). However important Leonardo's example was in his development of portrait painting, Raphael was also aware of other solutions in the Florentine *ambiente,* like those of Lorenzo di Credi, once a fellow pupil of Leonar-

do's in Verrocchio's shop. Nor would it be reasonable to assume that Raphael during this Florentine period remained exclusively in Florence without visiting other important centers in the area.

Raphael's activity during the years from 1505 to 1508 was largely centered in Florence, but he continued to travel a good deal and to execute commissions for patrons in other cities. He apparently was significantly involved in the fresco cycle in the Piccolomini Library attached to the Cathedral of Siena, depicting scenes in the life of Pius II. The decoration was commissioned from the older Umbrian master Bernardino Pintoricchio, and there is evidence in the form of a small preliminary cartoon that Raphael supplied some of the designs about 1505 (fig. 7). It is not easy to explain the circumstances in which the young master, about twenty-two or twenty-three years old at the time, would have played such an important role in the frescoes of the mature, even famous master Pintoricchio, but Raphael's involvement appears certain. In a contract entered into with another painter for an altarpiece in Perugia of the Coronation of the Virgin, Raphael lists cities where he might be found, which included Perugia, Assisi, Rome, Siena, Florence, Urbino, and Venice. This statement, coming at the end of 1505, even with an element of youthful bravura thrown in, should be taken quite seriously; since we know that Raphael continued to be active in Perugia, Urbino, and Florence during these years, there seems no reason to doubt the remainder of his list.

Interesting for understanding Raphael's early career is surely the mention of Venice, not only

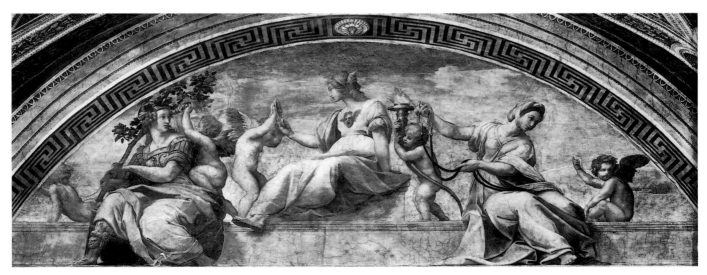

20. *Strength, Prudence, and Temperance.* 1511. Fresco, 22' 1½" at base.
Stanza della Segnatura, Vatican, Rome

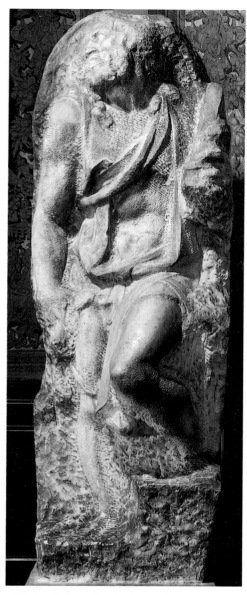

21. Michelangelo. *Saint Matthew*. c. 1505.
Marble, height 8′6¾″.
Accademia, Florence

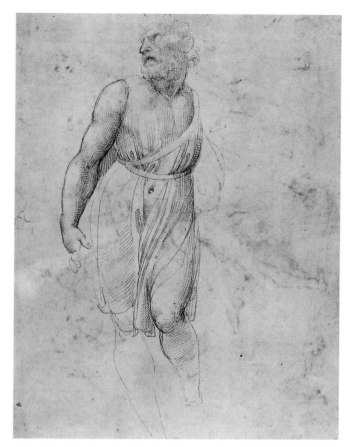

22. *Standing Figure* (after Michelangelo's *Saint Matthew*).
c. 1507. Ink on paper, 12⅝ × 9″.
British Museum, London

because of the growing eminence of Venetian art and its possible impact on the young Raphael, but also because any trip to Venice from Central Italy would have involved passing through Bologna and Ferrara, and thus still other artistic points of view would have become directly known to him. Already in his Florentine period, the landscape elements in Raphael's pictures are unlike anything known in Florentine painting, and certain analogies with the backgrounds in Giovanni Bellini's pictures, for example, may be drawn. Light is never handled with quite so specific a stress, but some direct experience with Venetian landscape paintings seems quite likely. It is also hard to imagine that he failed to visit nearby Bologna, and

there he appears to have had contact with Emilian art, in general, and with the style of Francesco Francia, that city's leading painter and goldsmith, with whom Raphael was on very close terms later on. The ingredients of Raphael's style of portraiture, and other subjects as well, resulted from the ingestion of a range of impulses filtered by his own training and his own increasingly independent artistic vision, as is exemplified by the haunting portrait known as *La Muta,* which still retains the general pose of the *Mona Lisa.*

Among the most frequently rendered subjects produced by Raphael in Florence were small Madonnas for private patrons. These paintings show Mary with the Christ Child or may include the little Saint John, a favorite of the Florentines because he is the patron saint of the city, or Saint Joseph; they clearly reveal Raphael's absorption of traditional Florentine types of this subject produced in the fifteenth century. The examples of Donatello and, especially, Luca della Robbia were indelibly imprinted on Raphael in such works as the well-known *Madonna of the Grandu-*

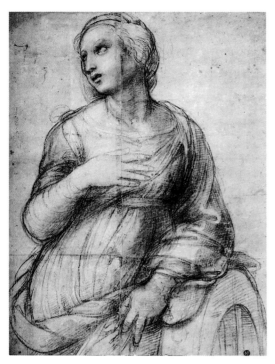

23. Cartoon for *Saint Catherine*. c. 1507.
Black pencil on paper, 23 × 17″.
Cabinet des Dessins, The Louvre, Paris

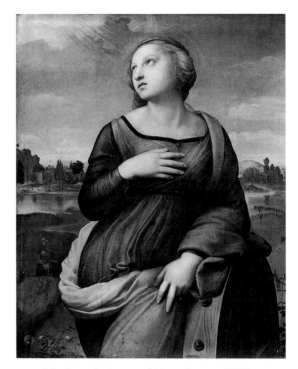

24. *Saint Catherine of Alexandria*. c. 1507.
Oil on panel, 28¼ × 21¼″.
National Gallery, London

ca (colorplate 11), *The Small Cowper Madonna* (National Gallery of Art, Washington, D.C.), *The Large Cowper Madonna* (fig. 26), and *The Mackintosh Madonna* (National Gallery, London). The impact of these Florentine quattrocento sculptural sources continues to be present even in *The Sistine Madonna* (colorplate 29), long after he left Tuscany.

The Madonna paintings that include Saint John, Saint Joseph, or Saint Elizabeth required more intricate compositions than the simpler Madonna with the Christ Child held in her arms or on her lap. For the more complex examples the influence of Leonardo's compositions is increasingly more telling. It was Leonardo who essentially invented the pyramidal composition for such pictures, a formula that offers remarkable stability in organizing groups of figures, as in *The Madonna of the Rocks* (fig. 25). Raphael saw the potentialities of such a figural arrangement for numerous paintings done in Florence. *The Madonna of the Goldfinch* (colorplate 13), *The Madonna of the Meadow* (Kunsthistorisches Museum, Vienna), and *La Belle Jardinière* (colorplate 15) use this general disposition of figures, varying the format somewhat from an equilateral to an isosceles triangle. For Raphael in Florence, Leonardo's example and discoveries were probably the catalyst for the development of his

new style, which reached full expression in Rome. Michelangelo's influence at this stage was relatively negligible; although Raphael did copy and study some of his Florentine works, Michelangelo's art held an immense sway over Raphael only somewhat later, in Rome.

The Entombment (colorplate 14), which was executed for Perugia, offers insight into the way Raphael has assimilated various and diverse sources. In the drawings for it (see, for example, figs. 36, 37), there is no doubt that he was vacillating between two different treatments: a Lamentation and a Transport of Christ to the Tomb. Both ideas seem to have their origins in Luca Signorelli's fresco in Orvieto (fig. 35) but were modified by impulses from Michelangelo and from antiquity.

Raphael also continued to have contact with Perugino, who was himself in Florence during 1507, although the "generation gap" was ever widening. In the following year Raphael must have felt ready to change roles. He was no longer prepared to sit at the feet of the giants; instead he was anxious for an opportunity to compete with them as an equal. He therefore wrote to his uncle Simone Ciarla in Urbino, seeking a letter from the Urbinate court directed to Piero Soderini, to persuade the head of the Florentine

state to allocate to Raphael a share in the decoration of a room in the Palazzo Signoria. He probably was referring to the Sala dei Cinquecento, where Leonardo and Michelangelo had been given important mural commissions. Nothing is known of the success of his request because toward the end of 1508 Raphael left for Rome, where he obtained the patronage of the pope. But his own self-evaluation was probably correct; he had learned his lessons well in Florence and could now stand beside the finest artists in Italy.

Just as the entire artistic and intellectual climate of Florence vitally affected Raphael's art, so his residence in Rome, beginning in the late fall of 1508, had a traumatic impact. The scale of the buildings and the ruins was unlike anything Raphael had experienced in Urbino, much less Florence, where only the dome of the cathedral possesses a monumentality akin to ancient Roman structures. The enormous commem-

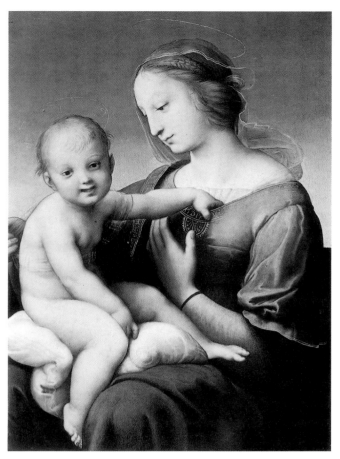

26. *The Large Cowper Madonna.* 1508.
Oil on panel, 32 × 22½".
National Gallery of Art, Washington, D.C.

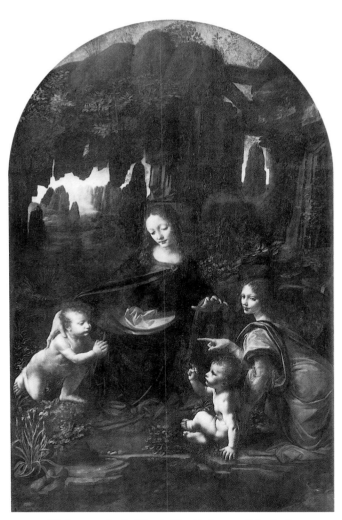

25. Leonardo da Vinci. *The Madonna of the Rocks.*
Begun 1483. Oil on panel, transferred to canvas,
78½ × 48". The Louvre, Paris

orative columns, triumphal arches, and vast vaulted structures, not to mention the Colosseum and the Pantheon, the latter preserved as a church throughout the Middle Ages and especially dear to Raphael, could not help but condition his powers of conception. Of equal importance in forming Raphael's artistic posture in Rome were his patrons and the kinds of commissions they assigned to him. Pope Julius II (Giuliano della Rovere) was, of course, the leading personality in Rome. He had undertaken the most ambitious artistic program of any Renaissance pope and had initiated the destruction of the venerable Early Christian church in favor of the new Basilica of Saint Peter's. He engaged Raphael's countryman and possibly a distant relative from Urbino, the architect Donato Bramante, to carry out the massive enterprise, and he hired Michelangelo from Florence to make a gigantic tomb for him in Saint Peter's. Artists from all over Italy flocked to Rome to share in important commissions. Rome had supplanted Florence in the early sixteenth century as the artistic hub of Italy

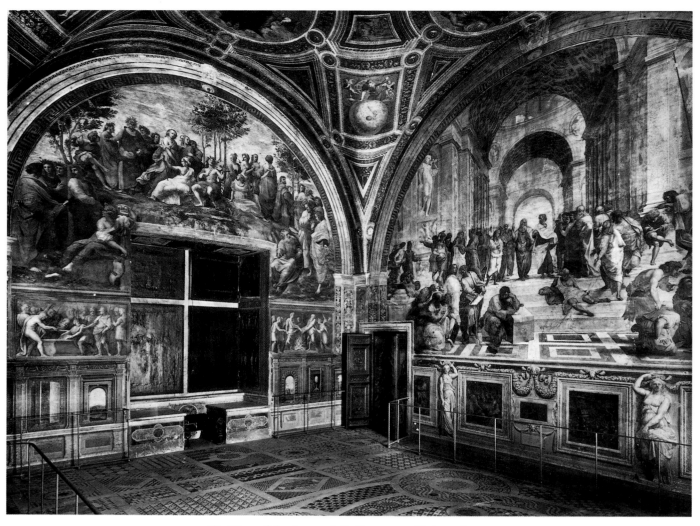

27. View of the Stanza della Segnatura, Vatican, Rome

under this vigorous *papa terribile,* who was both a general and a patron of the arts. Among those working for Julius were Bramantino from Milan; Lotto from the Veneto; Perugino, Pintoricchio, and Signorelli from Umbria; and Michelangelo, Bugiardini, and Granacci from Florence.

Raphael's first major Roman commission was the decoration of one of the papal rooms, the Stanza della Segnatura (fig. 27). The program for the room, which may have been used as a library and a judicial tribunal, is closely tied to the person of Julius II, who, along with his uncle and benefactor Sixtus IV, appears in the frescoes. The meaning of the decoration as a whole has been variously interpreted, from a Neoplatonic program to a Franciscan one based on the writings of Saint Bonaventura. Julius and his uncle were both of that order, and Sixtus particularly was something of a theologian in his own right. Whatever the exact sources, there is a harmonization of

Christian and classical thought in the room. One may also read the frescoes as a continuation of the tradition, well known in the fourteenth and fifteenth centuries, of *uomini famosi,* famous men from history and the arts together with leading church dignitaries. The range is encyclopedic in any case, from historical heroes to medieval Italians to contemporaries, including the artist himself and members of his circle.

The style in these frescoes, which include the *Disputa, The School of Athens,* and *Parnassus* (colorplates 18–21), developed naturally from his Florentine studies and especially Leonardo's example. On the other hand, the new visual experiences and the new relationships formed in Rome invigorated and expanded Raphael's expression. His early Roman period might well be thought of as his Julian phase, and the connections with Michelangelo's style of the Sistine Chapel ceiling, completed by late 1512, are not only the result of some direct borrowing on

Raphael's part. The frescoes of the Sistine ceiling are also the product of the same Roman heritage and the same patronage. Raphael's style in the Segnatura, which has come to be thought of as the standard for classic art in the Renaissance, is characterized by a harmony of all the parts, by clarity of composition, decorum in figural expression, and restraint in the coloristic qualities. There is a perfect balance between the ideas to be expressed and the means of expression, so that the effect is an uncomplicated exposition of immense artistic and visual logic.

With the success of the Stanza della Segnatura, Raphael was given another room nearby to fresco, the so-called Stanza d'Eliodoro, which obtained its name from one of the frescoes. Here, too, the iconography is very closely related to Julius II, whose likeness appears more than once in the room. The four wall frescoes, *The Expulsion of Heliodorus from the Temple*

(colorplate 26), *The Mass of Bolsena* (colorplate 27), *The Liberation of Saint Peter from Prison* (colorplate 28), and *The Repulse of Attila by Leo the Great*, begun no doubt during Julius's life, were finished under Leo X (whose portrait is found in one of the paintings). The subjects are dramatic, historical representations in which there may be analogies to political events during Julius's reign, which ended with his death in February 1513. *The Mass of Bolsena* is, like the *Disputa* in the Stanza della Segnatura, an affirmation of Julius's faith in the Eucharist. Like his uncle before him, he had special veneration for the stained cloth housed in the Cathedral of Orvieto, which was proof of the miracle of the Host to a doubting priest. The frescoes in this second stanza, with the exception of the *Attila,* continue and elaborate upon the stylistic language of the previous decoration. Within it, Raphael appears to experiment, as it were, with vigorous move-

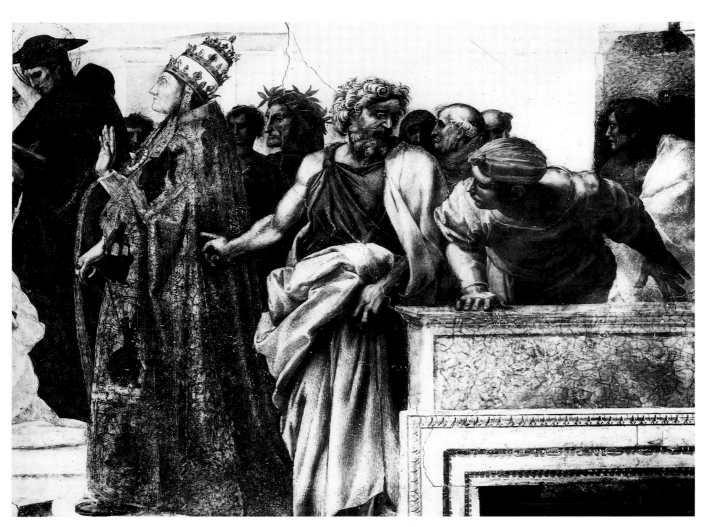

28. *The Disputation over the Sacrament* (detail). 1509–10.
Fresco. Stanza della Segnatura, Vatican, Rome

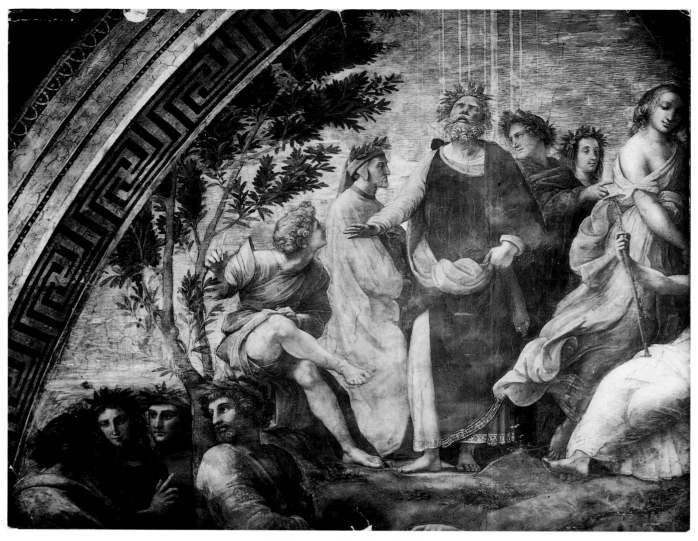

29. *Parnassus* (detail). c. 1511.
Fresco. Stanza della Segnatura, Vatican, Rome

ment, in the case of *The Expulsion of Heliodorus,* or to examine the effects of various light sources, as in *The Liberation of Saint Peter from Prison.* Also apparent in these frescoes is an increasing interest in and awareness of the architectural elements, and Raphael shows himself well informed of the newest directions in building, moving beyond the archaeological temple of *The School of Athens.* When the interiors in *The Mass of Bolsena* and in *The Expulsion of Heliodorus* are considered, it comes as no surprise that Raphael was chosen to be Bramante's successor as papal architect in 1514.

Other works of the Julian, or first Roman, period include two large altarpieces also directly related to the pope's patronage. *The Madonna of Foligno* was painted for the historian Sigismondo de' Conti, an intimate of Julius's, for the main altar of the Francis-

can Church of S. Maria in Aracoeli. *The Sistine Madonna* (colorplate 29) depicts Mary and the Christ Child with Saint Sixtus, who assumes the profile of Julius, probably in the last year of his life, and Saint Barbara. The altarpiece shows Raphael in absolute control of every aspect of the painter's craft: from the impeccable composition to the propriety of the color. The confidence of the Madonna, her self-sufficiency and absence of shyness, establishes one of those images that cannot be erased from the mind's eye.

Raphael had intimate knowledge of Julius's features, having painted them frequently. He also executed an official portrait of the pope (fig. 40, in London, and a version in the Uffizi Gallery, Florence), and at the same time he took on commissions for portraits of several prelates, including the *Portrait of Tommaso Inghirami,* known in two versions (fig. 38,

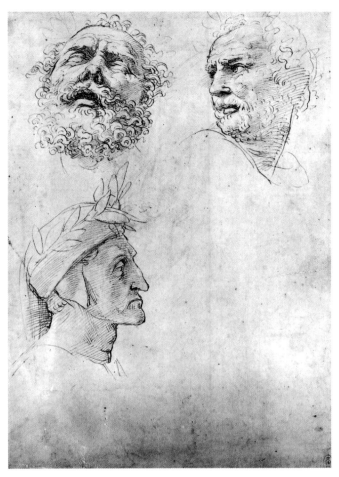

30. Studies for *Heads of Dante, Homer, and Virgil.* c. 1511. Ink on paper, 10½ × 7⅛". Royal Library, Windsor. Reproduced by gracious permission of Her Majesty the Queen

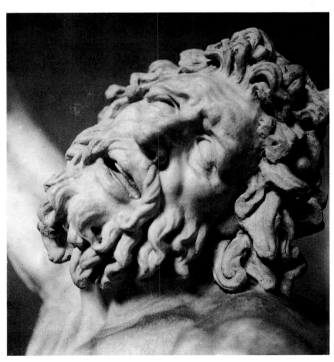

31. Head of *Laocoön.* Hellenistic-Roman. Marble. Vatican Museum, Rome

32. *The Madonna and Child with an Angel.* c. 1507. Ink on paper, 8 × 8¼". British Museum, London

in Boston, and one in the Pitti Gallery, Florence), executed in a tight, photographic style that recalls his earlier Florentine portraits.

The Sienese banker Agostino Chigi was second in importance only to the popes as an art patron of the period. Raphael was called upon to work for this Maecenas quite frequently during the decade after 1510, both for his personal residence in Rome, now known as the Villa Farnesina, overlooking the Tiber, and for church commissions for Chigi chapels in S. Maria della Pace and S. Maria del Popolo. The earliest of these Chigian commissions given to Raphael was probably the fresco of *Galatea* (colorplate 25), datable to about 1512, for the grand salon of his villa, and it represents Raphael's most impressive example of a purely classical subject to date. Work in the villa was under the direction of Baldassare Peruzzi from Siena, an architect as well as a painter, and Raphael surely benefited from an exchange of ideas with him. At this time, if not earlier, while at work on the Chigi villa, he also had contact with Sebastiano del Piombo, the Venetian painter who became his archrival, and with Sodoma, a North Italian master who had established a reputation in Siena.

The Prophets and Sibyls (see fig. 46) in the Chigi Chapel of S. Maria della Pace are from the same period. They reflect the enormous impact of Michelangelo's renderings of the same subjects from the Sistine Chapel. The singular rapport between Michelange-

27

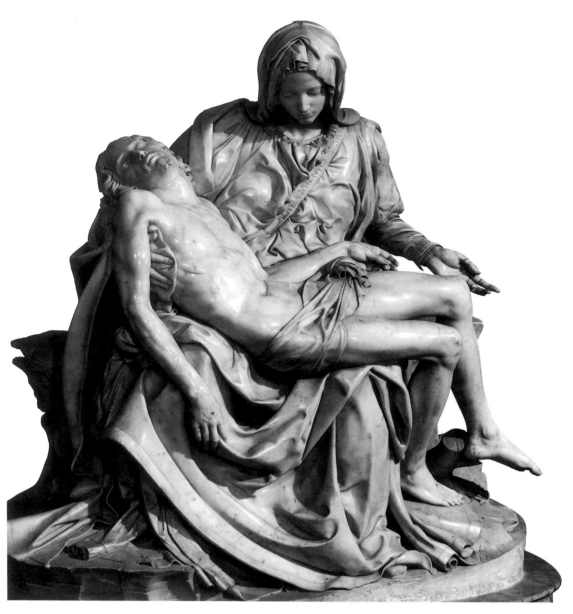

33. Michelangelo. *Pietà*. 1498–1500. Marble, height 68½". Saint Peter's, Rome

lo's and Raphael's styles is also found in the frescoed *Prophet Isaiah* in S. Agostino (fig. 44), which paraphrases Michelangelo's *Isaiah* from the Sistine Chapel ceiling (fig. 45). In effect, the personalities of Michelangelo and Julius II were determining influences at this phase of Raphael's career, and he too participated temporarily in that *terribilità* that characterizes both dynamic personalities.

By the time of Julius's death in February of 1513, Raphael had become the most successful painter in Rome. Michelangelo, after the ordeal of the Sistine ceiling, once again applied himself to sculpture, apparently with considerable relief. When the new pope, Leo X, sought to continue the program of decoration of the Vatican stanze, there was no doubt that

Raphael would be retained. In the fresco *The Repulse of Attila by Leo the Great* in the Stanza d'Eliodoro, the second room painted by Raphael, the execution demonstrably overlapped the reigns of Julius and Leo. Pope Leo the Great in the fresco has the features of the newly elected Giovanni de' Medici, who took the name Leo X. The identical likeness appears nearby in the guise of an attending cardinal, signifying that the fresco was originally painted for Julius II, who was shown accompanied by Cardinal Giovanni de' Medici. When Julius died, Leo's features were substituted for those of the deceased pope.

Leo X, the son of Lorenzo the Magnificent, had the advantage of a superior education directed by the finest humanists in Florence. He was elevated to the

cardinalate at the age of thirteen through the powerful influence of his persistent father; he ascended very early to the papacy, at thirty-seven. Physically and temperamentally Leo was the opposite of the fiery, tempestuous Julius; he had a good-natured, peaceful character. Elegant of speech and fond of music, he is said to have once remarked, "Let us enjoy the papacy since God has given it to us." Leo was generous toward the arts and letters and spent enormous sums during his papacy (1513–21). He was especially interested (and successful) in fostering the fortunes of the Medici family. Leo and his relatives, including Lorenzo, duke of Urbino, Giuliano, duke of Nemours, and Cardinal Giulio de' Medici (later Pope Clement VII), were all at one time or another patrons of Raphael. The artist survived the transferral of patronage from Julius II to Leo X by elevating his position, and the change coincides with a discernible shift in his style.

Leonardo da Vinci turned up in Rome under the patronage of the Medici, and he remained there for three years until the death of Duke Giuliano. Thus the three giants of Renaissance art, fatefully thrown

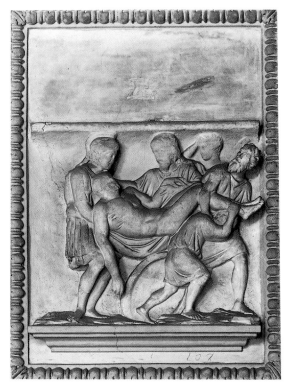

34. Fragment of Roman sarcophagus with the dead Meleager. 2d century A.D. Marble. Capitoline Museum, Rome

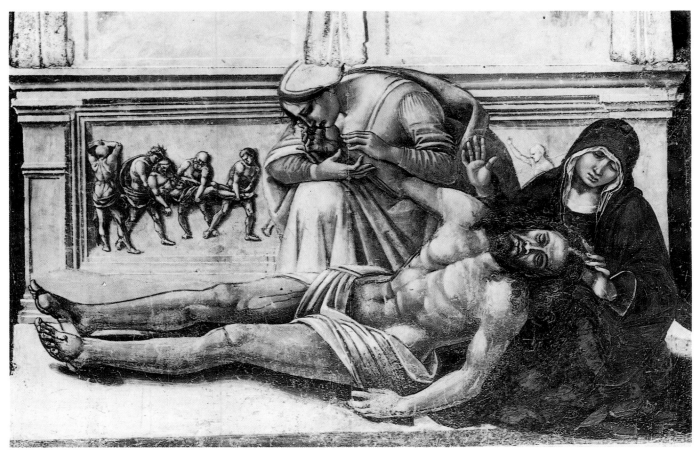

35. Luca Signorelli. *Lamentation over the Dead Christ*. c. 1500. Fresco. Brixio Chapel, Cathedral, Orvieto

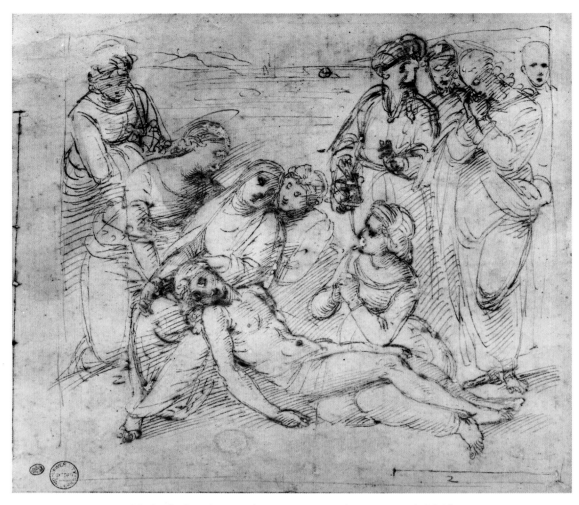

36. Study for *The Entombment*. c. 1507. Ink on paper, 7⅛ × 8″.
Ashmolean Museum, Oxford

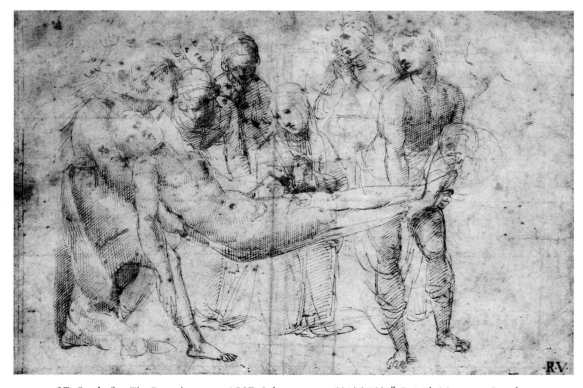

37. Study for *The Entombment*. c. 1507. Ink on paper, 8¼ × 12⅜″. British Museum, London

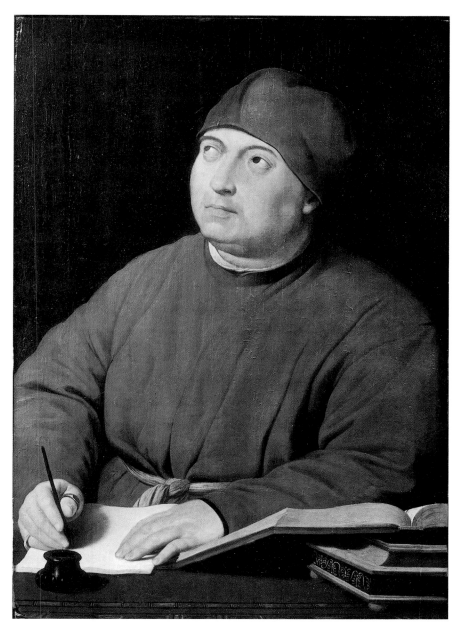

38. *Portrait of Tommaso Inghirami.* c. 1510. Oil on panel, 35 × 24½".
Isabella Stewart Gardner Museum, Boston

together in Florence a decade earlier, found themselves once more in close proximity. The circumstances were at this stage quite different because Raphael was no longer merely a skilled provincial bent on achieving his reputation; he had learned his craft, was among the most progressive painters of his day, and was sought after by the finest patrons. Almost certainly he had new contacts with Leonardo during this period, and a new Leonardesque interest in light, especially, appears in his art. This followed a five-year period when for all practical purposes Michelangelo's example had been the single dominant factor in his art.

The second Roman, or Leonine, period in Raphael's development is characterized by an expansion of the kind and number of activities he was asked to undertake. Of ranking importance was his appointment in 1515, upon the death of Bramante, as the architect of Saint Peter's, along with the ancient Fra Giocondo (who died the following year). The practice of architecture, for which he must have had some preparation with Bramante in the preceding years, opened an entirely new horizon for the young master, and he wasted little time in proceeding with the work at the basilica as well as with other architectural projects. In 1515 he was placed in charge of the antiqui-

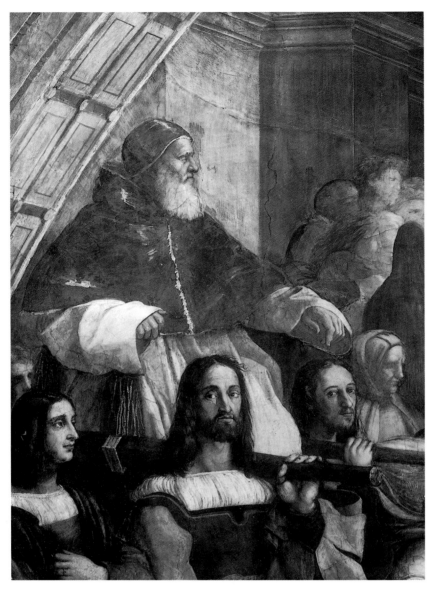

39. *The Expulsion of Heliodorus from the Temple* (detail). 1512.
Fresco. Stanza d'Eliodoro, Vatican, Rome

ties of Rome, adding still another dimension to his responsibilities under Leo X. His major concern was the preservation of ancient marble inscriptions, which were frequently being destroyed or reused. A few years later he undertook the production of a reconstruction map of ancient Rome but never got very far with his plan. He was also interested in sculpture, and some of his drawings reflect designs for monumental sculptural projects.

Nor did Raphael neglect his work as a painter despite these new ventures. About 1515 the pope commissioned Raphael to prepare ten painted cartoons for large tapestries to be woven in Flanders. These tapestries were designed for the Sistine Chapel and depicted events in the lives of Saints Peter and Paul. It must have been a highly satisfying commission for Raphael because his work would hang in the same room and beneath Michelangelo's frescoes, together with the magnificent group of quattrocento wall paintings by his teacher Perugino, as well as those by Pintoricchio, Botticelli, Ghirlandaio, and others. The cartoons should be considered for what they are, namely, colored designs from which the Flemish weavers could copy. They were not conceived as paintings per se, and the more limited palette Raphael employed in them is related to the color range he thought the weavers could obtain. In fact, the tapestries, preserved in the Vatican Pinacoteca, are rather colorless, with areas of blue, red, and a neutral beige dominating. The cartoons, further-

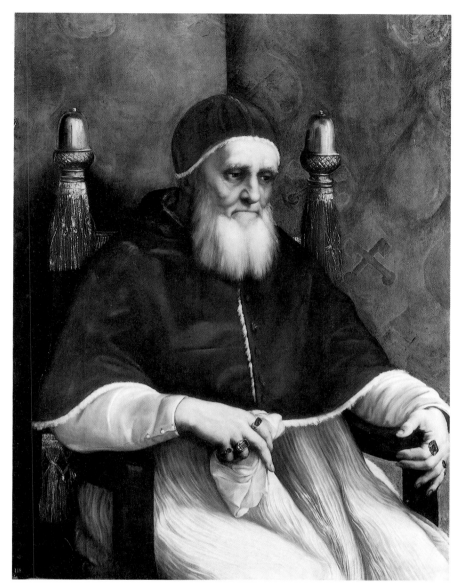

40. Copy after Raphael. *Portrait of Julius II.* c. 1511.
Oil on panel, 42½ × 31½″. National Gallery, London

more, were painted rapidly, probably in less than a year, since the laborious refinements required of usual panel and easel paintings were not necessary. Consequently, these cartoons display a lively freshness, with their bold, simplified application.

There emerges during this Leonine period an extreme flexibility and an intense willingness, even necessity, for new artistic solutions on Raphael's part. For the third papal room that Raphael painted in the Vatican Palace, the Stanza dell'Incendio, and the first entirely under Leo X (begun in 1514), Raphael did not abandon the dignified figural language he had developed in the first two stanze. He did, however, explore new and more complex spatial possibilities. In the fresco that gives its name to the

room, *The Fire in the Borgo* (colorplate 32), there is also an archaeological consciousness that should be understood in relation to Raphael's new appointment as director of antiquities, and his increasing awareness of new architectural combinations. But Raphael always retained the point of view characteristic of a painter. The group of figures in the left foreground, showing a magnificent youth carrying his old father from the flames with a lad in front and the old mother behind, is memorable (fig. 41). Massive in proportions, these nudes rival in conception and treatment figures from the Sistine Chapel ceiling. The group offers, as it were, an alternative interpretation to Michelangelo's group of a youth carried by his father in a hopeless effort to escape the rising waters in *The*

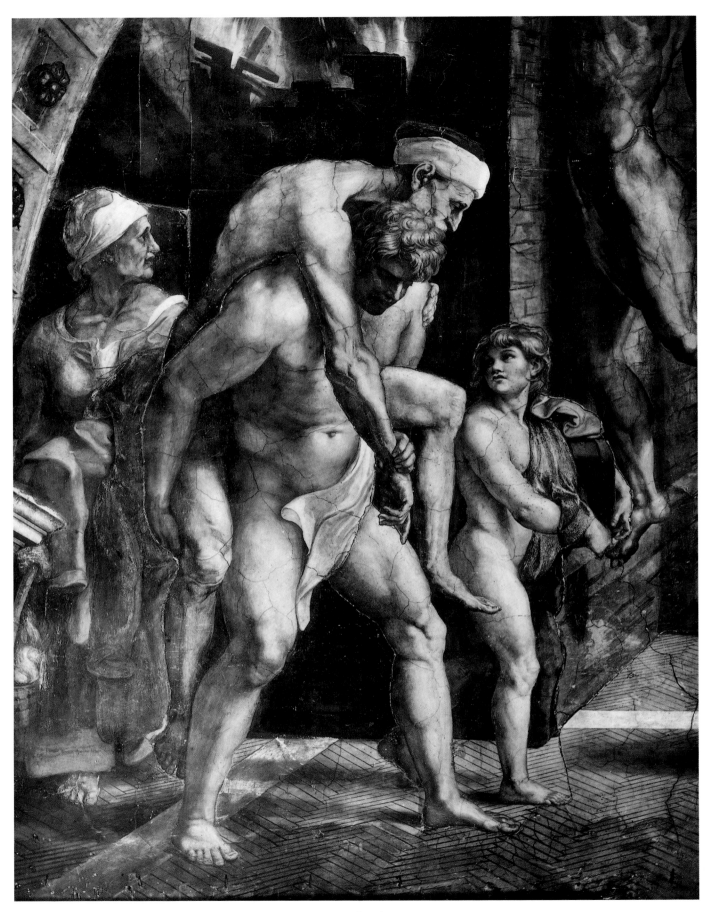

41. *The Fire in the Borgo* (detail). 1514–15. Fresco.
Stanza dell'Incendio, Vatican, Rome

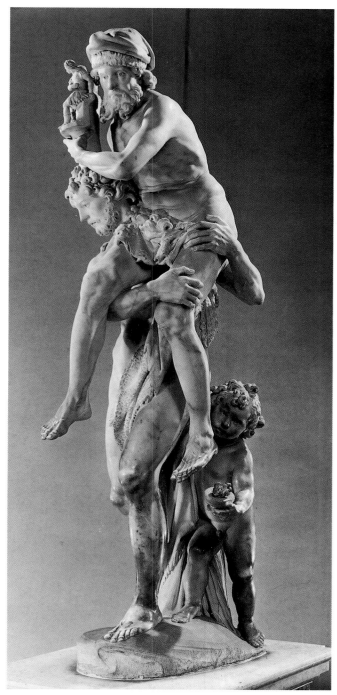

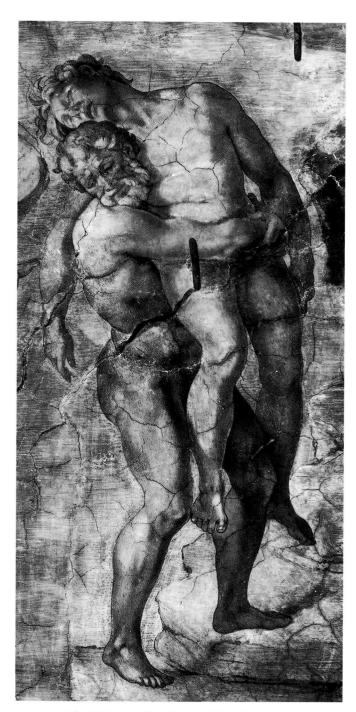

42. Gian Lorenzo Bernini. *Aeneas, Anchises, and Ascanius Fleeing Troy*. 1619. Marble, height 85⅝".
Borghese Gallery, Rome

43. Michelangelo. *The Flood* (detail). 1509.
Fresco. Ceiling, Sistine Chapel,
Vatican, Rome

Flood (fig. 43). The image Raphael invented was revived a hundred years later in a sculptured marble composition representing *Aeneas, Anchises, and Ascanius Fleeing Troy* by Gian Lorenzo Bernini (fig. 42). The expanding compass of Raphael's pictorial language is manifest in this dramatic painting in which, to be sure, his assistants had an important share.

The effect of the Roman *ambiente* upon Raphael

has already been noted, but once he became involved in the building of Saint Peter's, the new monumentality in his figure style, as in *The Fire in the Borgo*, becomes more pressing. Such a shift in figural proportions from the formulas in the first two stanze to the more robust, thicker, somewhat swollen images, like those mentioned above, has a parallel in Michelangelo's evolution during work on the Sistine Chap-

44. *The Prophet Isaiah.* 1511–12.
Fresco, 98½ × 61″. S. Agostino, Rome

el ceiling. Those Prophets and Sibyls, for example, that Michelangelo painted first are rather small in relation to the space into which they are set; the Jonah over the altar, presumably painted toward the end of work on the cycle, is so enormous that he overpowers the environment provided for him. Such an aggrandizement of scale must have been a virtually inevitable process, especially for a master connected with Saint Peter's, whose gigantic dimensions were already determined before he took charge. It should be recalled that Michelangelo's Tomb of Julius was at some point thought of for the new basilica. Raphael's appointment as architect of Saint Peter's placed him not only in strict proximity with the building but also made him the responsible party for its construction for six years. The sheer immensity of the great piers,

the height of the crossing, the scale of the dome as planned dwarfed anything Raphael must have known, except certain antecedents like the Pantheon and the Baths of ancient Rome.

During the Leonine phase, the operation of Raphael's shop underwent important changes. From an early date, probably already during his work for commissions in Città di Castello, Raphael availed himself of assistance. About the time of Giovanni de' Medici's ascendancy as Leo X, and especially when Raphael became chief architect of Saint Peter's, a marked shift must inevitably have occurred. Raphael required a large staff not merely of *garzoni* to mix colors and do chores, but of able painters in their own right, and he gradually became chief administrator of a complicated organization in which each member

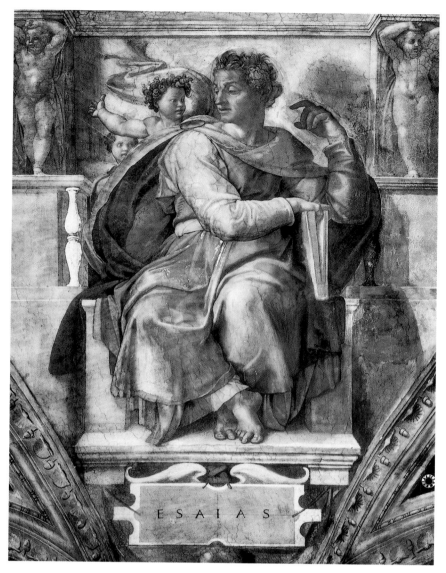

45. Michelangelo. *The Prophet Isaiah.* c. 1510.
Fresco. Ceiling, Sistine Chapel, Vatican, Rome

had his own well-defined part to play. By 1514 the leading figures in the *bottega* were Giulio Romano, Giovan Francesco Penni, called Il Fattore, and Giovanni da Udine; slightly later Perino del Vaga and Polidoro da Caravaggio joined. In every case these masters established distinguished, independent careers after Raphael's death, but during the decade from 1510 to 1520 they were instruments within Raphael's artistic process and participated, at diverse and probably well-fixed stages, in the creation of the tapestry cartoons, the third stanza, the logge frescoes, and the Psyche decorations in the Farnesina, as well as in independent, single commissions, including altarpieces and portraits.

Work progressed from initial sketches to more finished drawings; then preliminary cartoons were developed. Single elements might be subjected to restudy, and finally a cartoon was elaborated and the actual transferral onto panel, wall, or canvas was accomplished. The execution followed. At each step of the way there may have been participation by one or more members of the team. Ultimate responsibility rested, of course, with Raphael, who was even subjected to critical attack for certain shortcomings of works conducted by the shop. The degree of complication involved in isolating the particular share of one or another of these assistants in a given work is easily imagined. The difficulty is intensified because most of these gifted assistants were themselves very young, only then developing their own unique artistic idioms. It was surely Raphael's managerial as well as artistic genius, like Bernini's and Rubens's, that

46. *Sibyls* (detail). c. 1512. Fresco.
Chigi Chapel, S. Maria della Pace, Rome

decorative complex for the large logge, which included painted architectural devices and elegant stucco reliefs combining classical motifs with purely Renaissance ones.

The wall frescoes of Cardinal Bibbiena's stufetta, or bathroom, also in the Vatican, have a more exclusively decorative and sensual character. They antedate the logge decorations by several years and, in fact, anticipate some of the devices found in the logge. The painted decoration as well as the subject matter, representing Venus, is *all' antica* and was surely ideated by Raphael but executed by the shop with great delicacy (see fig. 53). The stufetta demonstrates the absence of conflict in Raphael concerning classical and Christian themes in a cultural atmosphere whose tone was set by Leo X. Michelangelo, on the contrary, might have had reservations had he been asked to paint such pagan scenes, but Raphael proceeded without qualms in executing the commission for this important cardinal and lifelong friend of the pope's. A more fully developed classical cycle was produced

enabled him to succeed in directing such an intricate operation; the individual, emerging personalities of his pupils were never allowed to overwhelm the Raphaelesque language of the entire work.

In the case of the tapestry cartoons, executed largely in 1515, several, including *The Miraculous Draught of Fishes* (colorplate 34) and *Christ Handing the Keys to Saint Peter* (Victoria and Albert Museum, London), appear to be designed and painted by Raphael himself, with only minimal assistance. In others, he had a lesser share and, in some, practically none at all. A similar division of labor may also be assumed for the famous logge frescoes, datable to 1518–19, with scenes largely from the Old Testament. By this date the shop procedures were highly perfected at the same time that the students and coworkers were much more experienced. Raphael's role must have been very slight. Probably he merely indicated the general program and produced a rare rough sketch for one or another of the scenes. Even in this case the scenes, which vary in quality and invention, are correctly called "Raphael's Bible," although most of the planning and all of the execution were handled by Giulio Romano, Perino, Giovanni da Udine, and the rest. These frescoes were only part of an ingenious

47. Study of two figures for *The Battle of Ostia*. 1515.
Sanguine, 15¼ × 11".
Graphische Sammlung, Albertina, Vienna

48. *The Oath of Leo III*. 1517.
Fresco, 21′10¾″ at base. Stanza dell'Incendio, Vatican, Rome

for Agostino Chigi, not in private chambers but in the large public loggia of his villa. Raphael was engaged to depict stories of Psyche on a vast scale. Here, too, the shop had a dominant role in the entire scheme, with Raphael's share residing primarily in providing the basic plan of the cycle and some points of departure. Perhaps he had a direct hand in several of the sections, but his participation was, at most, minimal.

Among the independent commissions Raphael executed during the Leonine period was a group of portraits produced for various members of the Medici family. He did portraits of both Medici dukes of the period, Giuliano, duke of Nemours, and Lorenzo, duke of Urbino, the same two whom Michelangelo memorialized in his Medici Tombs in Florence. Raphael's portraits of these two papal favorites were frequently copied and have come down in various versions and reflections, with the originals lost in both cases. Raphael also painted Pope Leo himself with his two cousins, Giulio de' Medici (later Pope Clement VII) and Luigi dei Rossi, who were

both cardinals. One of the best examples of Raphael's late style and one of the finest group portraits ever made, the *Portrait of Leo X and Two Cardinals* (color-plate 37) reveals the artist in perfect control of every tool at the painter's disposal. The composition, in which the three heads are nearly on the same level, unmistakably concentrates on the pope a short time after a conspiracy on his life by members of the College of Cardinals had been foiled. Apparently Leo put his trust in members of his own family more than ever. In the painting, in addition to the penetrating interpretation of the figures, there is a prevailing interest in the quality of things, the marvelous garments, the shining brass, the gold-and-silver bell, the open illuminated book. For this official portrait, treasured by the descendants of the family, Raphael spares no facet of his art to please this generous patron.

Raphael was also supported with Medici patronage for paintings with religious subject matter, but he received such commissions from other sources as

well. *The Way to Calvary (Lo Spasimo),* a large altarpiece for an order of monks in Sicily (colorplate 36), is an example analogous to the *Portrait of Leo X,* where Raphael seems to explore a range of visual, physical, and emotional experiences. It becomes a tour de force for the master where he also begins to study more persistently the possibilities of sharp contrasts between the lighted and unlighted areas in a picture.

Three large paintings that occupied Raphael and his shop toward the close of his career were Medici commissions. Duke Lorenzo, on behalf of the pope, ordered from Raphael two pictures to be sent to the French court: *Saint Michael Vanquishing the Devil* and *The Holy Family,* called "of Francis I" (colorplate 38). These two works are dated 1518 and were known to have been shipped to France in the middle of that year. Since they were meant to be sent abroad, where the level of art at the time was far below the progressive developments of the Renaissance style in Rome, Raphael may have found it less urgent to execute personally large portions of these pictures as he had done for the contemporary *Portrait of Leo X.* The characteristics of his late style are nevertheless unmistakably present: the new interest in chiaroscuro, more tenuous compositions, and enlarged figural types.

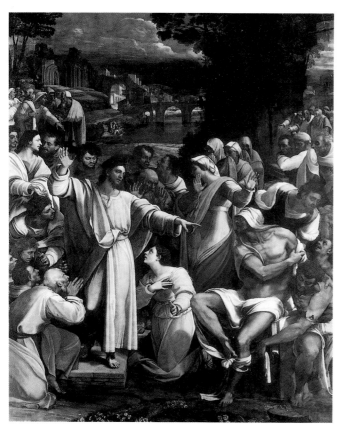

49. Sebastiano del Piombo. *The Raising of Lazarus.* 1518–19. Oil on canvas, 12′6″ × 9′6″. National Gallery, London

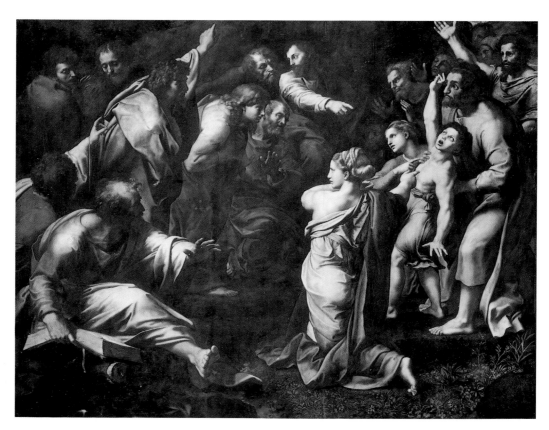

50. *The Transfiguration* (detail). 1518–20. Oil on panel. Pinacoteca, Vatican, Rome

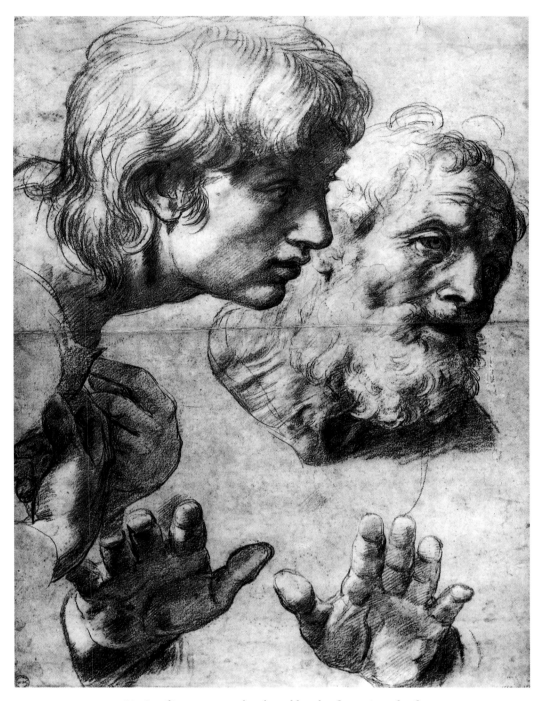

51. Auxiliary cartoon, heads and hands of two Apostles for
The Transfiguration. c. 1519. Black pencil and white lead,
19⅝ × 14¼″. Ashmolean Museum, Oxford

The most severe test of Raphael in these years was the commission from Cardinal Giulio de' Medici for an enormous altarpiece, *The Transfiguration* (colorplate 40), also destined for export to France. Although it was never sent, it did make a temporary voyage there three centuries later as part of the Napoleonic booty. The painting, like the two altarpieces for the royal family mentioned above, was a joint product of Raphael and his shop. Raphael probably painted parts of the upper zone, which must have been finished before the one below it; that is, he was following a general procedure in such cases, established to avoid injury to, and drippings on, already finished sections. In the lower part of the painting, Raphael's personal participation appears strongest in the Apostles on the left, where the effects of light

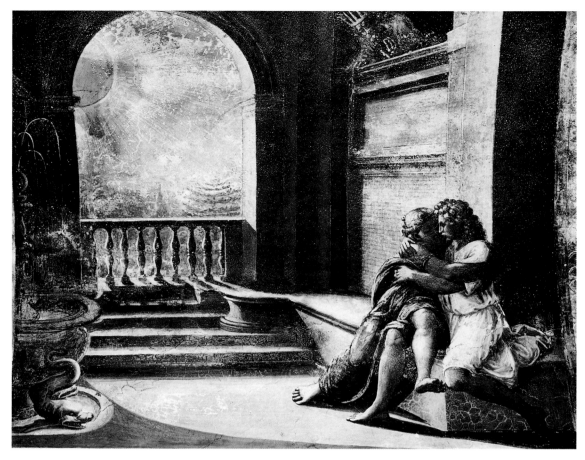

52. *Abimelech Spying on Isaac and Rebecca.* 1518–19. Fresco. Logge, Vatican, Rome

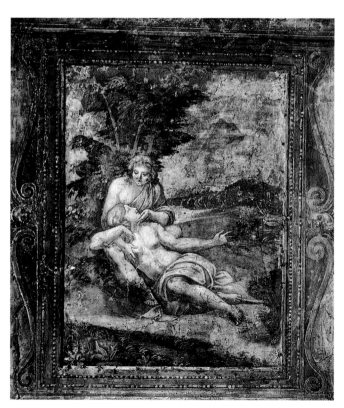

53. *Venus and Adonis.* 1516. Fresco.
Stufetta of Cardinal Bibbiena, Vatican, Rome

contribute to the drama of the subject matter, without the more obvious mechanics used on the other side of the painting, surely by Giulio and others. But Raphael had a special stake in this picture, even though it was to be sent to France, that called for his personal involvement. It had been commissioned in direct competition with Sebastiano del Piombo, who produced for the occasion *The Raising of Lazarus* (fig. 49), and therefore indirectly, at least, also in competition with Michelangelo, Sebastiano's mentor. Placed on Raphael's bier in the Pantheon, *The Transfiguration* was preserved in Rome and had an enormous impact on later artists, especially among the Tenebrists, led by Caravaggio.

Raphael's artistic evolution has been divided, broadly speaking, into four periods: (1) the early phase, from 1500 to 1504, when he was primarily working in Urbino, Città di Castello, and Perugia and largely under the aegis of Perugino; (2) the Florentine phase, 1505–8, when he assimilated the Tuscan tradition and was particularly impressed by the art of Leonardo; (3) the first Roman, or Julian, phase, from 1508 to 1513, when he became firmly established as

Rome's leading painter and when he more strongly felt the impact of Michelangelo's language; and finally, (4) the second Roman, or Leonine, phase, from 1513 to 1520, when his horizons were vastly expanded, especially in the field of architecture. One of the salient characteristics of his entire development was a remarkable ability to learn, to assimilate, and hence to grow.

At the beginning of his career, Raphael found the Umbrian soil fertile for his artistic growth. Its worthy tradition included Piero della Francesca, Signorelli, and Perugino. Then, when faced with a vastly enriched artistic milieu in Florence, he wisely studied the language of forms systematically, returning to the origins of Florentine Renaissance art, to Masaccio and Donatello. But Raphael was not blind to the new and somewhat different artistic forces that had developed in Northern Italy: the vitality of landscape in Venetian painting, the compositional and expressive strength of the Ferrarese, the optical effects of Mantegna in Mantua.

In Rome Raphael experienced the same cultural stimuli as had Michelangelo. The monumental scale altered his vision while the immediate proximity with antiquity reinforced and adjusted his figural language. Raphael also had before him Michelangelo's example, itself fired by the personality of Julius II. At the same time Raphael continued to have an open mind toward other solutions and contacts, such as those with Baldassare Peruzzi on the one hand and Venetian figure painting on the other, adding a further dimension to his art. The splendid court of Leo X offered new possibilities for the artist, and Raphael proved to be an attentive, congenial, and sought-after companion. Those affable qualities attributed to Raphael are reflected in the so-called *Portrait of Bindo Altoviti* in the National Gallery of Art, Washington, D.C. (fig. 56), sometimes considered a portrait of Raphael himself. Raphael's most steadfast admirer in the nineteenth century, Jean-Auguste-Dominique Ingres, used the portrait as the basis for his likeness of Raphael in the historical-mythological *Cardinal Bibbiena Presenting His Niece to Raphael* (fig. 57).

There was also something saintly about Raphael, whose family name was, after all, Santi. Born on Good Friday in 1483, he died thirty-seven years later on the same day. Some contemporaries even mistakenly took the number of years as thirty-three, that is, the age at which Jesus Christ died. Raphael never married because, Vasari reported, he held out the

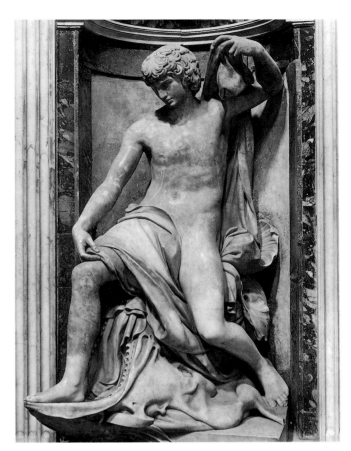

54. Lorenzo Lotti, called Lorenzetto.
Jonah. 1519–22. Marble.
Chigi Chapel, S. Maria del Popolo, Rome

55. Raphael's tomb, Pantheon, Rome

56. So-called *Portrait of Bindo Altoviti*. c. 1515(?).
Oil on panel, 23½ × 17¼″. National Gallery of Art, Washington, D.C.

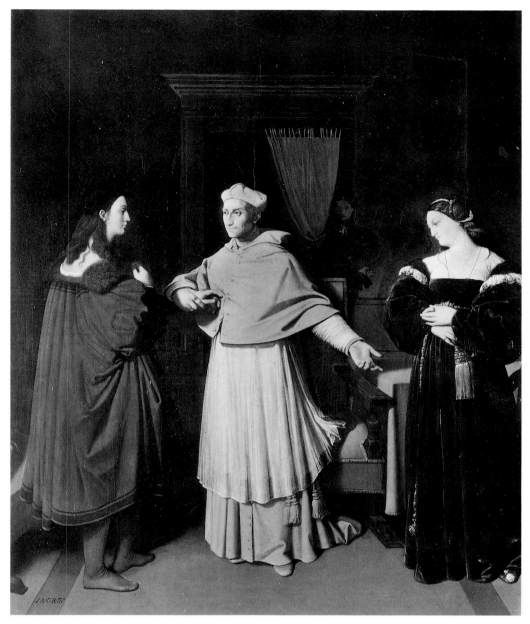

57. Jean-Auguste-Dominique Ingres. *Cardinal Bibbiena Presenting His Niece to Raphael.* 1812–13.
Oil on canvas, 23¼ × 18¼". Walters Art Gallery, Baltimore

hope that one day the pope might award him the cardinal's hat.

With the death of Raphael, an era came to an end. Many of his patrons and associates died about the same time: Leonardo a year before, Perugino three years after. Giuliano de' Medici was dead by 1516; his nephew Lorenzo died in 1519. Leo X survived Raphael by only a year, while Agostino Chigi died less than a week after the painter. Furthermore, the rumblings of the Reformation were being felt in Rome, though no one would have predicted the kinds of changes that were to take place in the years following Martin Luther's nailing of the ninety-five articles on the door of a German cathedral in 1517.

Michelangelo, the poet, created an emotional art; Leonardo, the scientist, produced a romantic vision. Raphael, whose extraordinary growth from 1504 to 1510 can only be measured in light-years, emerges as more human and more approachable than either Michelangelo or Leonardo. His art, the single most influential statement made during the Renaissance for artists of the following centuries, is characterized by a just balance of composition, form, and expression. This remarkable equilibrium makes Raphael, as one of his contemporaries observed, "among those of rare spirit, the rarest."

BIOGRAPHICAL OUTLINE

The dates given in this outline are almost entirely based on documented evidence. The hypothetical or speculative chronology, however reasonable, has not been included.

1483 APRIL 6: Birth of Raphael Sanzio in Urbino to Magia di Battista di Nicola Ciarla and her husband, Giovanni Santi, painter.

1491 OCTOBER 7: Raphael's mother dies.

1494 AUGUST 1: Raphael's father dies.

1500 MAY 13: Raphael is documented as being absent from Urbino and is probably in Perugia with the painter Pietro Perugino.
DECEMBER 10: Together with Evangelista da Pian di Meleto, he is commissioned to paint the altarpiece dedicated to S. Niccolò da Tolentino for the Church of S. Agostino in Città di Castello.

1501 SEPTEMBER 13: The altarpiece mentioned above is finished.

1503 AUGUST 18: Pope Alexander VI (Borgia) dies.
NOVEMBER 1: Giuliano della Rovere elected pope, as Julius II.

1504 Date on the *Marriage of the Virgin* (Brera Gallery, Milan) for S. Francesco in Città di Castello.
OCTOBER 1: Raphael is recommended to Piero Soderini, gonfaloniere of the republic of Florence, in order to perfect his study of art in Florence, in a letter by Giovanna da Montefeltro, widow of Giovanni della Rovere (brother of Julius II).

1505 Date on the *Ansidei Altarpiece* (National Gallery, London).

1506 SEPTEMBER 25: Pope Julius II arrives in Urbino, where he remains a few days.

1507 Date on *The Entombment* (Borghese Gallery, Rome).
OCTOBER 11: Raphael is recorded in Urbino.

1508 Date on *The Large Cowper Madonna* (National Gallery of Art, Washington, D.C.).
APRIL 11: Guidobaldo, duke of Urbino, dies.
APRIL 14: Francesco Maria della Rovere is made duke of Urbino.
APRIL 21: Raphael, in Florence, writes to his uncle Simone Ciarla (brother of his mother) in Urbino, indicating his wish for another letter of recommendation to the gonfaloniere of Florence.
MAY 10: Michelangelo begins painting the ceiling of the Sistine Chapel in Rome.
SEPTEMBER 5: Date of a letter written by Raphael from Rome to Francesco Francia, Bolognese painter and goldsmith.

1509 JANUARY 13: Raphael is paid for painting in the stanze, probably in advance for work in the Segnatura.
OCTOBER 4: Raphael is appointed writer of pontifical briefs, a position that provides him with an income without actual duties.

1511 Raphael finishes the frescoes in the Stanza della Segnatura.

1512 Date painted beneath *The Mass of Bolsena* in the Stanza d'Eliodoro.

1513 FEBRUARY 20: Death of Julius II.

1514 Date painted beneath *The Liberation of Saint Peter from Prison* in the Stanza d'Eliodoro.
APRIL 1: Raphael is made architect of Saint Peter's. Appointment confirmed on August 1.
JULY 1: Raphael writes to his uncle Simone Ciarla from Rome.

1515 Date inscribed on a drawing for *The Battle of Ostia,* which Raphael had apparently sent to the German master Albrecht Dürer.
JUNE 15: Date of the earliest mention of the cartoons for tapestries destined for the Sistine Chapel.
AUGUST 27: Raphael is placed in charge of the ancient inscriptions in Rome.
NOVEMBER 8: Raphael is presumably in Florence to discuss plans for the facade of the Medici church of S. Lorenzo.

1516 Date inscribed on the mosaic decoration of the dome of the Chigi Chapel in S. Maria del Popolo, Rome, designed by Raphael.
APRIL 19: The *Portrait of Baldassare Castiglione* (The Louvre, Paris) is mentioned as finished by this date, in a letter written by Pietro Bembo.
JUNE 20: The decoration of the stufetta of Cardinal Bibbiena is completed by this date.
DECEMBER 20: Raphael receives final payments for the tapestry cartoons he had begun the year before.

1517 Date beneath *The Oath of Leo III* in the Stanza dell'Incendio di Borgo.
JANUARY 19: Raphael undertakes to paint *The Transfiguration* for Cardinal Giulio de' Medici, the future Pope Clement VII and cousin of Leo X, in competition with Sebastiano del Piombo, who is to paint *The Raising of Lazarus.*

1518 JANUARY 1: The frescoes in the Loggia of Psyche in the Villa Farnesina commissioned by Agostino Chigi are mentioned as completed.
FEBRUARY 12: Raphael's *Portrait of Lorenzo de' Medici, Duke of Urbino,* mentioned as finished.
MAY 27: The painting now known as *The Holy Family of Francis I* and the *Saint Michael Vanquishing the Devil* (both in the Louvre, Paris) are mentioned as finished.
JULY 2: Raphael has not yet begun to paint *The Transfiguration,* according to a letter written by his rival, Sebastiano del Piombo, to Michelangelo.
SEPTEMBER 8: The *Portrait of Leo X and Two Cardinals* is mentioned as finished and in Florence (now in the Pitti Gallery, Florence).

1519 In a letter written during this year, perhaps with the help of Baldassare Castiglione, Raphael discusses the map of ancient Rome he is to produce.
DECEMBER 27: Seven of the tapestries made from Raphael's cartoons in Flanders are displayed in the Sistine Chapel.

1520 APRIL 6: Raphael dies at the age of thirty-seven, to the day. He is buried in the Pantheon.

SELECTED BIBLIOGRAPHY

The literature on Raphael is enormous, and only a small sampling is listed below. For a complete bibliography see Luitpold Dussler, *Raphael: A Critical Catalogue of His Pictures, Wall-Paintings and Tapestries,* London and New York: Phaidon, 1971, pp. ix–xxi. This is a work of extraordinary utility, summarizing a vast amount of earlier work on Raphael.

Becherucci, Luisa. "Raphael and Painting." In *The Complete Work of Raphael,* introducion by Mario Salmi, pp. 9–198. New York: Reynal, in association with William Morrow, 1969.

Beck, James H. *Italian Renaissance Painting.* New York: Harper Collins, 1981.

————. "Cardinal Alidosi, Michelangelo, and the Sistine Ceiling." *Artibus et Historiae.* Vienna, no. 22 (1990): 63–77.

————. *Raphael: The Stanza della Segnatura, Rome.* New York: George Braziller, 1993.

————, ed. *Raphael Before Rome, Studies in the History of Art.* Vol. 17. Washington, D.C.: National Gallery of Art, 1986.

Berenson, Bernard. *Italian Pictures of the Renaissance: A list of the principal artists and their works with an index of places. Central and North Italian Schools.* 3 vols. London: Phaidon, 1968.

Borghini, Raffaello. *Il Riposo.* Florence: Giorgio Marescotti, 1584.

Camesasca, Ettore. *All the Frescoes of Raphael.* Translated by Paul Colacicchi. 2 vols. New York: Hawthorn, 1963.

————. *All the Paintings of Raphael.* Translated by Luigi Grosso. 2 vols. New York: Hawthorn, 1963.

————, ed. *Raffaello Sanzio: Tutti gli scritti.* Milan: Rizzoli, 1956.

Crowe, Joseph A., and Cavalcaselle, Giovanni B. *Raphael: His Life and Works.* 2 vols. London: J. Murray, 1882–85.

d'Ancona, Paolo. *Gli affreschi della Farnesina in Roma.* Milan: Edizioni del Milione, 1955.

Dollmayr, Hermann. "Lo stanzino da bagno del cardinal Bibbiena." *Archivio storico dell'arte,* Rome, 3 (1890): 272–80.

Dubos, Renée. *Giovanni Santi; peintre et chroniqueur à Urbin au XV^e siècle.* Bordeaux: Samie, 1971.

Filippini, Francesco. "Raffaello a Bologna." *Cronache d'arte,* Bologna, 2, fasc. 5 (1925): 201–34.

Fischel, Oskar. *Raphaels Zeichnungen.* 8 vols. Berlin: G. Grote, 1913–41.

————. *Raphael.* Translated by Bernard Rackham. London: Spring Books, 1964.

Forlani Tempesti, Anna. "The Drawings." In *The Complete Work of Raphael,* introduction by Mario Salmi, pp. 303–428. New York: Reynal, in association with William Morrow, 1969.

Freedberg, Sydney J. *Painting of the High Renaissance in Rome and Florence.* 2 vols. Cambridge, Mass.: Harvard University Press, 1961.

————. *Painting in Italy 1500–1600.* Pelican History of Art. London: Penguin, 1971.

Gilbert, Creighton. "A Miracle by Raphael." *North Carolina Museum of Art Bulletin,* Raleigh, 6 (Fall 1965): 2–35.

Golzio, Vincenzo. *Raffaello nei documenti, nelle testimonianze dei contemporanei e nella letteratura del suo secolo.* Vatican City: Arti grafiche Panetto & Petrelli, 1936.

Gould, Cecil. *National Gallery Catalogues: The Sixteenth Century Italian Schools.* London: National Gallery, 1962.

Hofmann, Theobald. *Raffael in seiner Bedeutung als Architekt.* 4 vols. Zittau: Menzel, 1900–1911.

Hoogewerff, Gottfried. "Documenti che riguardano Raffaello ed altri artisti contemporanei." *Rendiconti della Pontificia Accademia Romana di Archeologia,* Rome, 21, fasc. 3 (1945–46): 254–68.

Imdahl, Max. "Raffaels Castiglionebildnis im Louvre." *Pantheon,* Munich, 20 (1962): 38–45.

Joannides, Paul. *The Drawings of Raphael.* Berkeley–Los Angeles: University of California Press, 1983.

Jones, Roger, and Penny, Nicholas. *Raphael.* New Haven: Yale University Press, 1983.

Longhi, Roberto. "Percorso di Raffaello Giovine." *Paragone,* Milan, no. 65 (May 1955): 8–23.

Middeldorf, Ulrich. *Raphael's Drawings.* New York: H. Bittner, 1945.

Müntz, Eugène. *Raphaël: Sa vie, son oeuvre et son temps.* 2d ed. Paris: Hachette, 1900.

Oberhuber, Konrad. "Die Fresken der Stanza dell'Incendio im Werk Raffaels." *Jahrbuch der Kunsthistorischen Sammlungen in Wien,* Vienna, 58 (1962): 23–72.

————. "Raphael and the State Portrait—I: The Portrait of Julius II." *Burlington Magazine,* London, 113 (March 1971): 124–30.

Oppé, Adolf Paul. *Raphael.* Rev. ed., edited and with an introduction by Charles Mitchell. New York: Praeger, 1970.

Ortolani, Sergio. *Raffaello.* 3d ed. Bergamo: Istituto italiano d'arti grafiche, 1948.

Parker, Karl T. *Catalogue of the collection of drawings in the Ashmolean Museum.* 2 vols. Oxford: Clarendon, 1956.

Passavant, Johann D. *Raffaello d'Urbino e il padre suo Giovanni Santi.* Notes and translation by Gaetano Giusti. 3 vols. Florence: Le Monnier, 1899.

Pope-Hennessy, John. *Raphael.* The Wrightsman Lectures. New York: New York University Press, 1970.

Pouncey, Philip, and Gere, J. A. *Italian Drawings in the Department of Prints and Drawings in the British Museum: Raphael and His Circle.* 2 vols. London: British Museum, 1962.

Prisco, Michele, and de Vecchi, Pierluigi. *L'opera completa di Raffaello.* Classici dell'arte, no. 4. Milan: Rizzoli, 1966.

Putscher, Marielene. *Raphaels Sixtinische Madonna: Das Werk und seine Wirkung.* Tübingen: Hopfer, 1955.

Redig de Campos, Deoclecio. *Raffaello nelle stanze.* Milan: Aldo Martello, 1965.

Shearman, John. "Raphael's Unexecuted Projects for the Stanze." In *Walter Friedlaender zum 90. Geburtstag,* edited by Georg Kauffmann, pp. 158–80. Berlin: W. de Gruyter, 1965.

————. *Raphael's Cartoons in the Collection of Her Majesty the Queen and the Tapestries for the Sistine Chapel.* London: Phaidon, 1972.

Stridbeck, Carl G. *Raphael Studies.* 2 vols. Stockholm: Almquist & Wiksell, 1960–63.

Vasari, Giorgio. *Le vite de' più eccellenti pittori, scultori ed architettori scritte da Giorgio Vasari.* Edited by Gaetano Milanesi. Florence: Sansoni, 1878–85.

Venturi, Adolfo. *Storia dell'arte italiana.* Vol. 9. Milan: U. Hoepli, 1926.

Wagner, Hugo. *Raffael im Bildnis.* Berner Schriften zur Kunst, vol. 11. Bern: Benteli, 1969.

White, John, and Shearman, John. "Raphael's Tapestries and Their Cartoons." *Art Bulletin,* New York, 40 (1958): 193–221, 299–323.

Wind, Edgar. "The Four Elements in Raphael's Stanza della Segnatura." *Journal of the Warburg and Courtauld Institutes,* London, 2 (1938/39): 75–79.

Winternitz, Emanuele. "Archeologia musicale del rinascimento nel Parnaso di Raffaello." *Rendiconti della Pontificia Accademia Romana di Archeologia,* Rome, 27, fasc. 3–4 (1952–54): 359–88.

Wittkower, Rudolf. "The Young Raphael." *Allen Memorial Art Museum Bulletin,* Oberlin, 20 (1963): 150–68.

S. NICCOLO DA TOLENTINO ALTARPIECE

1501
Oil on panel, 44 × 45¼" (size of two fragments together)
Capodimonte Museum, Naples

This fragment, actually two fragments joined, showing God the Father and Mary Magdalene, each holding a crown, was part of a large altarpiece made for the Augustinian church in Città di Castello, a town located on the present border between Umbria and Tuscany. It represents the earliest documented work by Raphael, who was only seventeen in 1500 when the commission came to him in partnership with the much older but less gifted painter Evangelista da Pian di Meleto. Some idea of the original appearance of the altarpiece may be obtained from a copy in the museum of Città di Castello and from the preparatory drawing of the altarpiece by Raphael, now in the Lille museum. The picture was completed during the following year, 1501.

The intricate and virtually insoluble problem of Raphael's early training and career is closely bound to this altarpiece. Furthermore, Evangelista's contribution, if any, is entirely unclear, although he was called a "master" in the contract for the *Coronation of S. Niccolò da Tolentino*. Raphael is also called a "master" in the same document, a surprising title for a lad of seventeen, which can probably be explained by the fact that he had inherited his father's workshop at the latter's death in 1494.

The picture was severely damaged in an earthquake in the late eighteenth century and survives in only a few fragments. The ones illustrated here formed the apex of the altarpiece. Not particularly distinguished, they do reveal an artist who had begun to master the painting style currently popular in Umbria and the Marches. This style is derived in part from Perugino, although here we see a decidedly provincial interpretation of that style. The four pretty heads of the cherubs gaze at the determined, thin-lipped image who holds the crown of martyrdom with spindly fingers. If the intrinsic value of these fragments is relatively insignificant, they nevertheless provide a gauge of the extent of Raphael's achievements before his thorough and complete assimilation of Perugino's style and consequently before his experience of Florentine art, ingredients that are basic to his subsequent development.

THE CRUCIFIXION

1502–3
Oil on panel, 9'2½" × 5'5"
National Gallery, London

This large altarpiece was painted shortly after the previous one and, like it, was made for a church in Città di Castello. Here, however, Raphael reveals more direct contact with Perugino. Giorgio Vasari, in his *Lives* of the artists, which in the case of Raphael is based on good firsthand evidence, remarked that had Raphael failed to sign this work at the foot of the cross, people would think it to be by Perugino. The sweet—one might say saccharine—expressions on the faces of Mary Magdalene, Jerome, Mary, and John the Evangelist beneath the cross could well be confused with Perugino's contemporary language. The features are miniaturized, doll-like, delicate. We sense in these images a somewhat forced and empty religiosity: the poses of the figures are Peruginesque stereotypes, while the coloration is brittle. The crucified Christ, however, belongs to a different formal idiom. Unlike the over-refined figures of the saints, the Christ has a more monumental, relatively robust structure related to the artistic vision of Luca Signorelli, one of the most gifted exponents of Central Italian painting during the Renaissance, whose art was readily available to the young Raphael.

There is a flat, decorative, calligraphic quality to the upper section of the picture; the ribbons of the angels, Christ's loincloth, and the silhouettes of the angels themselves establish a monogrammatic surface play in marked contrast to the highly sculptural Christ. Perhaps the most distinguished aspect of the picture, finished when Raphael was twenty, is the landscape; and here, too, Perugino's example assumes a crucial role. The meandering river beyond the cross, whose prominent central position in the composition is a probable reference to baptism, punctuates the gently rolling landscape, broken by low hills and a large, eroded cliff. A few dark trees in front of the lighted sky cut through the horizon. In the extreme distance the forms of the foliage, merely suggested with a few free strokes of the brush, are consumed by light and atmosphere. The impression of great distance is further enhanced by the gradual lightening of the tones near the horizon, both in the sky and in the landscape.

The picture (sometimes known as the *Mond Crucifixion* after a former owner or the *Gavari Altarpiece* after the family who originally commissioned the work) had a predella with small scenes dealing with the life of Saint Jerome, two of which are now in public collections. This commission must have been a challenging and important undertaking for the youthful master, allowing him to demonstrate his accomplishments on both a large and a small scale.

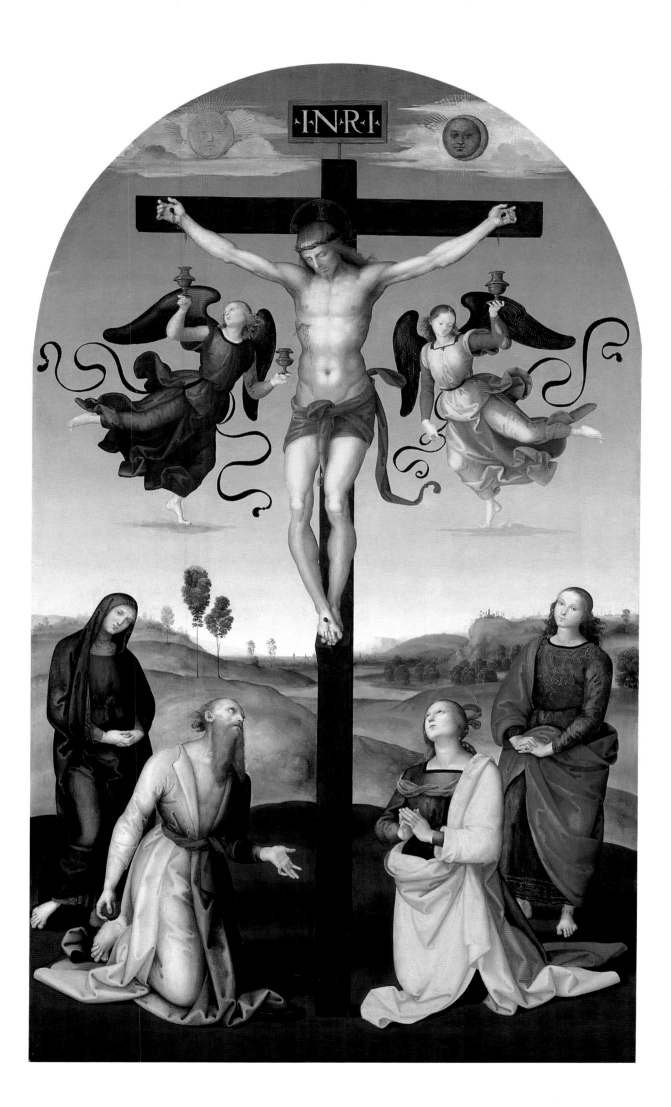

CORONATION OF THE VIRGIN

1503–4
Oil on canvas, 8'9" × 5'4"
Pinacoteca, Vatican, Rome

Commissioned for a chapel of the Oddi family in the Church of San Francesco in Perugia and originally painted on a panel, the *Coronation* was transferred to canvas at the beginning of the last century, after having been expropriated by the Napoleonic forces and brought to France; the painting was returned to Italy in 1815. In addition to the central section showing the Coronation, there is a predella with three scenes, including the *Annunciation,* the *Adoration of the Magi,* and the *Presentation in the Temple,* all episodes in which Mary plays a significant role.

The main field of the picture is divided horizontally into two separate zones. Below, the Twelve Apostles are disposed around the simply decorated sarcophagus of the deceased Mary, some looking to the vision above with that ecstatic expression so dear to Perugino. There are also abundant signs of connections with the art of the well-established master Pintoricchio, an older pupil of Perugino's. An unnatural green dominates the crisp, clear, cool, unatmospheric scene. The empty sarcophagus caused certain pictorial problems for Raphael. He will shortly after this time reveal himself as the finest composer of his age, but here the bodies of all but two of the Apostles are cut off from view, giving a degree of instability to these figures and to the entire lower portion of the picture. Furthermore, the oblique placement of Mary's stone tomb creates a void at the center of the pictorial field, broken only by a few flowers that grow out of it.

If the composition of the lower section of the altarpiece leaves something to be desired, the upper part showing Mary crowned by Christ is far more satisfactory. Both are seated on the same level, and Christ easily crowns the reverent Mary with his right hand. Mary tilts her head, thus locating it slightly below that of Christ. Overhead eight winged putti heads celebrate the event, while at the sides music-making angels resting on the clouds fill the heavenly scene with joyous sounds. These angels, for which there are some instructive drawings, derive from the Florentine quattrocento tradition, but in this case, as with other elements in the picture, filtered through Perugino's experience; we find, however, an emerging personal vision best seen in the preparatory drawings for individual heads of Apostles, where Raphael's extraordinary skills as a draftsman are amply revealed.

The interplay of a heavenly and an earthly sphere on a single field in the *Coronation of the Virgin* is a first essay by the artist on a theme that comes to fruition a few years later in the *Disputa* for the Stanza della Segnatura.

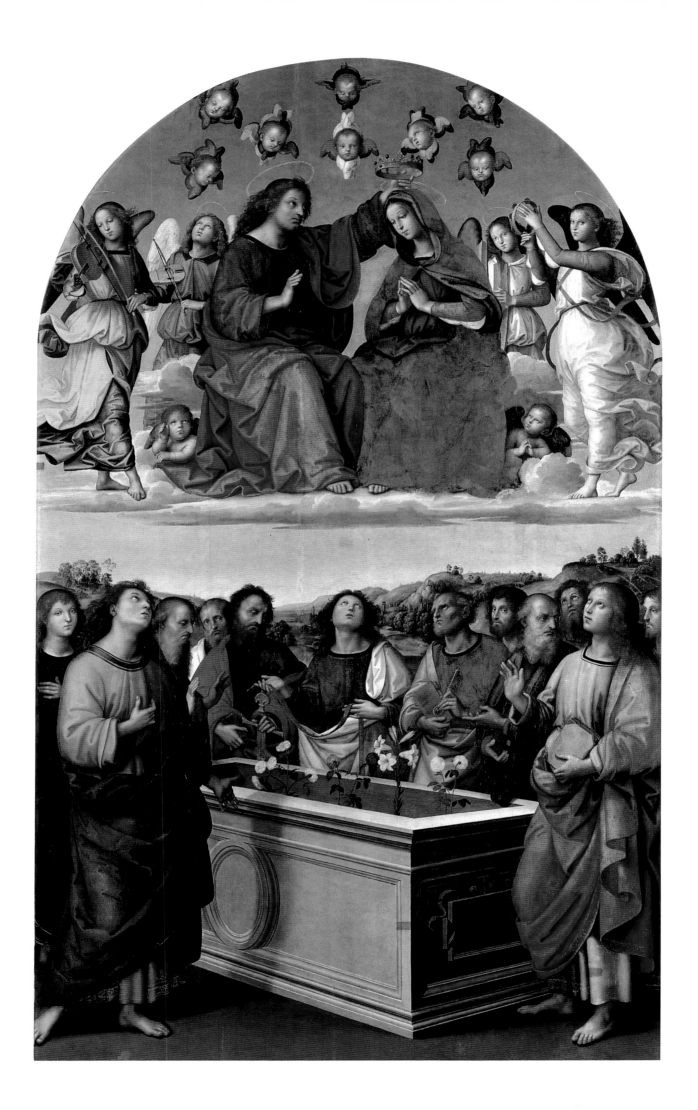

COLORPLATE 4

MARRIAGE OF THE VIRGIN

1504
Oil on panel, 67 × 46½"
Brera Gallery, Milan

A landmark in Raphael's early oeuvre for a variety of reasons, the *Marriage of the Virgin* was commissioned by the Albizzini family for their chapel dedicated to Saint Joseph in the Church of San Francesco in Città di Castello. It is signed and dated "RAPHAEL VRBINAS MDIIII," which furnishes a firm point in the chronology of the artist's development. It thus assumes a pivotal position for the identification of undocumented or undated works of this time. Immediately afterward, Raphael left Umbria for Florence, where the exciting artistic atmosphere radically changed the direction of his art.

The *Marriage of the Virgin* is Raphael's last painting wholly in the stylistic language of his master Perugino. If it is possible to say so, he not only equaled Perugino within his own formal vocabulary, as in *The Crucifixion,* but actually surpassed him in this picture. The general outline of the composition, with the arcuated top, follows one set forth by Perugino in several paintings. In the background there is a centralized temple set into the arched frame, whereas strung across the lower foreground the main figures act out the events. Connecting these two pictorial centers, the building above and the marriage scene below, are scattered, isolated images that populate the vast space.

Raphael composed the group of women at the left of the central figures and the disappointed suitors at the right with extreme fluidity, as opposed to Perugino's more friezelike treatment. The elegant, elongated figure of Joseph, about to place the ring on Mary's finger, typifies the expressive restraint within the whole work. The undiluted color, dominated by strong reds, makes for a clear, unambiguous reading of the scene. In the distance behind the temple, an immense, almost infinite, space is established, while a convincing atmosphere and light surround and encompass the domed building. With all its crystalline beauty, expansive landscape, disciplined use of perspective, and control of architectural elements, this panel not only reveals Raphael as a worthy pupil of Perugino, but also seems to show him returning one step back in time to Piero della Francesca, active in Urbino a generation earlier. The *Marriage of the Virgin* belongs at the end of a development for Raphael and for Italian painting rather than at the beginning of a new direction; although chronologically painted well into the new century, it remains a quattrocento picture of great fascination.

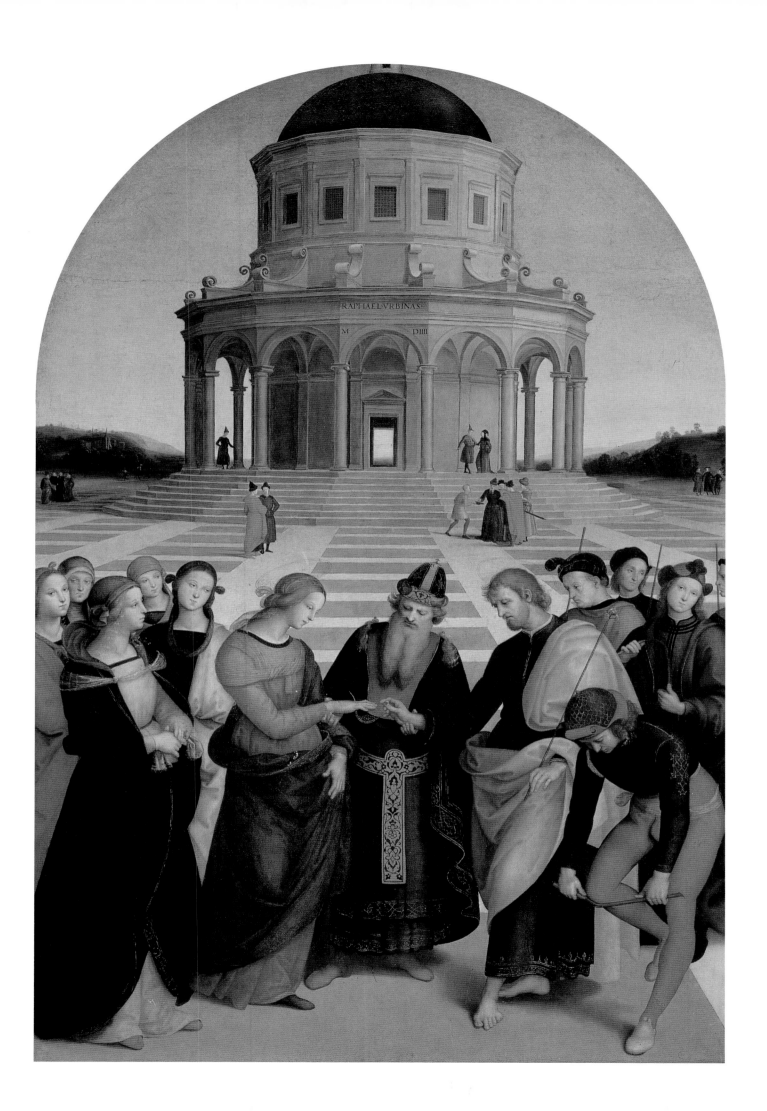

THE MADONNA AND CHILD ENTHRONED
WITH FIVE SAINTS
(COLONNA ALTARPIECE)

c. 1505
Oil on panel, 68 × 68"
The Metropolitan Museum of Art, New York City

The effects of Raphael's residence in Florence, beginning during the autumn of 1504, were enormous. He began at once to assimilate the lessons of Michelangelo and especially of Leonardo, whose example was fundamental to the young provincial master at this critical stage of his development. In *The Madonna and Child Enthroned with Five Saints,* also known as the *Colonna Altarpiece* because it once belonged to that Roman house, Florentine elements begin to come to the surface, but the overall effect of the picture remains closely allied to Perugino's formulas, indicating that the altarpiece, made for the sisters of Saint Anthony of Padua in Perugia, belongs to an early phase of Raphael's residence in the Tuscan capital. He probably brought the commission with him to Florence, and the painting, including the predella with three scenes from the Passion of Christ, was executed there (see fig. 13).

This picture of the Madonna Enthroned is on a square panel and is a highly balanced and symmetrical composition. Mary and the two children are separated from Saints Peter and Catherine on the left and Paul and Margaret on the right, being raised on a stepped platform and protected by a circular canopy above. The three central figures are conjoined by a series of glances: Mary looks to the little Saint John; he in turn looks up prayerfully at the Christ Child, who returns the glance as he simultaneously blesses John. The saints on either side of the throne are ordered so that in the front row Peter looks out while his counterpart, Paul, looks to the side at the open book in his hand; in the back row, reversing the arrangement, Catherine is in profile, and Margaret is shown in full face.

Although the facial types of the central figures and the two female saints retain a cast related to Raphael's previous painting style, the two male saints not only show a more classical rigor, and this is especially true for Saint Paul, but they are built up with more vigorous and bold yet simplified modeling, which is surely one of the characteristics of a tradition in Florence that goes back to Masaccio and, even further, to Giotto. Thus Raphael, like Michelangelo at a somewhat more precocious age, was beginning to relive the development of Florentine art that forms the basis of the High Renaissance style of which he became the prime spokesman.

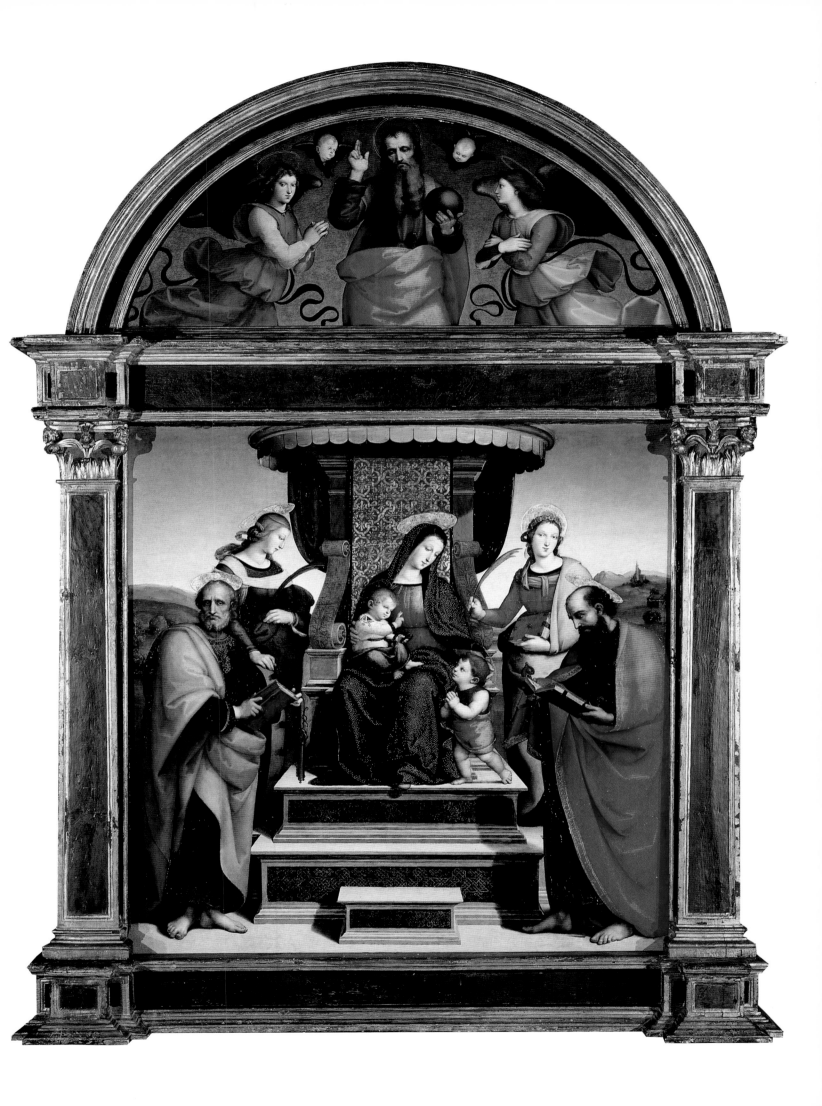

COLORPLATE 6

SAINT MICHAEL AND THE DRAGON

c. 1505
Oil on panel, 12¼ × 10¾"
The Louvre, Paris

With the grace of a ballet dancer, the youthful Saint Michael pirouettes with raised sword as he tramples the horrific beast underfoot. The Dantesque landscape is cluttered with awful apparitions of both men and beasts, but not from any known world. There is a battle for souls where devils in every form vie for their prey. Such nightmarish visions are not part of Raphael's usual syntax; in fact, this is virtually a unique picture in his oeuvre, and he must have seen either paintings or prints by Netherlandish masters such as Hieronymus Bosch (c. 1450–1516), whose fantasy for such images was endless and unexcelled. Even the sky has taken on a threatening and ghostly aspect, reflecting the ominous mood of the picture. Amid this Walpurgis Night, the confident Saint Michael, angel of the Resurrection and warrior who drove Lucifer from heaven, is quite in charge of the situation and leaves no doubt that virtue will triumph over vice and corruption. *Saint Michael and the Dragon* was executed in conjunction with a painting of *Saint George and the Dragon* (colorplate 7), also in the Louvre, whose basic theme is similar and whose dimensions are identical. The two pictures may well have been made for Duke Guidobaldo of Montefeltro of Urbino, soldier and knight of the Order of the Garter. He had seen his territory occupied by the hated Cesare Borgia during 1502 and 1503, but Guidobaldo reentered Urbino on Saint Augustine's Day after hearing the news that Alexander VI (Borgia) had died. Since Saint Michael was the patron of knights and Saint George the patron of the Order of the Garter, both pictures may be seen as referring to Guidobaldo.

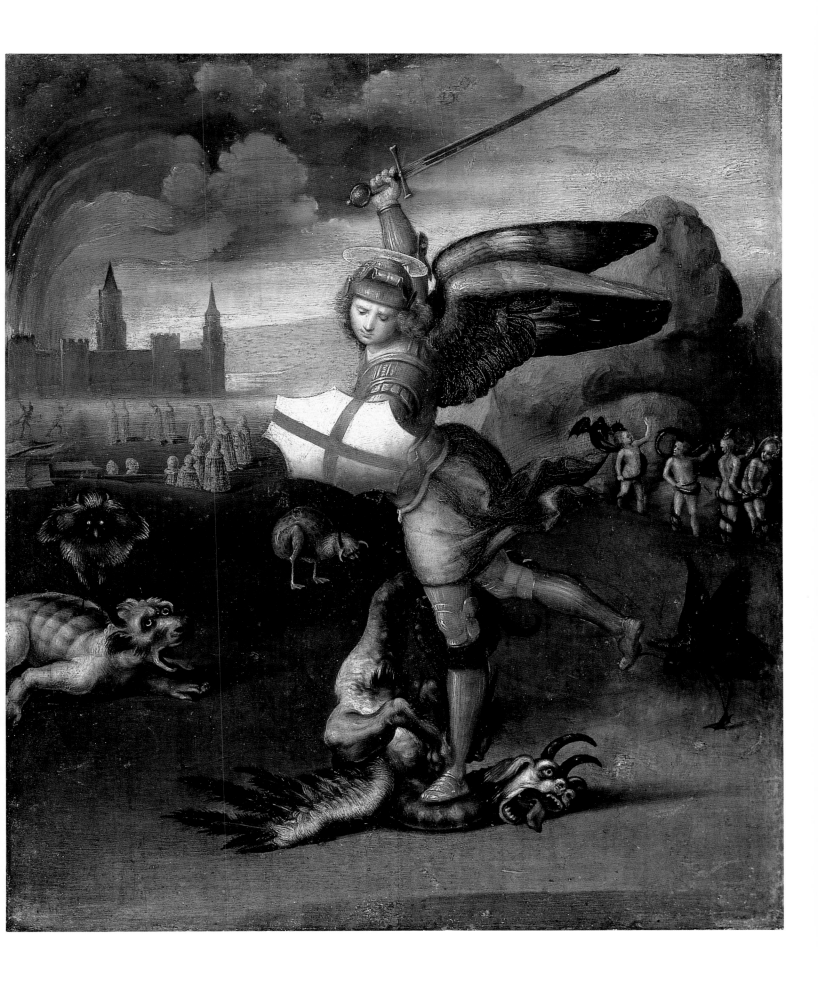

SAINT GEORGE AND THE DRAGON

c. 1505
Oil on panel, 12¼ × 10¾"
The Louvre, Paris

Like the *Saint Michael and the Dragon,* to which this *Saint George* is closely related, the action takes place along the central axis of the picture, and once more the protagonist has raised his sword, prepared to deliver the coup de grace. The dragon had already been mortally wounded by the thrust of a lance, now broken from the force of the blow. The strong decorative and coloristic counterpoint offered by the red-and-white-striped fragments of the pole beneath the white horse was added to the conception of the scene at a point subsequent to the elegant study for the picture in the Uffizi Gallery, where a few bones of the dragon's previous victims are haphazardly placed instead. The princess flees toward the right, out of the picture in the middle distance; on the opposite side, leafy trees break the skyline, while at the horizon the landscape recedes into the infinite distance.

There is an analogous frenetic air to the *Saint George* and its counterpart, the *Saint Michael:* the ugly, menacing beast, the broken lance, the desperate princess, the frightened, rearing horse. The principal pictorial source for the battling horseman may be found in Leonardo, whose interest in such a rearing equestrian group goes back to his Milanese years and even before and reached a culmination in Florence during precisely the time Raphael was in that city: Leonardo was then working on the *Battle of Anghiari* cartoon (1504–5). There is evidence in the form of a sketch that Raphael was engaged by this work, and he may also have had an opportunity to see some of the many studies Leonardo had prepared for it. But the final result in this little picture is purely Raphael's own, based upon an equilibrated vision, movement, action, and the justice of an exact composition.

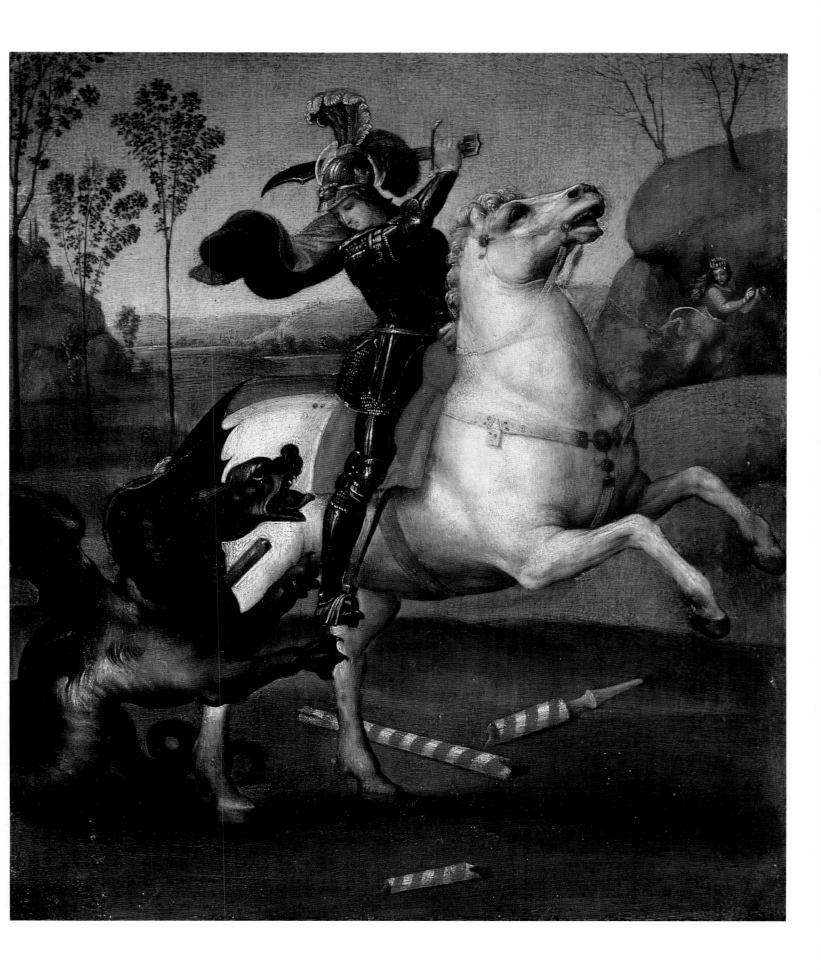

THE THREE GRACES

1505–6
Oil on panel, 6¾ × 6¾"
Condé Museum, Chantilly

Derived either directly or indirectly from ancient classical sculpture, this panel may have had as its prototype a small Roman group now in the museum of Siena Cathedral or a late-fifteenth-century medal that incorporated the same motif. The three handsome figures probably represent, from left to right, Chastity, Beauty, and Amor. Chastity is quickly recognized because she wears a thin, transparent veil over her lower torso while her sisters have no such covering. Furthermore, her breasts are shielded from view by the extended arm of the central figure; Amor's breasts, on the contrary, are revealed. While Amor wears a necklace and Beauty has a string of beads that falls down on the back of her neck from her hair, Chastity appears with no adornment.

There has been considerable discussion about the proper dating of this tiny painting, which should be associated with a picture of identical size in the National Gallery, London, called the *Dream of a Knight* (fig. 12). The robust conception of the full, sturdy, volumetric bodies, their easy contrapposto, the determined modeling, all make a date before the *Marriage of the Virgin* and before at least some first-hand knowledge of Florentine art impossible. Despite its small size, or perhaps because of it, *The Three Graces* has shed those Late Gothic elements that lingered on in Raphael's previous work: the Peruginesque proportions and the oversweet expressions of the figures; instead they are more soft-spoken, restrained, self-contained images.

Instrumental in producing the impression of high order in this composition is its format—a perfect square—like that of *The Madonna and Child Enthroned with Five Saints* (colorplate 5). While there is a strong symmetrical emphasis in the picture, the subtle deviations become more significant and produce the needed variety and interest. Although all three figures are posed in approximately the same way, the shapes of the spaces between them are surprisingly disparate. The central figure, whose back is toward the spectator, actually blocks out the left leg of Chastity. There is hardly any dependence upon the color for expression or for the purpose of defining forms; drawing and modeling have been used to capture the enticing ancient theme and perhaps to improve upon it.

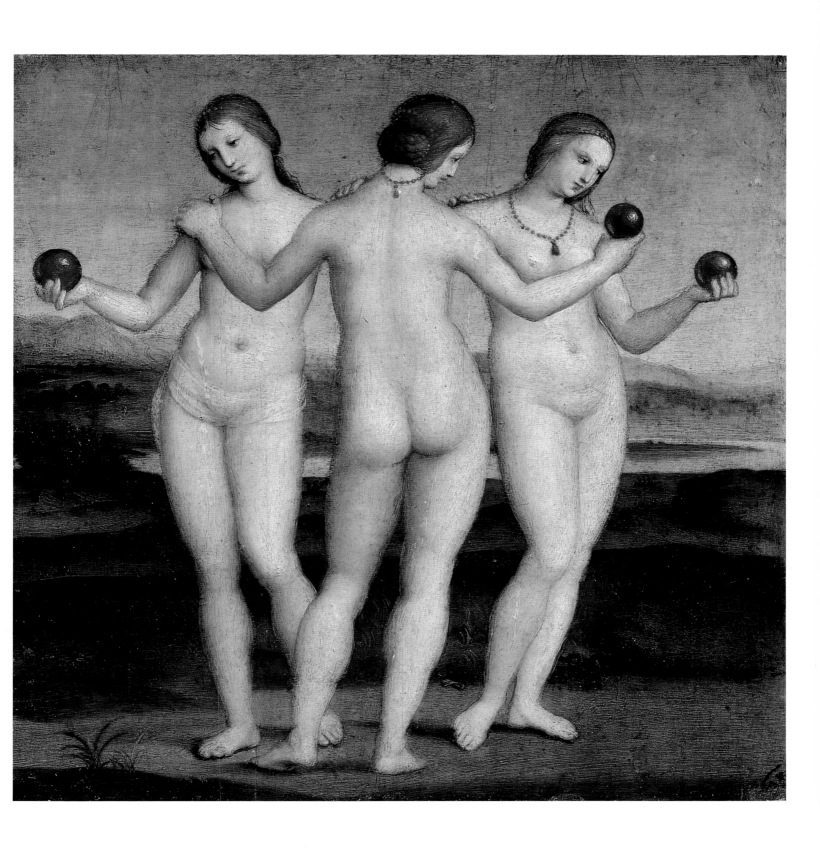

PORTRAIT OF ANGELO DONI

c. 1506
Oil on panel, 24¾ × 17¾"
Pitti Gallery, Florence

Three stunning portraits from Raphael's Florentine period stand out among his finest productions and among the most perceptive examples of that genre in Renaissance painting as a whole. They are *The Woman in Green,* also called *La Muta,* in the National Museum in Urbino, and the portraits of Angelo and Maddalena Doni in the Pitti. The Doni portraits form a pair and were made to be seen together, with the husband at the left. Angelo Doni, representative of the merchant class, had also commissioned Michelangelo to execute a tondo depicting the Holy Family for him, and apparently there had been a dispute between the artist and the patron over the price. The astute Angelo Doni was seeking to pay less than the price agreed upon. His plan backfired, however, when the cantankerous Michelangelo then demanded, and apparently finally obtained, double the original price. Whatever the price he ultimately paid, Doni's place in history was determined precisely because he had the good sense or the good fortune to have commissioned pictures from these two giants of Renaissance art.

Raphael has achieved a tenuous and difficult balance between the highly descriptive fifteenth-century portraits from Northern Europe and North Italy and a more idealized, classical format. Once again there is a debt to Leonardo, more noticeable perhaps in the Maddalena than in her husband's likeness, but Raphael is never so mysterious or, one might even say, mystical as Leonardo. He analyzes his subject directly and sharply without that smoky veil: the penetrating, even shrewd eyes, the thin lips, the highly active disposition of the smallish head combine for a straightforward, unembellished portrait of a successful businessman. The finely attired, neatly groomed Florentine is posed with pride and much self-assurance before the countryside of the Arno Valley, yet his short, square hands are graceless and unaristocratic. When Ghirlandaio sought to paint with the same objectivity, the effect was close to caricature. Raphael, on the other hand, has achieved a perfect balance between object and idea; in the *Portrait of Angelo Doni* he has captured the contemporary spirit of Florence as no Florentine artist was able to do.

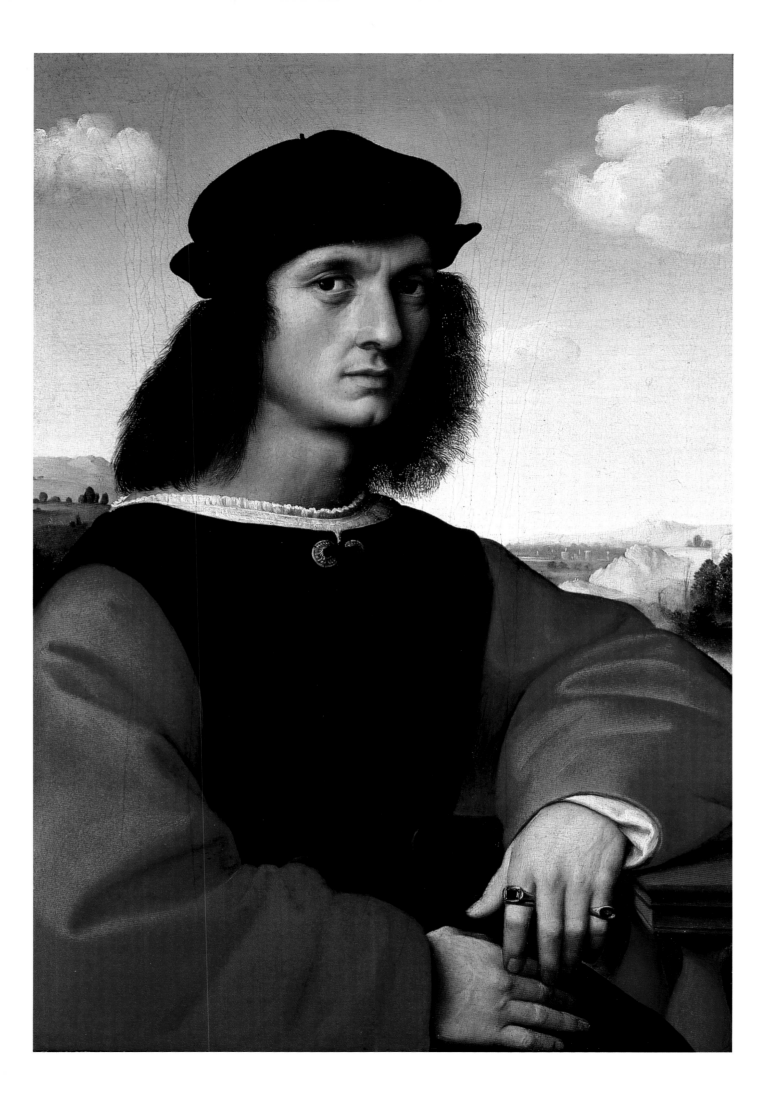

COLORPLATE 10

PORTRAIT OF MADDALENA DONI

c. 1506
Oil on panel, 24¾ × 17¾"
Pitti Gallery, Florence

The formula that determines this portrait belongs to Leonardo da Vinci and particularly to the example set by his *Mona Lisa* (fig. 17). The hands of the sitter, resting easily one over the other, become an important expressive and pictorial element that serves to enhance and enliven the head. The lower portion of the three-quarter-length seated image was placed in profile by Leonardo and, after him, by Raphael, but the upper torso is turned in the direction of the spectator, though still at an oblique angle. The head is turned farther on a plane parallel to the surface of the picture. Hence, despite the calm attitude of Maddalena Doni, a convincing impression of life and movement is achieved. Leonardo uses a high horizon with an immense fantastical landscape painted in unnatural tones behind the sitter, which, together with the sfumato, adds an unreal quality to his picture. These features, along with the remarkable and puzzling "smile," contribute to its fascination. Raphael, less obscure, less personal, takes a more detached view of Maddalena Strozzi, wife of the merchant Angelo Doni.

She is a rather plain, round-faced, round-shouldered, expressionless young woman with few secrets. Dressed in a deep-toned bodice with great sleeves of blue damask, she is placed before a Tuscan landscape similar to the one in her husband's portrait and stylistically associated with Perugino's backgrounds. The lacy trees that break the sky are a sharp contrast to the bulky presence of this buxom lady. She shows off her most treasured possessions, including an enormous irregular pearl that hangs from her graceless neck. In Raphael's uncompromising portrait, Maddalena appears to have neither great intellect nor an inner life, notwithstanding the fineries; she is content, it would seem, in a subservient role to that of her more dynamic husband.

The faces of both the husband and wife are painted in light, clear flesh tones set against the darks established by the hair, which, in turn, is set against the light background of sky. Some strands of hair are rendered individually and precisely by the artist, while great attention is also paid to other minute details, giving a note of realism to this portrait and its companion, as well as a strong objectivity. There appears to be little psychological insight into the bland, humorless young woman, but her appearance is rendered with unprettified directness and truthfulness.

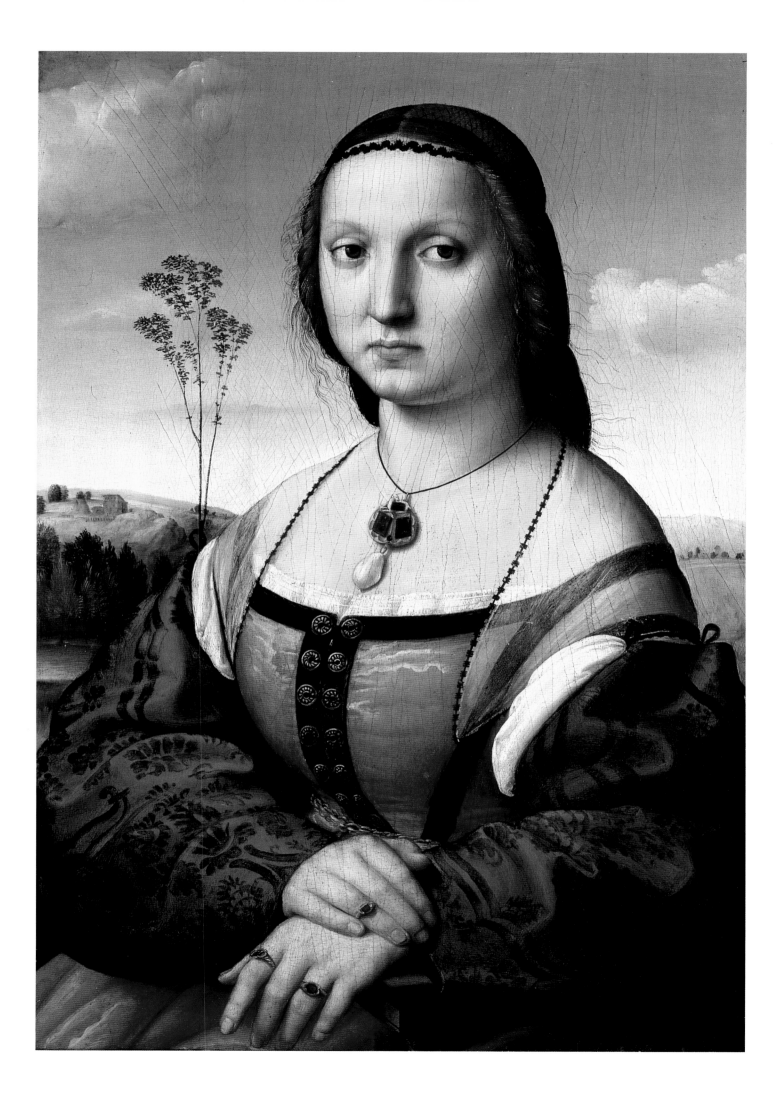

THE MADONNA OF THE GRANDUCA

c. 1506
Oil on panel, 33 × 21½"
Pitti Gallery, Florence

Raphael's Madonnas have had enormous appeal from the time they were made, and as a subject category they still remain among his most attractive and engaging pictures. No other artist has been able to explore so intensely and to render with such sensitivity the delicate and tender relationship between a child and his mother, examining a host of poses and combinations. Over the past four and a half centuries, Raphael's Madonnas have become—through engravings, etchings, copies, and photographs—synonymous with the type itself. Among the first of his Florentine Madonnas, and among the most frequently reproduced, is *The Madonna of the Granduca*. As a general composition, it is related to highly popular sculptured groups produced in the fifteenth century, and both reliefs and freestanding examples by the leading sculptors of Florence, including Ghiberti and Donatello, were readily available. The closest parallel to the Granduca Madonna is found in the glazed terracotta sculptures of Luca della Robbia.

The painting owes its title to the fact that it was owned by the Hapsburg Grand Duke Ferdinand III at the end of the eighteenth century, and his attachment to it was so great that he carried it with him on his travels. Previously it formed part of the collection of the well-known Florentine Baroque master Carlo Dolci, who was himself famous for his sweet renderings of the Virgin.

The three-quarter-length Mary easily balances the Christ Child in her arms as she looks down beyond the spectator; the child's gaze is more direct and more penetrating. Mary's geometrized oval head, tilted slightly off the vertical axis, rests on a sturdy neck and surprisingly massive body, whose drapery is treated with strict simplicity. The child's body is shown in profile, but it has a remarkable freshness. The dark background acts as a foil for the figures and accentuates the play of lights and darks; originally there was probably an airy landscape behind a parapet, a formula associated with Leonardo. The modeling of the flesh tones in the body of the child and in the two faces has a softened, veil-like character also related to Leonardo's procedures; the result is a simple, silent, effortless image that, once encountered, is virtually impossible to forget.

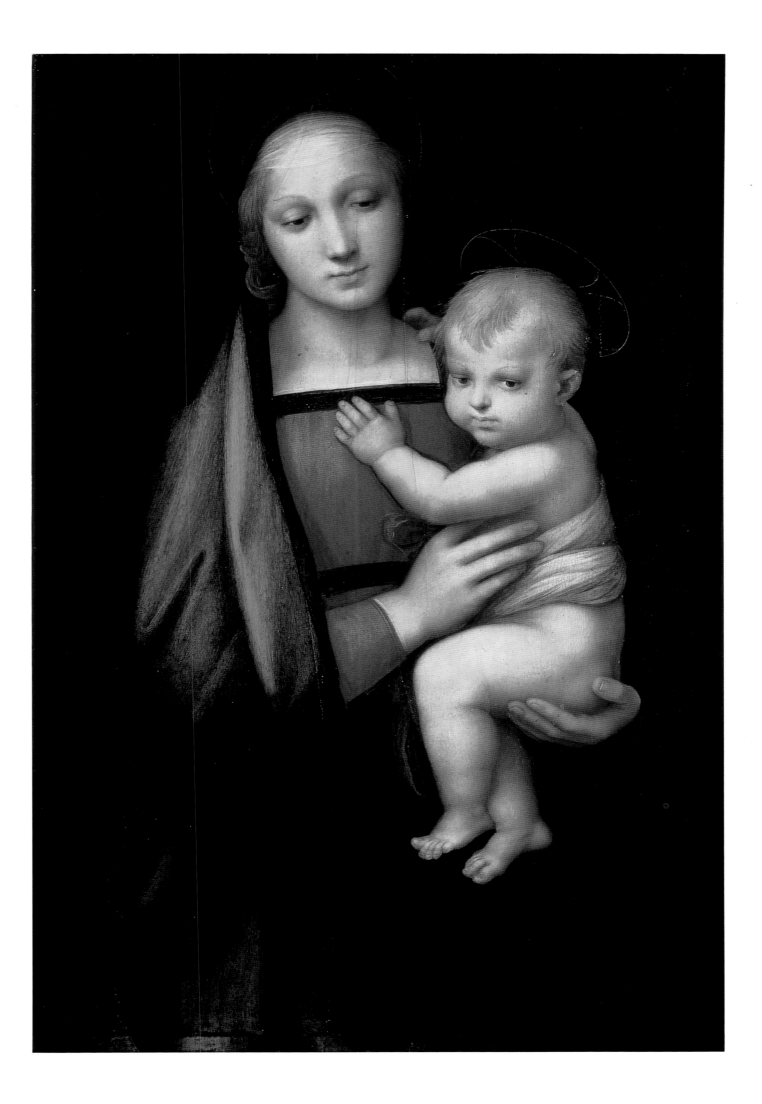

THE HOLY FAMILY WITH SAINTS ELIZABETH AND JOHN
(THE CANIGIANI HOLY FAMILY)

c. 1506
Oil on panel, 51½ × 42⅛"
Alte Pinakothek, Munich

The challenge of setting the Madonna and Child motif into new compositional arrangements occupied Leonardo, Michelangelo, and Raphael during the first years of the sixteenth century. Soon the problem was expanded to include not only the little John the Baptist but also Saint Joseph, as in Michelangelo's *Doni Holy Family;* the Madonna and Child with Saint Anne is found in several works by Leonardo. Raphael painted the tiny *Holy Family with the Lamb* (versions in Vaduz and Madrid) and a more advanced configuration, this signed work of *The Holy Family with Saints Elizabeth and John,* also known as *The Canigiani Holy Family.* He employed a pyramidal structuring of the figures: the two women form the sides of an equilateral triangle whose apex is the head of Saint Joseph. It is thus a strongly balanced composition with the seated old Elizabeth supporting John counterweighted by Mary supporting the little Jesus, who plays with a ribbon.

As with other works from this period, Raphael has drawn heavily upon the example of the two older Florentine masters, but the ultimate result is nevertheless quite original and characteristically Raphaelesque. In part the effect is achieved by the remarkable landscape setting (derived from Emilian painting) into which Raphael has placed the figures. The middle distance is rich in detail, including farmhouses and a meandering hill town that has a northern flavor, while mountains extend into the distance. In the foreground are clumps of vegetation closely related to several of his own earlier pictures. Originally there were putti in the clouds above, as is revealed by old copies and by X rays of the picture, but subsequently they were painted over.

The psychological insights are primarily established by a series of interlocking glances: Joseph looks down to Elizabeth, who returns his glance; the two children gaze at each other while Mary's eyes rest on John. Mary is the most isolated of the figures because none of the others turns to her. In every respect the picture is marked by an ironclad control, an equilibrium of forces virtually unknown in painting before this time: the emotion of each individual is held in check by the unity of the whole; the extent of the landscape appears in perfect harmony with the figural masses; the nude children are played off against the heavily draped adults; their extreme youth is counterbalanced by the youthful Mary on the one hand and her aged husband and her cousin Elizabeth on the other.

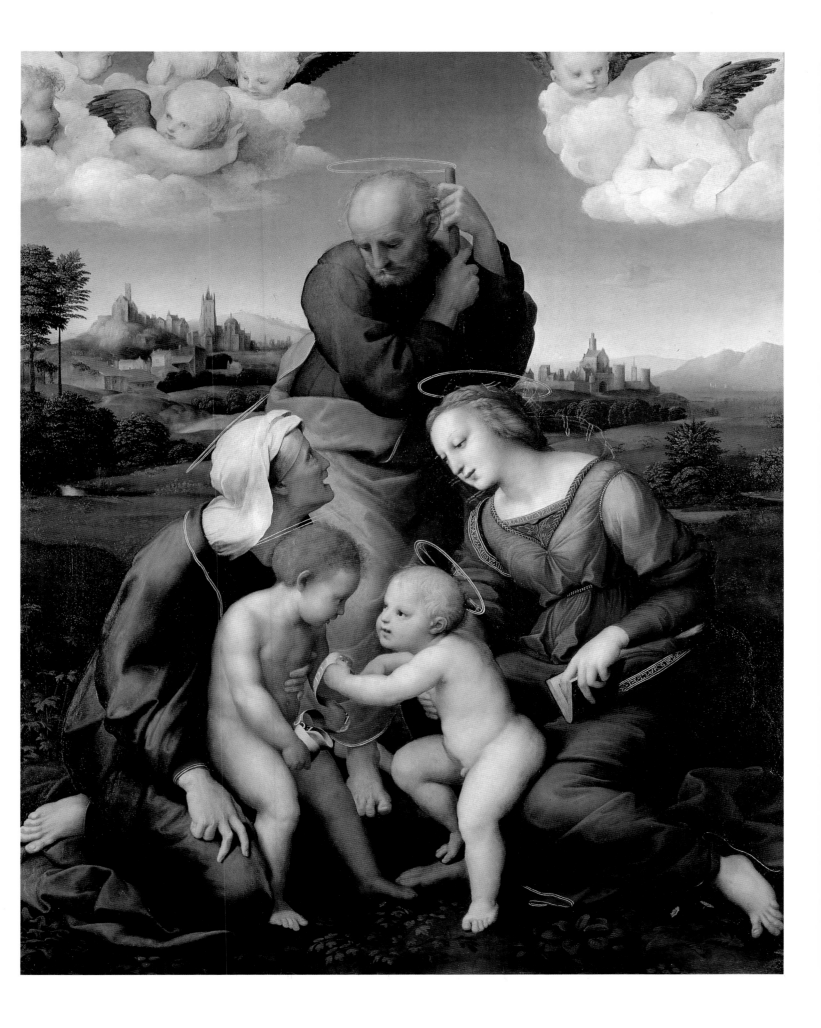

THE MADONNA OF THE GOLDFINCH

1506–7
Oil on panel, 42⅛ × 30¼"
Uffizi Gallery, Florence

Raphael made a number of compositions in which the Christ Child is united with the young Saint John the Baptist. John is the patron saint of Florence, and his presence in such pictures was almost mandatory when destined for a Florentine commission. Much taken with the potentialities of a pyramidal construction for such complex groups, Raphael made use of it in various paintings of this period, including *The Canigiani Holy Family, La Belle Jardinière, The Madonna of the Meadow,* as well as here in *The Madonna of the Goldfinch,* which takes its name from the bird held by Saint John. The capacities of this basic compositional system and its variations were first explored by Leonardo in *The Madonna of the Rocks* (begun 1483; fig. 25). The figures become locked into place within the geometric framework, giving a sense of absolute unity to the group. In Raphael's picture there is a strong axial emphasis: Mary's head is at the center and at the apex of the pyramid, high above the zone containing the two children.

The Christ Child, who caresses the tiny goldfinch, stands between the knees of his mother and is protected by the mass of her body, an arrangement related to Michelangelo's *Bruges Madonna* (finished before 1506); but into his icy marble prototype Raphael injected warm flesh tones, locating the group within an airy landscape of lacy trees, brooks, and mountains. In the distant background on the right is a walled city that bears a strong resemblance to Florence, with its two architectural and political centers, the Duomo and the Palazzo Signoria, discernible. This topographical element was part of a mid-sixteenth-century restoration, added after the picture had been severely damaged in a fall. In this painting and in *La Belle Jardinière,* together with a group of related works using the same basic composition, Mary is isolated from the children as if to indicate their separate destinies and diverse roles.

Basic to the appeal of such a picture as *The Madonna of the Goldfinch* is the beauty of the individual figures: the curly-headed John, the chunky, plump-cheeked Christ Child, the youthful, handsome, blond Mary, whose gentle restraint and kindly glance epitomize Raphael's Madonnas of this time. The fascination of this panel also has to do with its moderate size, which makes it highly approachable, and the pure human relationship of the figures to one another and to their environment, in this case the Tuscan landscape. Raphael has achieved a rare equilibrium without resorting to the sentimental in such pictures designed for private devotion.

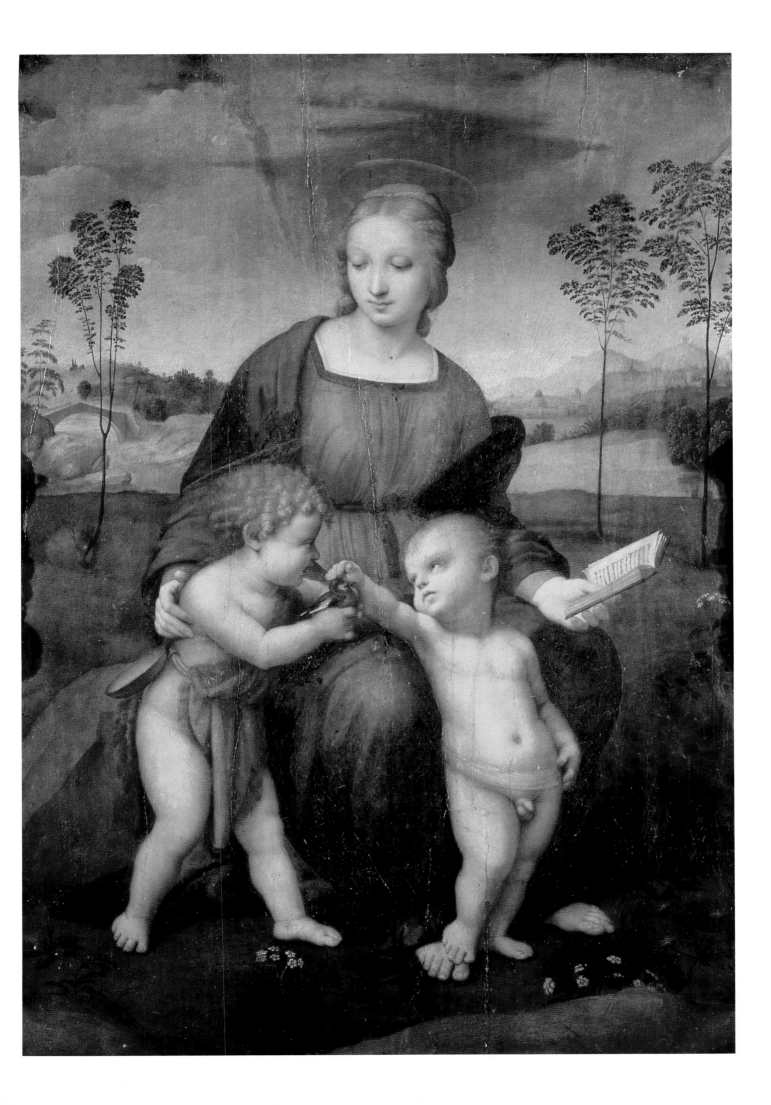

THE ENTOMBMENT

1507
Oil on panel, 72½ × 69¼"
Borghese Gallery, Rome

More than a dozen studies have survived for *The Entombment,* making it the most amply documented of Raphael's paintings and permitting some real insights into the development of Raphael's ideas as he studied a given problem. A signed and dated work, it was destined for the Church of S. Francesco al Prato in Perugia and was, according to the best available evidence, commissioned by Atalanta Baglioni a few years after her son, the young Grifonetto Baglioni, murdered his relations in order to gain control of the government of Perugia—only to be killed himself a few days later. The painting thus represents and celebrates the pain of the bereaved mother. There are two principal and distinct motives within the picture, one being the suffering Mary swooning at the right, an apparent reference to Atalanta Baglioni, with probably a corollary reference to Mary as coredeemer with Christ as she echoes his Passion. The other motive represents the transport of Christ's body to the tomb, which is shown on the extreme left.

At an early stage in his conception of the altarpiece, Raphael had developed a more unified subject showing a Lamentation over the Dead Christ, a composition preserved in a drawing in the Ashmolean Museum, Oxford (fig. 36); gradually the final solution evolved, which shows the two distinct and separate motives. Despite the arduous planning, the painting is something of a failure, although a brilliant one. All the ingredients of Raphael's style as it had been transformed in Florence, the many lessons he learned there, especially from Leonardo and Michelangelo, are present. The pose of the figure seated on the ground to the right of the main group is a quotation from Michelangelo's Mary in the *Doni* tondo (fig. 19), with the torso, however, turned sharply; the highly refined and sensitive head of Christ has strong connections with the *Pietà* in Saint Peter's (fig. 33), as well as an important impetus from Signorelli's fresco in Orvieto (fig. 35). There are also antique references, such as the massive figure on the right, who supports Christ, but oddly enough its exaggerated classicism is closer to Jacques-Louis David and Neoclassicism than to anything done in the sixteenth century. All elements for a successful painting are here, yet the expressions are forced, the figures for the most part are unnaturally and stiffly posed, and their actions are ambiguous.

The painting is vigorously colored, with sensitive passages like the pale rose of Christ's loincloth, and stands as one of the sources of inspiration for Caravaggio's *Entombment* in the Vatican Pinacoteca, painted a century later. In fact, during the seventeenth century, Raphael's *Entombment,* often called *The Deposition,* must have been highly prized since it was secretly appropriated from Perugia by Pope Paul V and in 1608 was given to his nephew Cardinal Scipione Borghese, among that period's most remarkable collectors and patrons of the arts.

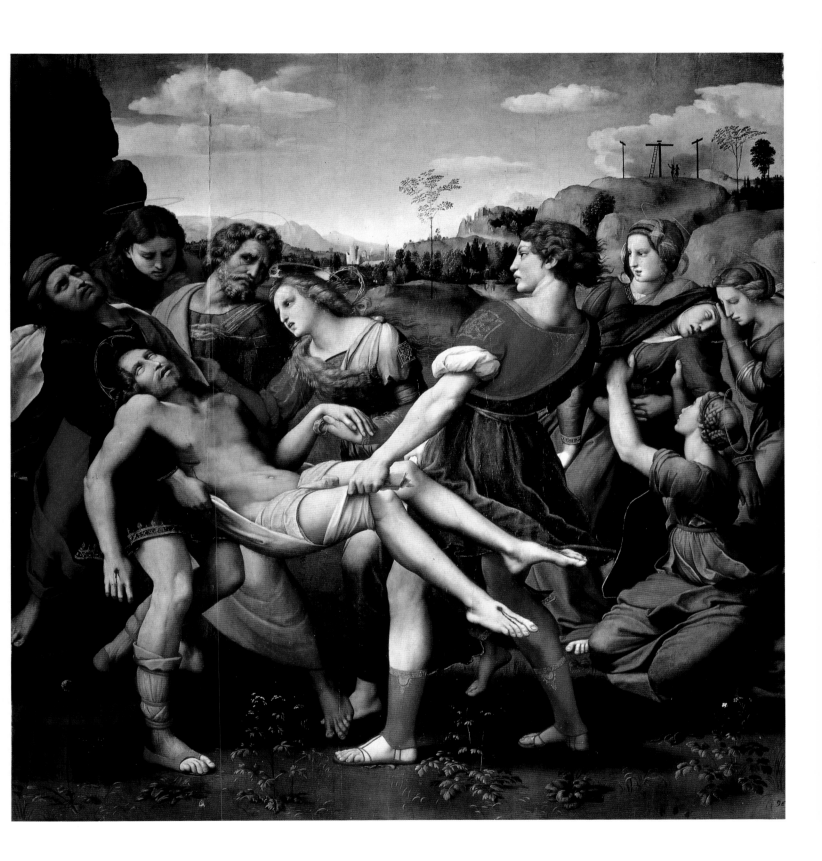

COLORPLATE 15

LA BELLE JARDINIERE

1507–8
Oil on panel, 48 × 31 ½"
The Louvre, Paris

The few isolated flowers and plants in the foreground of *The Madonna of the Goldfinch* have proliferated here in this closely related picture, whose title in fact derives from Mary's placement in the meadow. The pyramid is still the basic form for the arrangement of the three figures, although the formula has become more flexible. The Christ Child on the left side is juxtaposed with the genuflecting John, who rests on the edge of the central axis. The harmonious, easy internal balance is here stretched; the borders of a disequilibrium are surveyed though never crossed. The arcuated form of the top of the panel, which Raphael had used earlier in the *Marriage of the Virgin,* serves to further unite the group under a domelike sky.

All of the figures, including Mary, who wears a transparent veil and whose all but invisible halo almost disappears in the atmosphere, are somewhat more fleshy than in earlier examples. The tendency toward more robust proportions derives from Raphael's exposure to the art then being produced in Florence. In addition, the extraordinary and strongly contrappostal pose of the child, whose upper body and head turn sharply, represents an attitude meditated by both Leonardo in his *Leda and the Swan,* which Raphael copied in a drawing now preserved at Windsor (fig. 16), and Michelangelo in the child from the *Bruges Madonna.*

If we are to believe Vasari, Raphael left this picture unfinished when he departed for Rome, and it was completed by an assistant. The painting, though signed and dated, does have a more enamel-like finish than most of Raphael's pictures of this period. Several drawings are related to it, including a study in the Louvre that represents a much earlier point in the evolution of the idea and is without the more daring composition and the elastic pose of the Christ Child that typify the final result. This pose becomes very much a part of Raphael's subsequent vocabulary and is used for the *Galatea* fresco in the Villa Farnesina, painted a few years later, after he had become well established in Rome.

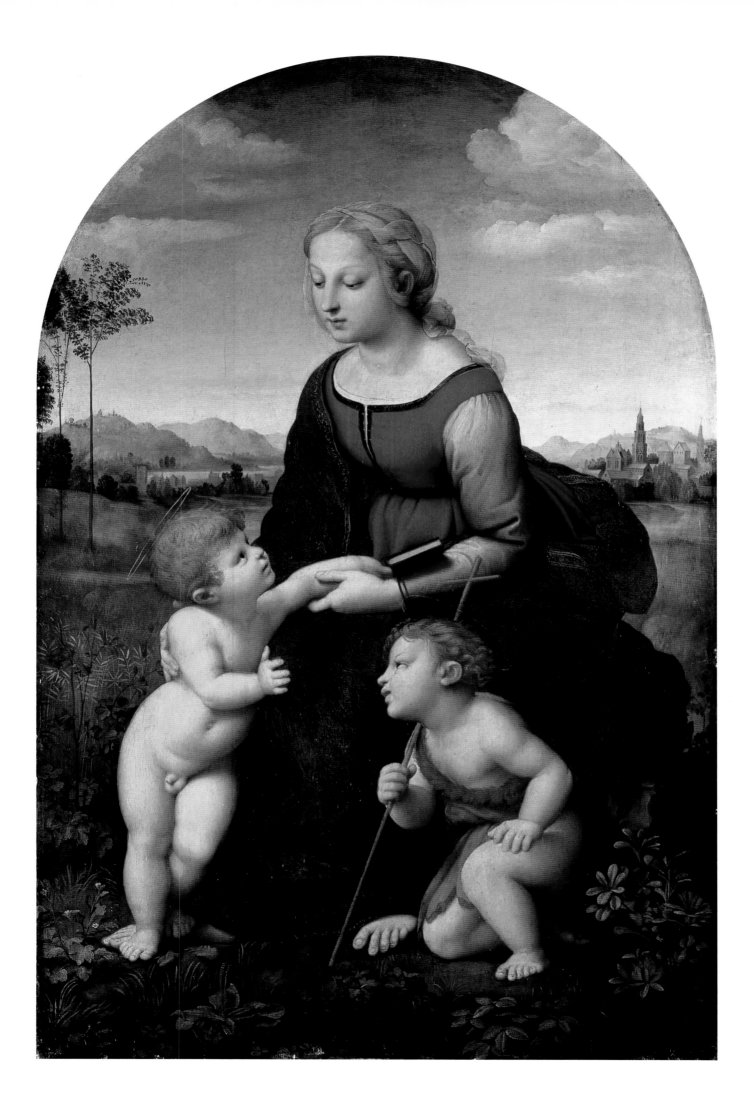

THE MADONNA OF THE BALDACCHINO

1508
Oil on canvas, 9' × 7'4"
Pitti Gallery, Florence

Among the last works Raphael executed while in Florence and actually left unfinished when he departed for Rome in 1508, this Madonna and Child Enthroned with Saints Peter and Bernard on the left and James and Augustine on the right was made for the Dei family chapel in the Church of S. Spirito. It is a large picture whose size was increased by the addition of a section at the top during a restoration conducted toward the end of the seventeenth century. Mary is placed on a tall throne protected by a canopy or baldachin, from which the picture gets its name. The strongly centralized composition is further enhanced by the delightful winged putti at the foot of the high steps. The whole scene is located within the interior of an apsidal structure that has a coffered half-dome. Despite the contemporaneity of the architectural setting and the vigorous attitudes of the saints, the picture, bleak in coloristic effects, retains close connections with fifteenth-century altarpieces for this type of *sacra conversazione.*

The Madonna with the chunky child on her lap shows Raphael's continuing assimilation of types found in Florentine sculpture, especially from the Della Robbia workshop. In this case he includes the charming motive of the child playing with his toes. The putti at the base of the picture fill an otherwise empty zone and are clearly cousins to those whimsical angels in the same location in *The Sistine Madonna.*

There are other seeds of Raphael's Roman style buried within this somehow awkward painting. Saint Augustine, by gesturing to the center of the field, leads the eye of the spectator to the figure behind him and, thence, to the throne; the eye is then led back from Saint Bernard to Saint Peter. Such punctuation, providing a logical and straightforward reading of the picture, typifies Raphael's frescoes in the Stanza della Segnatura, which he began shortly after he stopped work on *The Madonna of the Baldacchino.* Still, there is no denying that the actors in this painting are mechanically posed and that their idiosyncratic expressions lack the heroic refinement and dignity of Raphael's later work; on the other hand, they have lost a certain delicacy and innocence typical of the previous pictures. The exception is the figure of Saint Bernard, clad in a nearly white garment and holding a large open book, whose noble conception is already stated in the preparatory drawing.

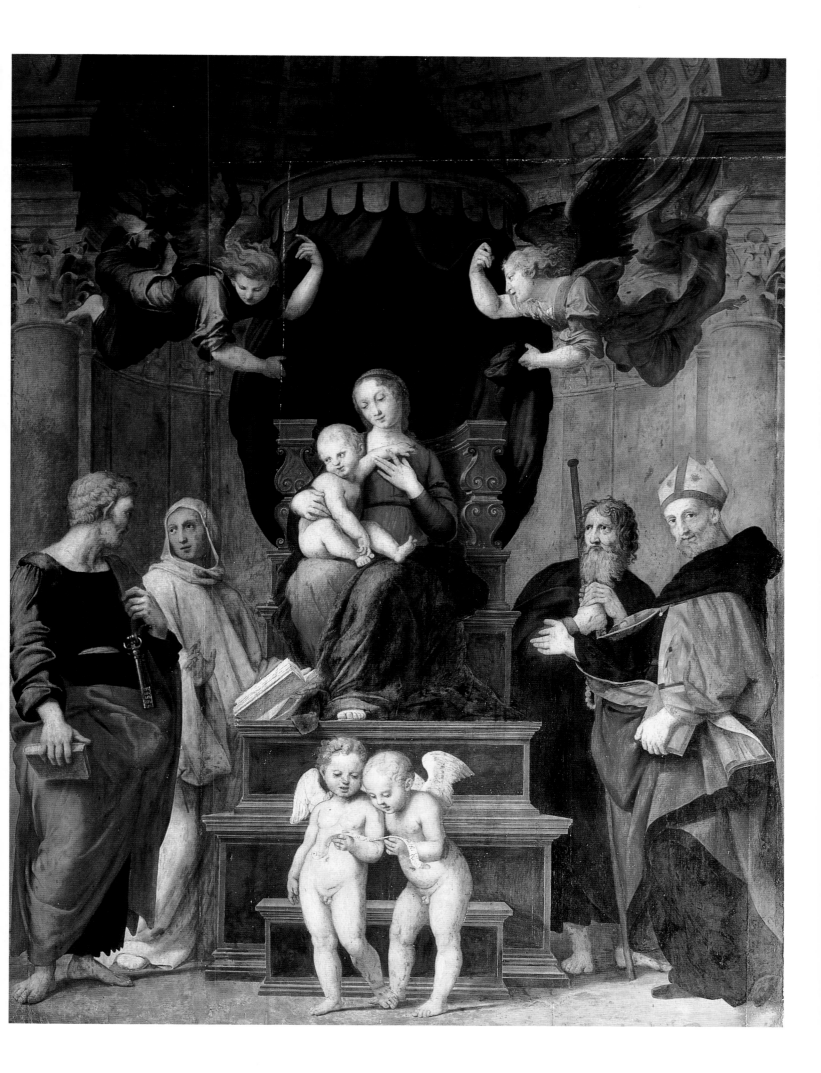

THE FALL

c. 1509
Fresco, 47½ × 41½"
Ceiling, Stanza della Segnatura, Vatican, Rome

Raphael interprets Original Sin not from the purely misogynist view that was common but as resulting from a mutual *culpa* on the part of both Adam and Eve. Eve holds out the tiny fruit to her husband's outstretched hand while he easily turns toward her; the serpent, entwined about the tree, looks on. With the head and upper torso of a handsome woman, it has set the trap that induces the disobedient children to fall from grace. The scene is, of course, essential to the entire Christian epic. It is matched with *Apollo and Marsyas, The Prime Mover,* and *The Judgment of Solomon* on the other corners of the ceiling in the Stanza della Segnatura, as well as with roundels with the personifications of Philosophy, Justice, Theology, and Poetry.

The undulating vaulting of the ceiling of these papal rooms created special problems for the painter since there is hardly a smooth surface upon which to paint, although this effect is not readily apparent in reproductions. Raphael painted the golden sky to appear to be composed of tiny tesserae characteristic of mosaic, an idea he may have obtained from examples by the painter Bernardino Pintoricchio, with whom he collaborated in Siena. The imitation mosaic would also have served as a reference to the typical mode of decoration in the earliest Christian churches then still existing in Rome. Against the unreal or otherworldly quality of gold background, the figures are built up by means of a vigorous play of lights and darks, creating convincing monumental images. The foliage is also realistically rendered.

It is always tempting to compare Raphael's early Roman works with contemporary paintings by Michelangelo, especially in this case, since the same subject was illustrated by both masters. Also on a ceiling, although in a much larger, higher, and more important space, Michelangelo united his *Fall* and the *Expulsion of Adam and Eve* in a single field, with the tree of the knowledge of good and evil in the center separating the two scenes. For *The Fall,* both artists have one figure seated and the other standing, but in Michelangelo's treatment the figures are more aggressive in their actions; Raphael's Adam and Eve slowly and deliberately pantomime their inevitable roles. Raphael's Eve, a stocky, high-busted, thick-hipped Venus, appears to have just taken a step forward; as a type she is related both to Leonardo's *Leda* and to antique examples. Adam was the result of direct studies from the nude, as is shown by a drawing for the figure in the Louvre.

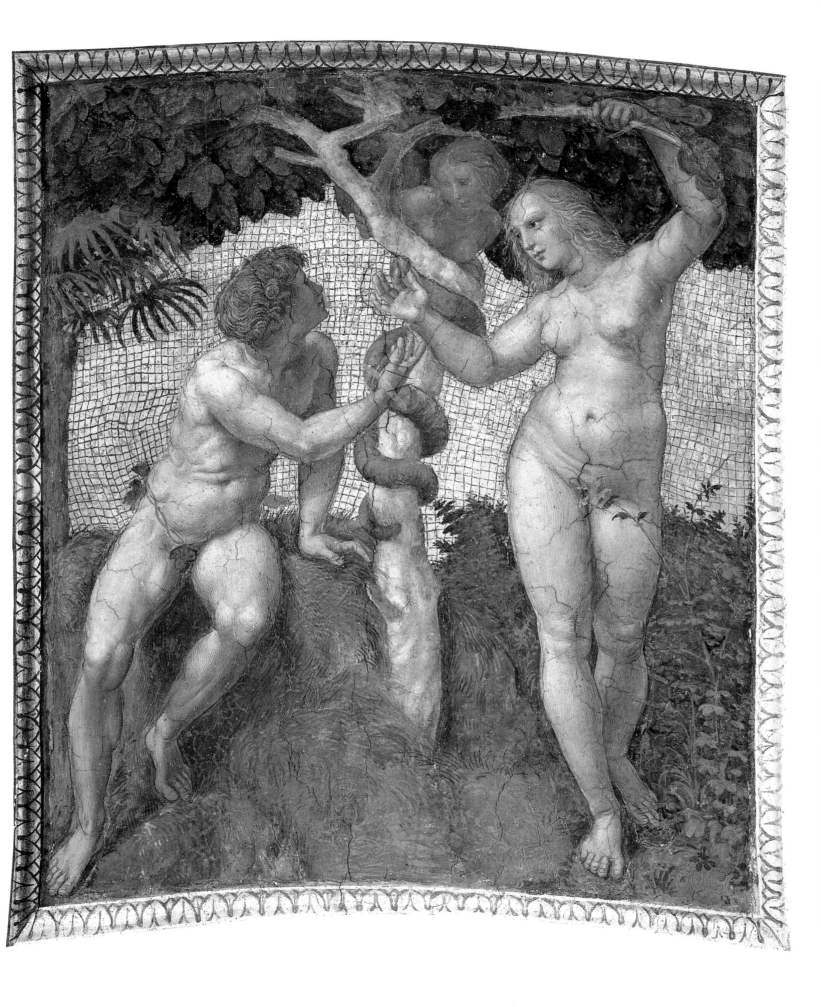

THE DISPUTATION OVER THE SACRAMENT
(DISPUTA)

1509–10
Fresco, 25'3" at base
Stanza della Segnatura, Vatican, Rome

Together with *The School of Athens* on the opposite wall, the *Disputa,* as the painting is known in Italian, is intimately connected with Raphael's fame and reputation. These two frescoes set the highest possible standard for multifigured paintings and have always been studied, copied, analyzed, and admired by artists. The commonly used title itself is somewhat misleading, for the fresco does not represent dispute as much as it does amplification, in which theologians analyze and expound upon the meaning of the Eucharist resting on the altar at the center of the picture. It could well be thought of as an exaltation of the Christian faith.

To a large degree the figures are identifiable. The four principal personalities are Doctors of the Church, Saints Gregory the Great and Jerome on the left side of the altar, Ambrose and Augustine on the opposite side. Among others who may be singled out are Saint Thomas Aquinas, Pope Innocent III, and Saint Bonaventure. Standing on the right side of the painting, Sixtus IV, uncle of the reigning Pope Julius II, who commissioned the work from Raphael, is dressed in a golden cope and papal tiara. Directly behind him the unmistakable profile of Dante is to be seen. On the other side of the composition the most devout painter of the previous century, Fra Angelico, is included along with Bramante, the chief architect of the new Church of Saint Peter's, Raphael's friend, sponsor, and *paesano,* who is shown leaning on the railing. Raphael's own image may be seen in the guise of the bishop standing behind Pope Gregory, who, in turn, has the features of Julius II. Thus contemporaries are sometimes shown alongside historical and saintly figures; at other times their features are superimposed upon these earlier personalities.

The disposition of the figures in a sweeping arc at the bottom zone of the composition is echoed above where the heavenly entourage is arranged beneath the seated Christ. Old and New Testament personages, including Peter, Adam, John the Evangelist, David, and Jeremiah on the left, are numbered with Judas Maccabaeus, Moses, Matthew, Abraham, and Paul on the right, combined with the postbiblical deacon saints Stephen and Lawrence. These painted figures are oddly unsculptural yet have strong three-dimensional conviction nonetheless. The entire assembly above, both earthly and celestial, is crowned by a golden light with actually raised stucco rays and God the Father at the top. In the *Disputa* Raphael has embraced an extraordinary wealth of meaning and an immense historical range from Adam to Raphael's own contemporaries. In the distance at the left a landscape with buildings emphasizes the terrestrial character of the lower zone. Everything in the painting, despite its complexity, is intensely clear, virtually self-evident.

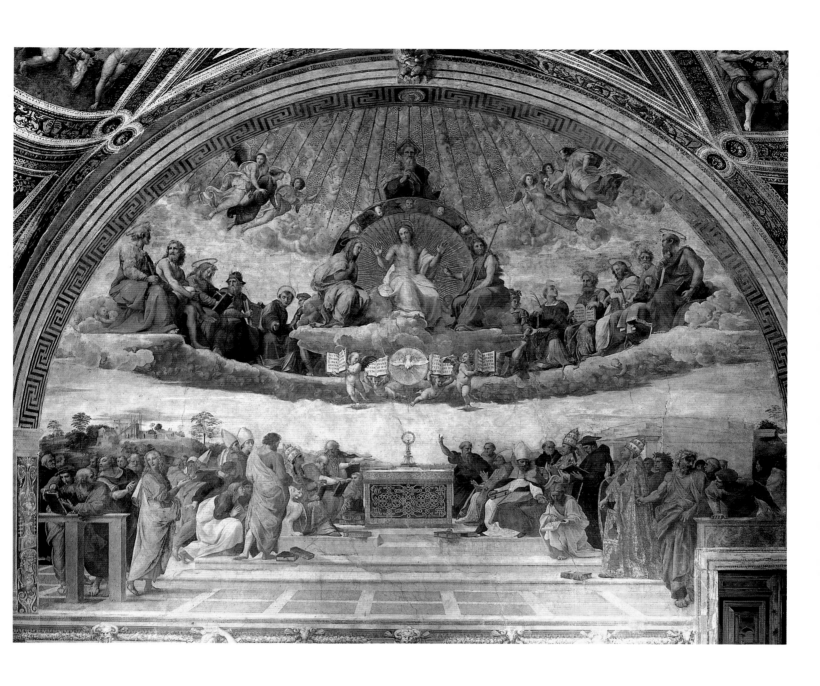

THE SCHOOL OF ATHENS

1510–11
Fresco, 25'3" at base
Stanza della Segnatura, Vatican, Rome

If in the *Disputa* the central axis contains all the primary components of the meaning, in its counterpart on the opposite wall—*The School of Athens*—the emphasis is on a horizontal reading, and the main figures, located on the top of the short stairs, are strung out like an animated frieze. Such a distribution is related to the fact that in this fresco the stress is on earthly zones rather than on otherworldly ones so characteristic of its analogue. In the case of the *Disputa,* the golden tonalities reflect theological and spiritual values in connection with the miraculous nature of the Eucharist; these are in contrast to the clear blues and whites and the crisp, charged atmosphere that characterizes *The School of Athens.* This is a realm where the power of philosophy and reason, as opposed to faith, seems to dominate.

The two central figures, isolated from the others by a framing archway, are Plato and Aristotle and with them the world of classical antiquity. The former points skyward as he holds his book *Timaeus,* while Aristotle, also with a book, the *Ethics,* gesticulates toward his surroundings. With these gestures Raphael is able to capsulize their respective philosophies with remarkable and apparently effortless simplicity; such was his genius that the most complicated and intricate become easily comprehensible. The learning of antiquity is further spelled out in the subgroups and in the accessory figures on either side of the two leading players. On the extreme left a nearly nude youth rushes onto the scene clutching a scroll, as if he had been called upon to clarify a point under discussion with some new proof. Some listen and transcribe, others ponder, still others comment. Here is surely a world entirely of the mind, where ideas are professed, exchanged, and weighed.

The School of Athens is laid in a wholly classical setting. The interior of the vast structure, with an open dome behind the central figures, the coffered vaults and massive piers, might well be a reflection of plans for the new Church of Saint Peter's that was being built in precisely these years under the direction of Bramante. The inlaid marble decoration as well as the abundant sculpture, both in relief and in the round, including Apollo and Minerva in niches on either side of the nave, are very closely related to ancient Roman examples. There is a fundamental congruency between means and meaning throughout the painting: all elements bespeak the central theme.

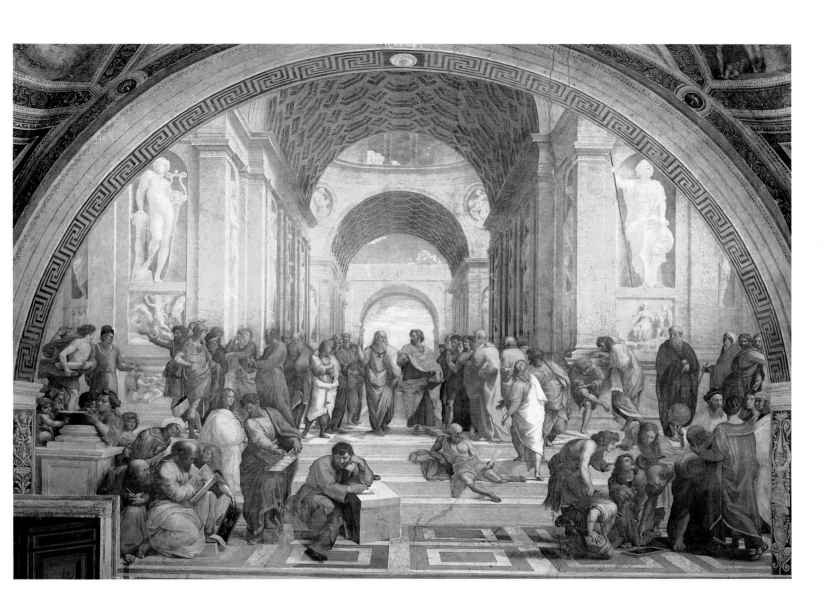

THE SCHOOL OF ATHENS (detail)

This detail from the lower right-hand section of *The School of Athens* includes four erect figures, two being contemporaries and two historical persons. The crowned figure with his back to the viewer represents Ptolemy, the Alexandrian astronomer, who balances a globe with his left hand; directly in front of him is Zoroaster: his globe is that of the starry universe. Beside him are two figures who peer out from the scene like somewhat self-conscious actors in a theater who desire to appraise the size of the audience from the stage. The youthful man is, of course, Raphael himself, the painter of the scene, whose intense eyes, full nose, thick lips, and powerful neck are quickly recognized. Next to him is another painter who is usually identified as Sodoma, a slightly older (by six years) North Italian master who had worked in the papal chambers even before Raphael's arrival in Rome. There is every reason to believe, however, that this man, whose grayed hair and lined face betray a person of considerable age, is Raphael's old teacher, Perugino, who also had been actively painting in the papal rooms.

The images of the two painters were not planned for inclusion in the fresco when the cartoon was made, nor for that matter was the seated, monumental figure of Heracleitus on the front plane at the center of the composition. It appears that Raphael had expanded the references to his contemporaries by including Heracleitus, who has been identified as a disguised portrait of Michelangelo. Other references to contemporary artists include the Plato image, usually considered a portrait of Leonardo da Vinci, while Bramante once again appears in the Stanza della Segnatura, this time in the guise of Euclid. Thus Raphael, if these identifications are correct, is surrounded by his actual teacher and those who served, in effect, as his teachers, adding thereby a curious autobiographical dimension to this meaning-packed painting.

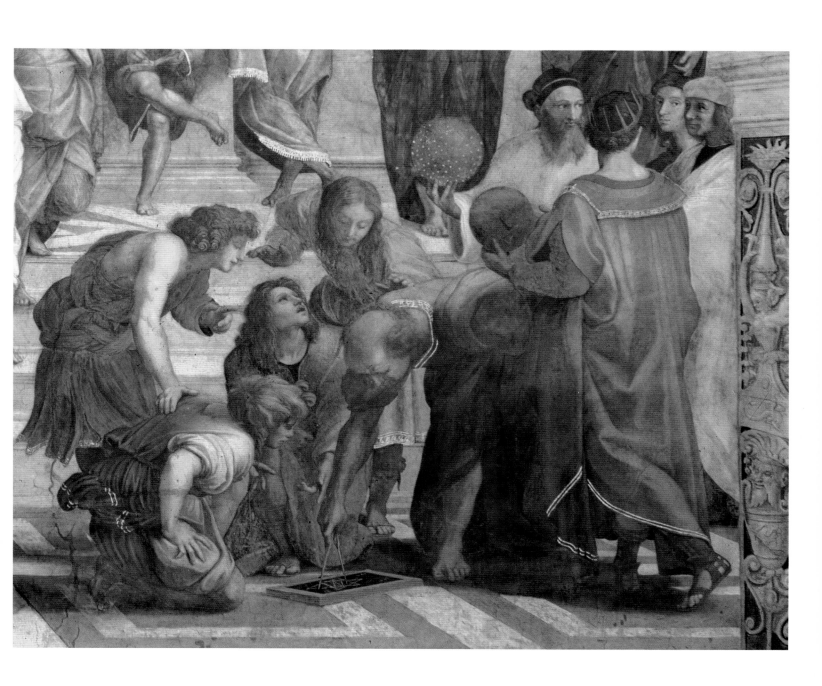

PARNASSUS

c. 1511
Fresco, 22'1½" at base
Stanza della Segnatura, Vatican, Rome

The School of Athens illustrates the concept of Philosophy, *The Disputation over the Sacrament,* Theology. *Parnassus,* with the seated Apollo in the center, represents, in the same context, Poetry, as is evidenced by the personification in a tondo directly overhead. Here the greatest writers of the ancient world congregate and are interspersed with the chief exponents of the craft from postclassical Italy, including some of Raphael's own friends and contemporaries. These are accompanied by the nine Muses, arranged on either side of Apollo at the top of the hill, who act to inspire the poet. Calliope, the noblest of all, according to Hesiod, reclines on the left side of Apollo and is balanced by Erato, whose name means "lovely one"; the others, standing, are grouped on either side of the composition, and in large measure their poses and even their instruments were copied from Roman sarcophagi. Apollo, a figural type probably based upon a seated Mars known from a small Roman bronze but confirmed by direct study from the model, holds an instrument that is modern. Its nine strings rather than the usual seven correspond to the total number of Muses shown in the fresco. This numerological metaphor is carried further within the fresco so that the poets may be seen as divided into two categories: nine ancients and nine moderns. Those most easily recognized are the group on Mount Parnassus at the left, where Dante with his unmistakable profile stands beside the majestic Homer, while on the other side of the sightless poet is Dante's guide, Virgil. Among the other identifiable Italian poets, mention may be made of Petrarch, Boccaccio, and Ariosto.

Once again Raphael has created a memorable composition. In *The School of Athens* and the *Disputa,* actual door openings intruded upon the field of the fresco but only in the periphery, so that they were rather easily adjusted to the architecture depicted within the frescoes. In *Parnassus* the center was perforated by a large window, requiring Raphael to construct his figural arrangement around the opening, which he conceived as a base for the mountain. At the bottom on the left is Sappho, the greatest poetess of antiquity, whose pose is witness to a growing Michelangelesque current in Raphael's Roman style. Her pose introduces the spectator into the scene. The eye is then led upward and across the top of the composition, thence down the other side to the figure of Horace, the worthy Roman counterpart to Sappho. The scene, set entirely outdoors without the benefit of architectural props, is dominated by the fresh green tones of the laurel trees, whose leaves are worn by most of the participants. The figure next to Virgil bears a reasonable likeness to Raphael himself, also something of a poet.

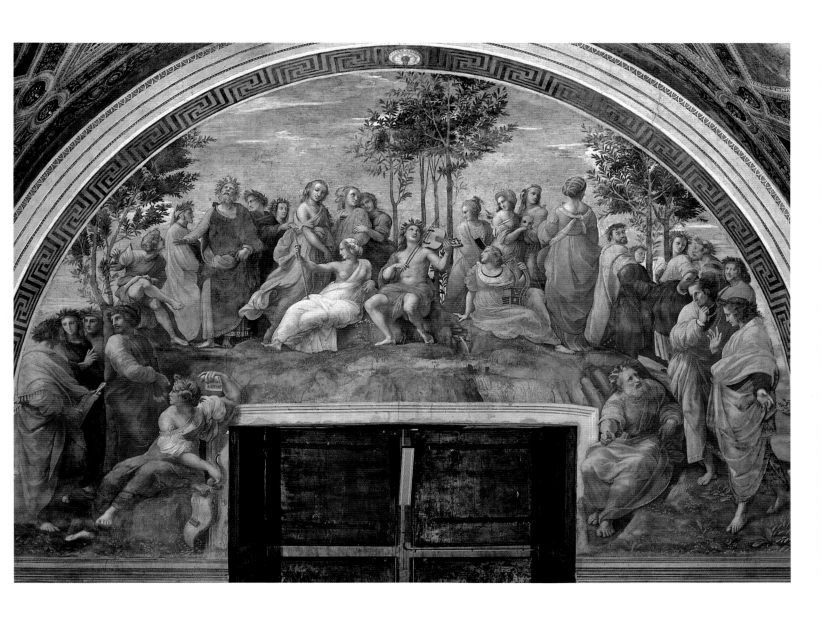

THE GARVAGH MADONNA

c. 1510
Oil on panel, 15¼ × 12⅞"
National Gallery, London

Once again, as is so often the case with Raphael's Madonnas, the impulse behind this delightful little painting depicting the Madonna and Child with Saint John derives from ideas first defined by Leonardo da Vinci, who had already experimented with a format in which the Madonna was placed in an interior containing apertures on either side looking out onto a broad landscape. The arrangement of Mary with the little Saint John, and even the gestures and glances, recall, in reverse, Leonardo's *Madonna of the Rocks.* The actual position of Mary is somewhat difficult to decipher because the pose is unusual and unexpected. She sits astride the high stone step so that her left leg is thrust across the seat and tucked under her right knee. This idea occurs on a sheet of drawings by Raphael located in the Uffizi that is usually associated with *The Bridgewater Madonna* (National Gallery of Scotland, Edinburgh), but only in embryo. In *The Garvagh Madonna* the head of Mary is located exactly on the central axis and in the middle of the wall, giving an authoritative, highly structured composition. Furthermore, the nearly pure oval shape of her head, rather evenly lighted and set upon a conical neck, adds to the pervasive formal order.

Rather than falling in from the open windows, the light emanates from above and to the left, thus allowing for a second, interior kind of light contrasted to that of the landscape. The picture was in the Aldobrandini Collection in Rome during the eighteenth century and is still sometimes referred to as *The Aldobrandini Madonna.* Purchased by Lord Garvagh in 1818, it passed to the National Gallery a half century later. In its peregrinations the small, somewhat uncharacteristic painting incurred some damage to the surface, and the awkward left hand of Saint John is a restoration.

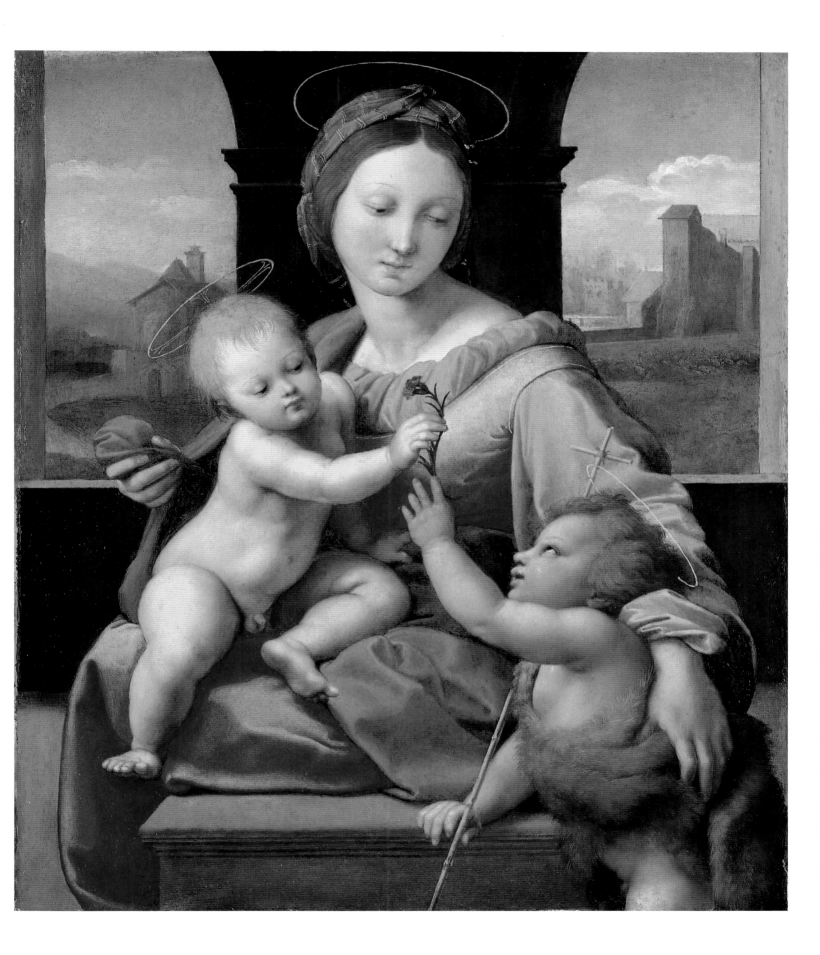

COLORPLATE 23

PORTRAIT OF A YOUNG CARDINAL

1510–11
Oil on panel, 31⅛ × 24"
The Prado, Madrid

During the first years of his stay in Rome, Raphael's principal energies were devoted to frescoes in the Vatican Palace and elsewhere; he also executed a number of lesser commissions, including this remarkable portrait of a cardinal, done in oils. Here the possibilities for greater detail and greater subtlety of modeling in this medium are sharply demonstrated. The sitter is most likely Cardinal Francesco Alidosi, here depicted by Raphael as a youngish man with rather pointed features that seem to correspond, nearly, to the shape of his cap. Raphael does not offer any insight into the character of the man or a psychological exploration of his personality. He presents, rather, the man's unmistakable external appearance in his clerical robes, apparently leaving further interpretation to the spectator if he or she is so inclined. Raphael does not depend upon caricaturist devices for his likeness; instead he seems to proceed here much like his Netherlandish predecessors in unfailingly capturing the outward appearance of his sitter. Such precision is virtually impossible when operating in the medium of fresco. While there are scores of portrait likenesses in the Stanza della Segnatura, the intensity of the image is never so immediate as in that of this unknown cardinal: his thin lips, sharp nose, deep-set eyes, and long neck are rendered with impeccable exactitude and finality.

The pose still owes something to Leonardo; the cardinal's left arm, resting at the base of the picture (cut down) parallel to the edge, the slightly oblique positioning of the sitter's body and head appear to be a translation of the *Mona Lisa* type, which Raphael had previously adopted for both Doni portraits. The head of the figure retains some of the quizzical, ambiguous, mysterious quality of the famous portrait by Leonardo. At the same time the image has a monumentality achieved by the massive proportions of the torso in relation to the head. Nor should it be forgotten that despite the directness of observation revealed in the face, there is a strong element of idealization that also typifies Raphael's other Roman works. It is precisely this careful admixture that raises this portrait far beyond the reportorial level.

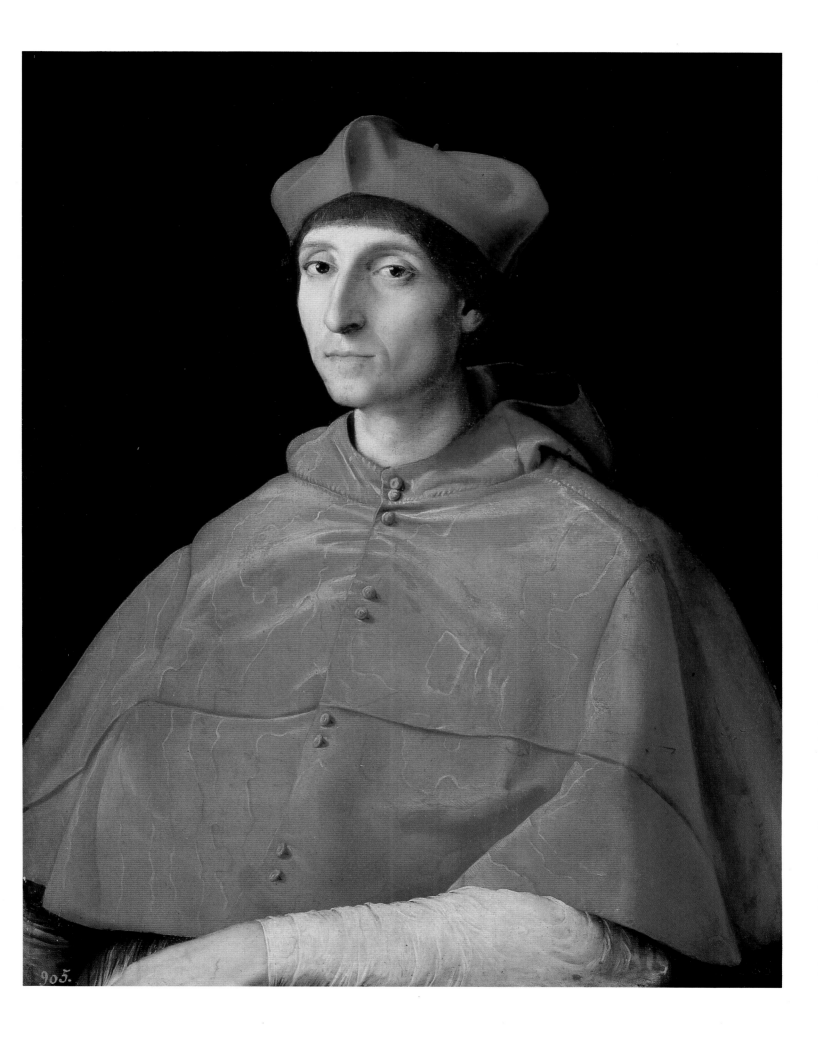

COLORPLATE 24

THE ALBA MADONNA

c. 1511
Oil on canvas, diameter 37¼"
National Gallery of Art, Washington, D.C.

This tondo has a rather complicated history. It was once in the collection of the Spanish Duke of Alba, hence its name. Purchased for Czar Nicholas I of Russia in the nineteenth century, it was obtained from the Hermitage Gallery, Saint Petersburg, for the Mellon Collection in 1937 and subsequently entered the National Gallery. Undated, the painting must have been executed during Raphael's activity in the Stanza della Segnatura and more specifically in the period of the *Parnassus;* in fact, Mary's pose is a variation, in reverse, of the Muse Erato in the fresco, but worked further in a drawing from life, now in Lille. Although the painting is set into a circular framework, the main formal stresses are not circular: the landscape, an airy, expansive portion of the Roman *campagna,* stretches out horizontally. As a balance the few plants and flowers scattered beneath the Virgin tend to follow the curvature of the tondo. There are also strong diagonal pressures created on the one hand by the series of glances from Mary and Christ to the little Saint John kneeling on the left and on the other hand by the thrust of Mary's left arm and left leg, but the basic formal character of the painting, originally executed on wood and then transferred to canvas, is obtained by the triangular or pyramidal construction of the figures as a tightly knit group, locked into their positions.

Raphael had already learned such compositional devices in Florence, which developed from his study of Leonardo; nevertheless, using a similar geometric arrangement in a tondo is new and daring. It combines the stability of the triangle, whose long baseline concentrates the weight on the ground, with the perfection associated with the circle. The nobility of the composition and the distinctive color are not altogether maintained in the expression of the figures. Furthermore, the anatomy of the Christ Child displays a certain incongruity created by the smallish, delicate head and shoulders attached to a powerful lower torso and thick legs.

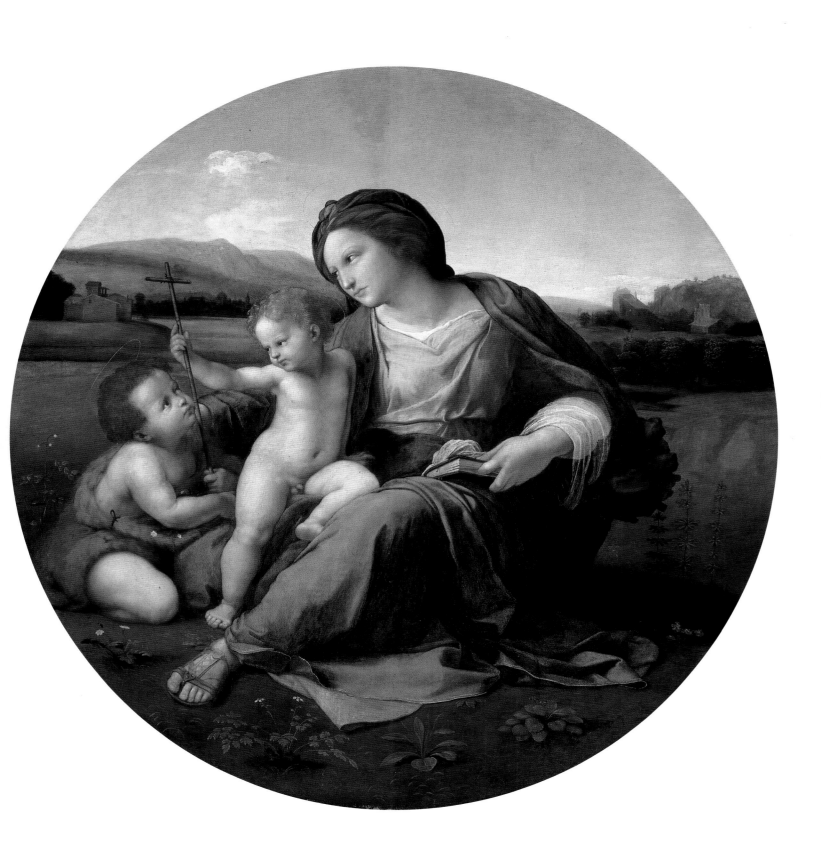

GALATEA

c. 1512
Fresco, 9'8⅛" × 7'4"
Villa Farnesina, Rome

The Sienese banker and art patron Agostino Chigi, whose great wealth made him one of the most powerful men of his age, built his Roman villa in the Trastevere district. Its construction and decoration were conducted by the Sienese painter and architect Baldassare Peruzzi, who, in turn, brought in other painters, including Sodoma and Sebastiano del Piombo, to execute parts of the fresco decorations. The ground-floor grand salon of the house has an ingenious and highly intricate ceiling fresco that treats Chigi's horoscope; the stars were painted in the guise of personifications arranged in the sky at the moment of his birth. On the walls were planned a series of frescoes dealing with the gods of the earth and of the sea. Only two were ever executed: Sebastiano's *Polyphemus* and Raphael's *Galatea*. In contrast to its counterpart next to it, Raphael's fresco offers continual turmoil and swift movement, as the graceful Galatea streaks across the sea in a shell propelled by dolphins.

It is quite natural to compare this purely classical scene with a similar one from the previous generation: Botticelli's *Birth of Venus* (Uffizi Gallery, Florence). In it, the emphasis is on the beauty of the surface and the elegance of decoration and design; the world of Botticelli's Venus is a fairyland. In both paintings the wind blows vigorously; Galatea's long golden locks swirl in the swift breeze that also affects her russet garment. Raphael's rendering captures the spirit of the ancient world, and alongside it Botticelli's exquisite work appears almost medieval. To be sure, Raphael has relied heavily upon classical sources, not painted examples—which were exceedingly rare—but the much more common Roman reliefs, especially marine sarcophagi such as those located in Chigi's native Siena. In the lusty pagan interpretation in which the sea nymphs are being carried off in all directions by the swarthy, muscular Tritons to the sound of horns, Raphael has been preceded by Andrea Mantegna, whose engraving of *The Battle of the Sea Gods* he undoubtedly knew.

The text from which Raphael's interpretation is derived comes from antiquity via a poem by the Florentine Poliziano; for the central figure Raphael has introduced a new and highly engaging pose, necessitated by the theme. The figure is being pulled along diagonally by the ferocious dolphins, and her torso and arms are pivoted from the central axis to accommodate this directional force; at the same time, she is centrally placed in the composition and stands with an almost exaggerated contrapposto, precariously maintaining her balance. The right leg carries the weight while the sharply turned head, which looks in the direction of the giant Polyphemus in the adjacent fresco, counterbalances the diagonal thrust of the torso.

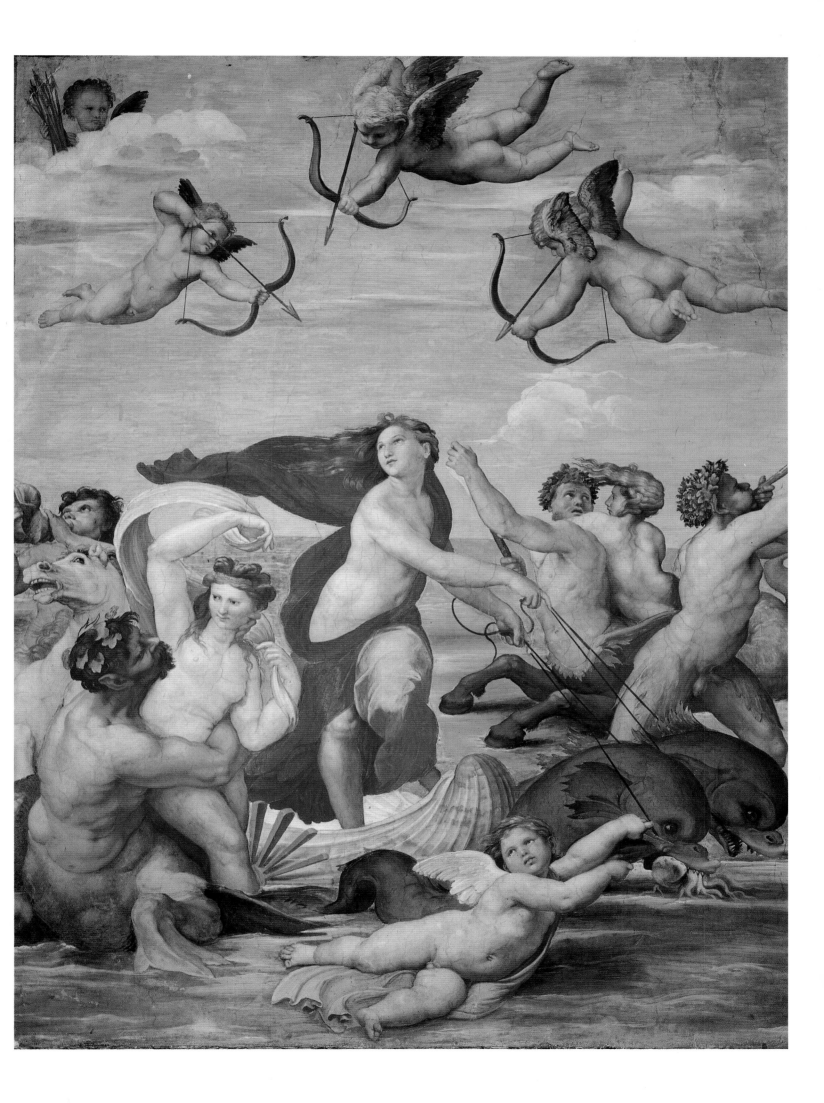

THE EXPULSION OF HELIODORUS FROM THE TEMPLE

1512
Fresco, 24'7" at base
Stanza d'Eliodoro, Vatican, Rome

In contrast to the restrained, abstract, conceptual subjects of the Stanza della Segnatura, the frescoes in the contiguous room are historical in nature and dramatic in expression. The first of these murals to have been painted in the room, *The Expulsion of Heliodorus from the Temple,* is based upon the narrative found in the Second Book of Maccabees, and it gave rise to the name of the room itself—the Stanza d'Eliodoro. In a number of details Raphael's interpretation closely follows this rather complicated Apocryphal account of treachery. Because of his hatred for the high priest Onias, Simon the Benjaminite, overseer of the temple, "betrayer of the money and of his country," told the king of riches held in custody within the temple. Heliodorus was sent to carry off the treasures, but in response to the prayers of the sorrowful Onias and of the populace, a horse with a "terrible rider . . . struck Heliodorus with his forefeet" while two other figures scourged him to the brink of death.

Raphael placed the agonized high priest beside the distant altar under the golden dome at the center of the composition; on the right, as spoils are being carried out, Heliodorus is thrust to the ground. His men are horrified by the miracle unfolding before them. On the opposite side of the painting, Julius II, carried on his litter, intensely follows the events. Onias, at the altar, also has Julius's features, and his presence in this scene raises the likelihood of its contemporary relevance; there is, in fact, good reason to associate the painting with the rebellious cardinals who, encouraged by the French king Louis XII, had called a council at Pisa to depose Julius in 1511, but it ended in conspicuous failure. The Apocryphal narration concludes with the sparing of Heliodorus's life through the prayers of Onias.

The composition of the painting, which appears as a logical consequence of the frescoes in the Segnatura, reads from left to right, with the eye carried sharply and rapidly by the gesticulating figures to the raised center and then out again by the rearing horse and racing angels. The stagelike construction of the space in *The School of Athens,* in which figures are strung out across well-defined planes, is still followed, but these neat divisions have been decisively punctured, especially at the extremities, where figures pour through the side aisles of the temple. The architecture, too, seems to take part in the dramatic action, and the massive columns offer a more vigorous play of lights and darks than the essentially flat forms in *The School of Athens.* The enormous pier on the right, with its engaged columns, is puzzlingly larger than its counterpart but might have been necessitated by the quality of action taking place nearby. Raphael once more demonstrates his uncanny ability to invent a new compositional format and a new concept of space and dramatic movement when the requirements of the subject demand it.

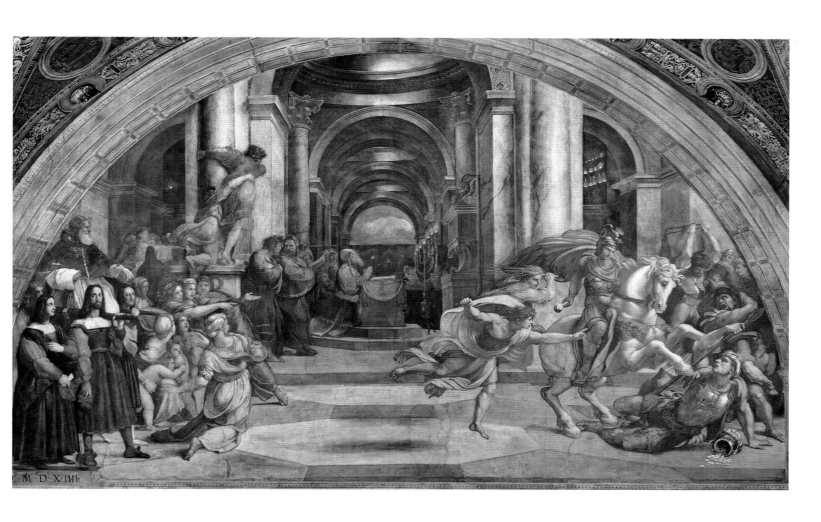

THE MASS OF BOLSENA (detail)

c. 1512
Fresco, 21' 8" (dimensions of whole at base)
Stanza d'Eliodoro, Vatican, Rome

The image of Pope Julius II appears prominently in the fresco entitled *The Mass of Bolsena,* which commemorates a thirteenth-century miracle connected with the feast of Corpus Domini. A traveling Bohemian priest, who had been troubled by doubts about transubstantiation, was given proof of the Eucharist when the altar cloth he used for a mass became stained with blood from the Host. This relic was brought to nearby Orvieto Cathedral, where it was specially venerated by Julius's uncle, Sixtus IV, as well as by Julius himself, who had paid homage to the cloth previous to one of his military campaigns. The relic is still preserved in a special altar of the cathedral.

A topical significance may be found in the detail of the fresco shown here, from the right side of the picture: members of the papal guard of Swiss soldiers, an institution introduced by Julius early in his pontificate. There may be further timely significance to their inclusion because Julius had used Swiss soldiers, known in the Renaissance for their innate ferocity and disciplined organization, in his battles against the French. They had been officially termed protectors of the church in 1512 and at the same time were given the characteristic sword and beret, held by the nearest guard in the painting, during the summer of that year, which helps to date at least this part of the fresco.

These handsome youths have been much admired over the centuries, especially for their elegant, colorful, differentiated dress. Such freshness of tones and such bold decorative effects have raised questions as to the origins of these elements in Raphael's art; suggestions have ranged from the possibility that Raphael had been influenced by Venetian art to a proposal that this segment of the fresco, among the last parts finished, was actually executed by some North Italian working under Raphael. Proposals of this kind fail to comprehend the range of the artist's vision on the one hand and the character of his Umbrian origins on the other. Why should it be surprising for a countryman of Piero della Francesca and Luca Signorelli to have such interests? What, of course, is also remarkable about these unself-conscious figures is their sturdy monumentality, clearly paralleling some of Michelangelo's images found on the ceiling of the Sistine Chapel, completed by then. Painted with the directness of a Velázquez, they are probably individual portraits of personalities well known in court, so arranged that while four are placed in profile and turned inward, the fifth guard, in the middle of the group, looks out blatantly at the spectator.

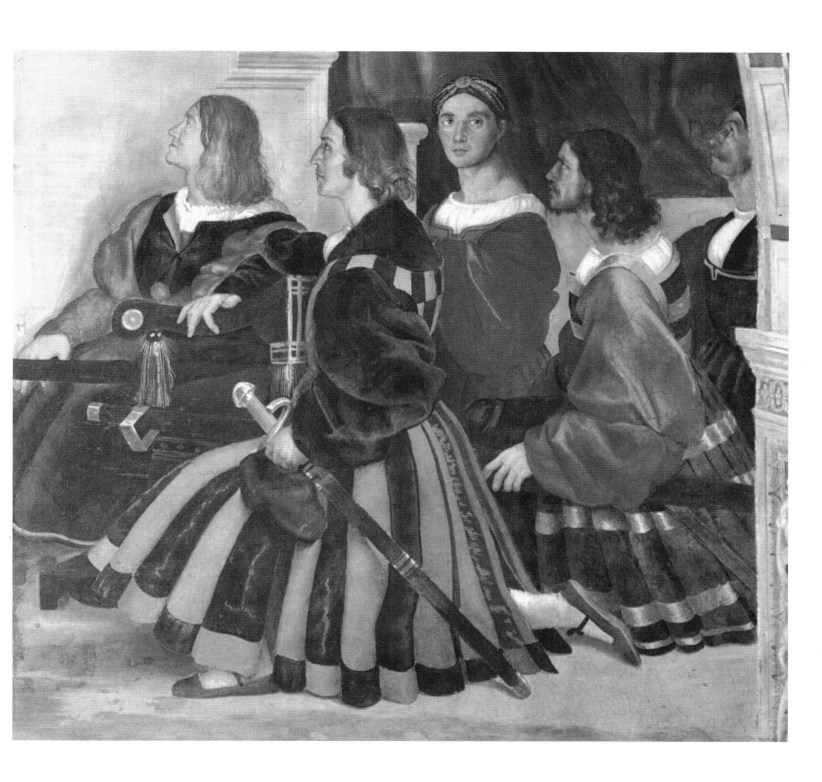

THE LIBERATION OF SAINT PETER FROM PRISON

1512–13
Fresco, 21' 8" at base
Stanza d'Eliodoro, Vatican, Rome

Like the other two frescoes mentioned previously, *The Liberation of Saint Peter from Prison,* whose textual origins are found in the Acts of the Apostles, has direct connections with Julius II. S. Pietro in Vincoli (Saint Peter in Chains) in Rome was his titular church when he was a cardinal, as it had been for his uncle Sixtus IV; his attachment to it is verified by the fact that after the French left Italy in 1512, the pope, in his moment of triumph, made a special pilgrimage there lasting several days. The fresco probably makes reference to this "liberation" of the papal state, and the physiognomy of Peter in the fresco can be compared with that of Julius; the picture must have been finished or well along by the time he died on the night of February 20, 1513. Raphael closely follows the biblical text: "Peter was sleeping between two soldiers, bound by two chains: and the keepers before the door kept the prison. And, behold, the angel of the Lord came upon him, and a light shined in the prison."

The motive of light becomes the principal theme and represents still another dimension of Raphael's innovative artistic solutions. On this level, the painting is among the boldest studies of a night scene composed during the entire Renaissance. The cold tones of the crescent moon illuminate the clouds in the upper left, while underneath the first rays of predawn silhouette the hillside. The aroused soldier gesturing toward Peter's cell, as if intuiting the miracle taking place within it, holds a burning torch whose flame cuts the night air and is reflected diversely by the flesh and armor of those nearby. On the central stage, raised like the *Parnassus* and *The Mass of Bolsena* to accommodate an actual window, the supernatural, angelic halo of light is of the highest intensity and emanates warm golden rays. The face of the sleeping Peter is picked out from the darkness, his hands, neck, and feet fastened by chains. A similar light in the form of a mandorla encloses the angel, who with the entranced yet triumphant Peter now prominently displays the papal keys. This is probably the last "portrait" of Julius II, the *papa terribile,* himself soon liberated from the fetters of earthly life. Julius's own massive tomb, which occupied Michelangelo for decades, was finally set up, although on a highly diminished scale, fittingly enough near the prized chains in his favored Church of S. Pietro in Vincoli.

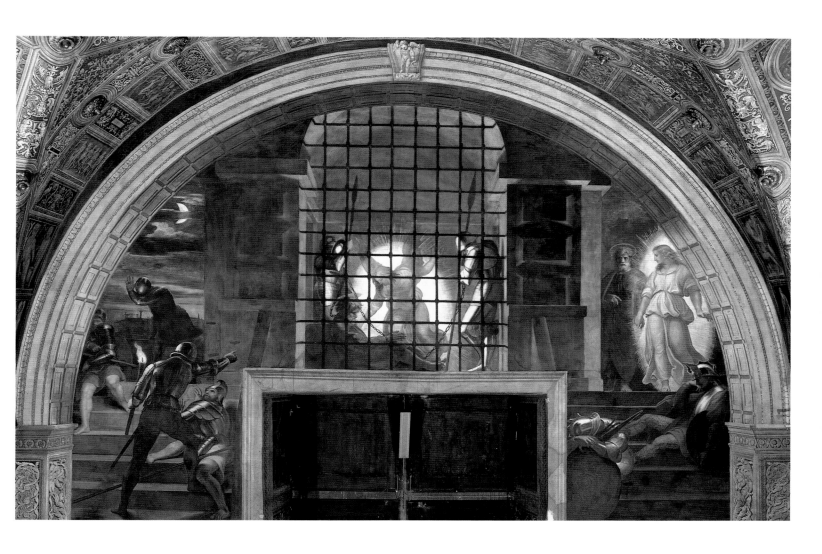

THE SISTINE MADONNA

1512–13
Oil on canvas, 8'8" × 6'5"
Gemäldegalerie, Dresden

This painting was probably commissioned for the main altar of the Church of S. Sisto in Piacenza, the North Italian city on the Po River, through the offices of Pope Julius II. His features are recognizable in the person of the third-century Saint Sixtus II (in Italian, Sisto, hence "Sistine") on the left and are quite in agreement with those found on Saint Peter in prison from the fresco depicting the Liberation, painted contemporaneously. Thus the Della Rovere family is alluded to both in the person of S. Sisto in his special role for Julius's uncle, Pope Sixtus IV, and in Julius himself. The presence of Julius's portrait seems to rule out a date much after the pope's death in February 1513. His companion is the youthful Barbara, also an Early Christian saint, who had been particularly venerated in the same church.

The Sistine Madonna is perhaps the most thoroughly discussed and analyzed of all Raphael's paintings—more than one lengthy monograph has been devoted to it—yet questions of interpretation remain unanswered. The open curtains, a trompe l'oeil device of great ingenuity, function to reveal this vision of the holy personages as if they constituted some sort of sacred relic that is exposed only temporarily. The use of drawn-back curtains had a long tradition in medieval and Renaissance tombs, in both three-dimensional and bas-relief sculpture, and these monuments may have provided Raphael with the original idea. The vision is set before a wooden parapet, upon which rests not only the papal tiara with the acorns of the Rovere *impresa* but delightful, seemingly bored, winged putti, who serve as a suitable counterpoint to the sacred figures above. These elements occupy the world of the spectator, as does the curtain, so that, like *The Madonna of Foligno* completed shortly before, the painted world and the real world overlap.

The composition should be read both spatially and diagrammatically. The two saints are posed in sharp foreshortening, and S. Sisto's pointing hand nearly punctures the surface of the canvas, thereby serving to bring the viewer into the world of the painting. S. Sisto looks inward toward the standing Mary, while Saint Barbara, who as a type recalls Leonardo's art, faces out. Arranged to establish a stable equilateral triangle with the corners shaved off at the base, the figures are silhouetted against the bright clouds, creating vibrant contrasts. With an expanded palette that typifies Raphael's works of the period, the coloristic effects rise to the occasion of the impeccable composition and perfected figural types.

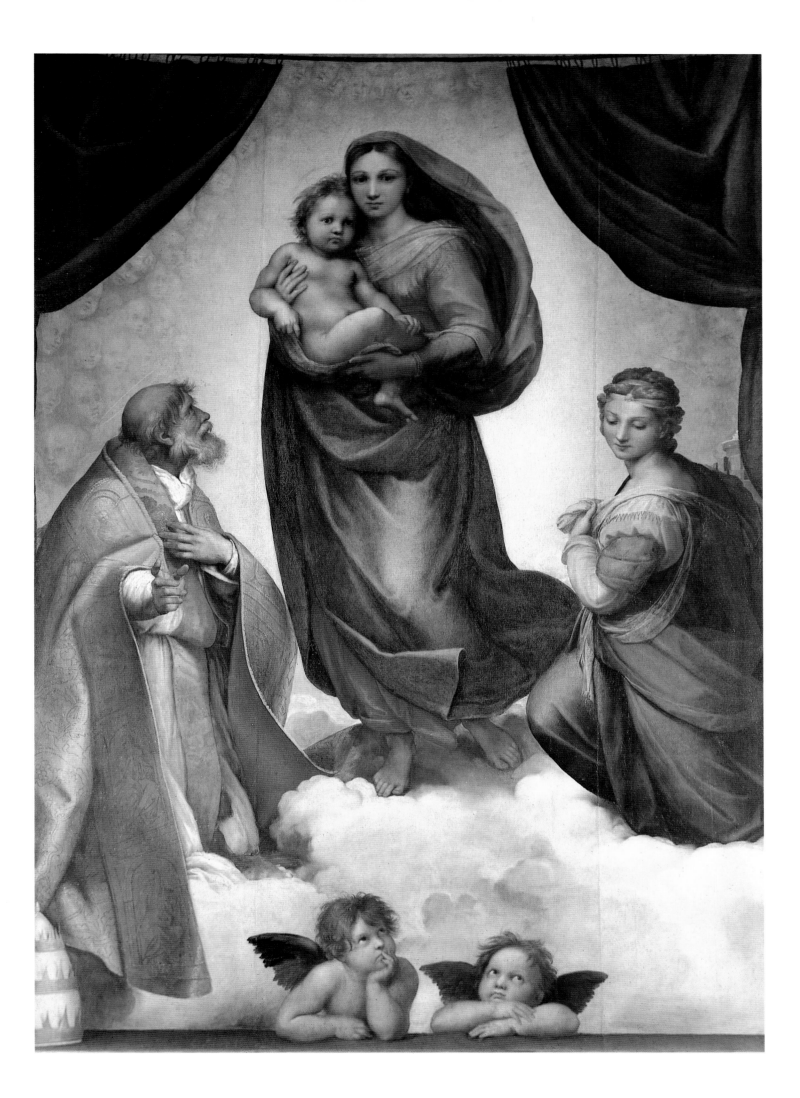

THE S. CECILIA ALTARPIECE

1513–14
Oil on canvas, 86½ × 53½"
Pinacoteca, Bologna

This, the third in a group of large altarpieces made after Raphael had settled in Rome and painted simultaneously with the frescoes in the Vatican stanze, was done last, after *The Madonna of Foligno* and *The Sistine Madonna.* Originally painted on wood for the Bolognese Church of S. Giovanni in Monte, it shows Saint Cecilia spatially enclosed by Saints Paul, John the Evangelist, Augustine, and, on the extreme right, Mary Magdalene. The details of the commission were probably worked out among Raphael, Cardinal Lorenzo Pucci, and his nephew Bishop Antonio Pucci, acting for a pious Bolognese woman who desired the work for her family chapel; they may also have drawn up a portion of the iconographic program. There are new elements in Raphael's treatment of this Early Christian saint, whose principal relics are buried under the altar of a church dedicated to her in the Trastevere, Rome. Her increasing role as patron saint of music, especially church music, apparently stems from the fame of this painting rather than vice versa.

Raphael's picture thematically rejects as vanities the disorderly strewn musical instruments in the foreground: the centrally placed viola da gamba has large cracks in its belly, and all the strings of the instruments are broken. The pipes of the hand organ held by Cecilia are about to fall to the ground. There is likely an implicit reference to Cecilia's pledge of chastity at her wedding when she rejected the secular music played on that occasion and *sang* instead with her heart directly to God, as the *Acts* of her life recount. Thus the heavenly vocal music of the angels singing above, the object of her ecstatic vision, is favored over the secular, earthly music symbolized by the instruments. These still-life elements are, to be sure, among the most praiseworthy ones in the picture, although they were probably not executed by Raphael himself but delegated to the specialist in his workshop for such subjects, Giovanni da Udine.

The entire scene, which takes place in the open air like *The Madonna of Foligno,* is placed in front of a low, hilly landscape reminiscent of the territory around Bologna. Each of the individualized saints, with his or her attributes, has a different bearing, and each plays a specific role in the composition. Perhaps most remarkable of all is Mary Magdalene, who turns toward the spectator and stares blatantly out of the picture. Her attenuated, elegant body, long neck, and smallish oval head represent a shift in proportions and in conception from the other figures, contrasting most noticeably with Saint Paul on the opposite side of the composition, who is rendered with robust musculature and broad, simplified handling. The Magdalene, clothed in haunting off-whites and pale pinks, seems to belong to another aesthetic.

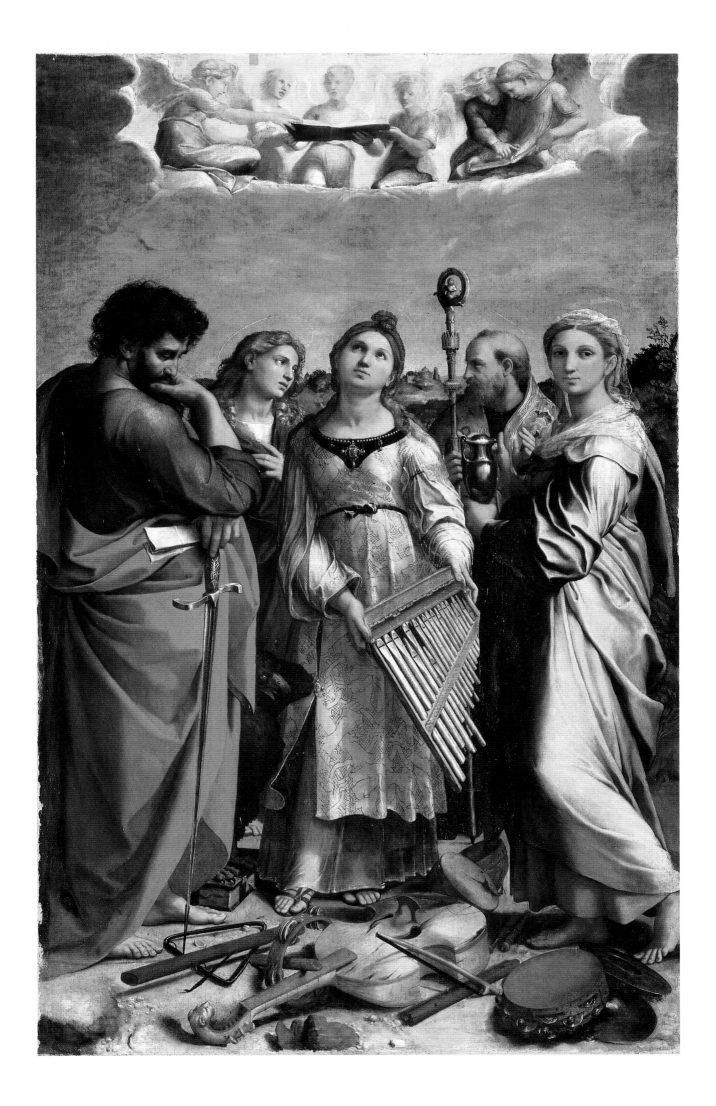

LA DONNA VELATA

c. 1514
Oil on canvas, 33½ × 25¼"
Pitti Gallery, Florence

Raphael had shown exceptional skill in rendering portraits from early in his career. As his painting style evolved into the majestic statements of the first two stanze, a similar monumentalization took place in his portraiture. In the *Portrait of Baldassare Castiglione* and in *La Donna Velata* (or *The Woman with a Veil*), both of nearly equal dimensions, he has presented ideal examples of a male and a female. The model for the *Velata* was likely identical with the one used for Mary in *The Sistine Madonna,* and her image reoccurs in several other works of this period. Furthermore, the artistic conception is related to *The Sistine Madonna,* especially in the quality of the expression and in the pictorial treatment of the head. The tight modeling of his earlier portraits, including those done in Rome, has given way to a more simplified and generalized approach, one based upon a greater inherent understanding of the forms rather than intensified detailed study. Thus Raphael approaches a solution collateral to that of the great Venetians Giorgione and Titian. His superior control over drawing, however, is never entirely subordinated to painterly qualities. The massive sleeve of the sitter's dress is set on the front plane, where it becomes a nearly independent motive as a passage of pure still-life painting and is another connection to Venetian practice.

The possibility is strong that the portrait was conceived as a devotional painting of Saint Catherine and that the religious references were subsequently painted out. An outstanding feature of *La Donna Velata* is the color, which, essentially limited to a narrow range, might be thought of as a study in white, that most precarious and elusive of tones; here it is played off against the neutral gold ground, the soft flesh tones, and the isolated darks of the hair and penetrating eyes.

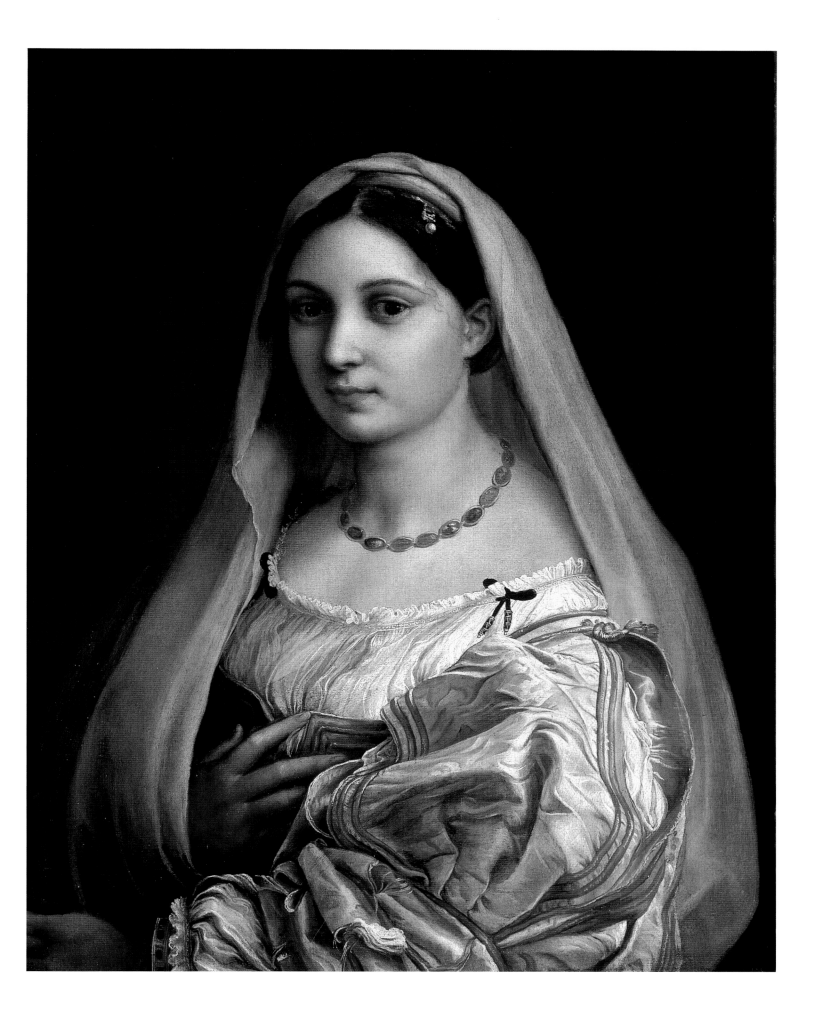

THE FIRE IN THE BORGO

1514–15
Fresco, 22' 1" at base
Stanza dell'Incendio, Vatican, Rome

Raphael is known to have begun to work in still another room of the Vatican Palace in the summer of 1514, a room that obtained its name, the Stanza dell'Incendio, from this fresco. Called in English *The Fire in the Borgo,* it depicts an incident in the life of Pope Leo IV, when a menacing fire broke out in 847 in the district of Rome before the Basilica of Saint Peter's called the Borgo: the pope, with a blessing given from Saint Peter's, conquered the flames. The other three frescoes in the same room illustrate events in the life of the same pope and in the life of Leo III. The reference to the reigning Pope Leo X (Medici), who was Raphael's patron, is clearly manifest, and his image occurs in several of the scenes but not in *The Fire in the Borgo.* Above, in the ceiling painted by Perugino some five years earlier, are large tondi with images of Christ and the Trinity, indicating that a somewhat different program had been planned for the room by Julius II.

A painting of enormous complexity, *The Fire in the Borgo* is part of the new direction to which Raphael turns his own classical style of the previous years, toward a redefinition and reconstruction of Renaissance forms. The tightly balanced compositions of the Segnatura and Eliodoro frescoes give way to spatial intrigues and intricacies. Although the central figure of the priest in prayer from *The Expulsion of Heliodorus from the Temple* is in the far background, the empty foreground beneath him and the thrusts of the perspective insure his primary role. Not so with the barely visible blessing pope in the loggia, raised high in the pictorial field off the central axis. There appears also an insistence upon imbalance from side to side and from the front plane to the more recessed areas of the painting. In fact, the transitions are often sudden and even shocking.

There are signs here of Raphael's active interest in contemporary architecture on the one hand and Roman archaeology on the other—both fields will increasingly occupy his energies during the final years of his life. The prominently placed Corinthian columns and the entablature above and the Ionic order shown on the opposite side of the pictorial field, together with a view of the facade of Old Saint Peter's, then giving way to Bramante's new basilica, are rendered faithfully.

By this stage in Raphael's evolution his workshop exercised an ever-expanding share in the actual execution of his numerous commissions, and there is good reason to believe that for this painting much was turned over by Raphael to his pupils, although in this fresco at least they appear to have been carefully supervised.

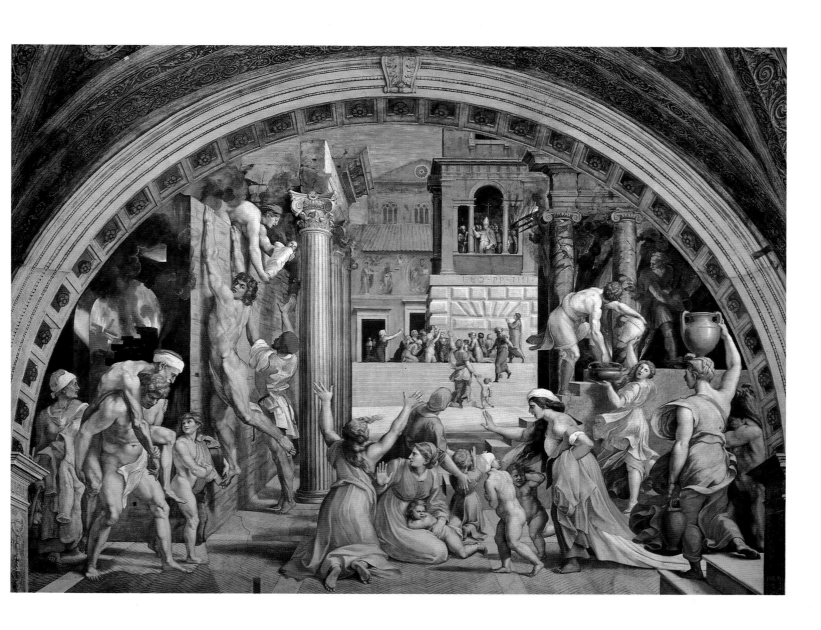

THE MADONNA OF THE CHAIR

1514–15
Oil on panel, diameter 28"
Pitti Gallery, Florence

The *Portrait of Baldassare Castiglione* stands as a final solution for single male portraiture within the Renaissance style, *La Donna Velata* is a female portrait equivalent, and *The Sistine Madonna* rests at the apex in the evolution of the *sacra conversazione* altarpiece. *The Madonna of the Chair (La Madonna della Sedia)* represents the culmination of the development of the tondo form in Raphael's art. It is a format the painter favored from his Florentine years onward, but in this, perhaps the most famous of all his Madonnas, the scale of the figures has changed radically. They now occupy more of the available space, and indeed the Christ Child appears to be the module for all other proportions and relationships within the painting. Were the child to stand at the base of the frame, he would exactly touch the edge with his head. Hence this set of interlocking ratios is radically different from, say, *The Alba Madonna,* also a tondo; nor was the idea of the painting—at least in its earliest stages—conceived in a circular format, but the translation into a circular form was exceptionally fruitful.

Much may be said for the skillful accommodation with which Raphael consolidated these three figures into the restricting tondo framework. Mary's torso, like that of Christ, is set in profile in order to appear less crowded, while her legs are thrust up to provide a comfortable place for the child (although it is extremely difficult actually to reconstruct her pose). In the foreground the corner of a chair, from which the painting takes its name, establishes the outer limit of the compressed space of the painting, which suggests the form of a sphere or globe, especially through the curvature of the Madonna's right arm and the child's left arm.

The painting has had enormous popular appeal, due in part to the gentle touching of the heads of the two central figures, their sheer handsomeness and directness, the perfect balance between the simplified, generalized treatment of the figures, and the attention to detail found in the Virgin's finely embroidered shawl. Also enriching is the element of daring color: the marvelous green of the Virgin's garment, the cerulean blue, and the bright red sleeve juxtaposed with the vibrant orange of Christ's drapery.

112

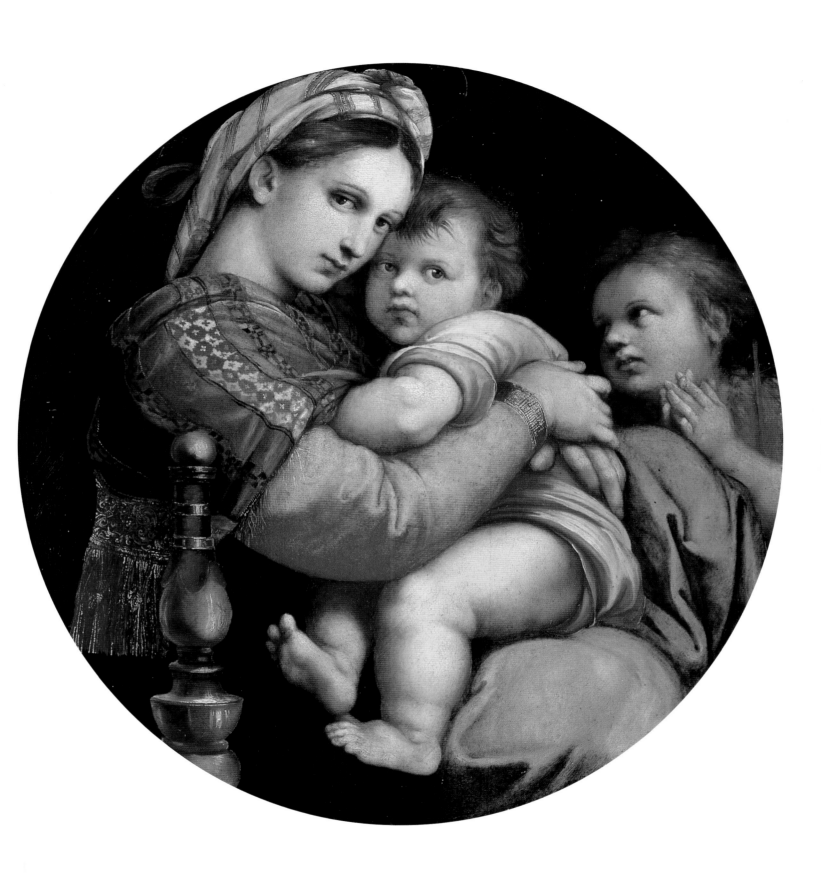

THE MIRACULOUS DRAUGHT OF FISHES

1514–15
Tempera on paper, 11' 10" × 13' 2"
Victoria and Albert Museum, London. Crown Copyright

This is one of a group of painted cartoons made by Raphael and his ever-expanding workshop that served as designs for tapestry weavers in Flanders. The ten tapestries with ten scenes showing events in the lives of Saints Peter and Paul were commissioned by Pope Leo X. They were destined for the Sistine Chapel, providing the painter with an unusual opportunity to compete directly with his most distinguished rival, Michelangelo. Although some of the cartoons were entirely the product of assistants, there is general agreement that Raphael, essentially unassisted, was responsible for *The Miraculous Draught of Fishes,* a theme based upon the biblical narrative in Luke. Disposed in two boats, the fishermen of the lake are soon to become fishers of men. Actually Raphael conflates the episode of the miraculous, abundant catch and the calling of Peter and his brother Andrew, as recounted in Mark and Matthew. The future Apostles are shown with Christ in one boat, also overflowing with fishes. The other group, comprising James and John, probably with their father, Zebedee, is gradually becoming aware of the unfolding drama in the boat in front of them. Their poses are reminiscent of certain figures from Michelangelo's battle cartoon in Florence, although the reclining boatman recalls an ancient statue of a river-god.

The cartoon was so conceived by Raphael as to retain its compositional strength when reversed, since the process of weaving from the design has that result. When the cartoon was being used for transposition by the weavers, it was cut into vertical strips that can still be seen, despite repeated repairs and restorations. Also consistent with the function of the cartoon, the painter narrowed the range of tonalities to conform to the inherent limitations of tapestry.

The scene is placed in a naturalistic setting, one that occupies a large area of the painting. Thus the expansive lake, the vast buildings on the opposite shore, the birds in the sky overhead, and those most engaging cranes in the foreground all vie with the sacred event for attention and admiration. The cartoon offers the widest possible appeal then—from the attraction of the dignified, powerful figures with expressive postures and movements to their reflections in the water, the landscape elements, and the archaeologically evocative structures in the background. The cartoons, including this one, were frequently copied over the centuries and their fame was further spread by engravings, making them highly influential works from the Renaissance.

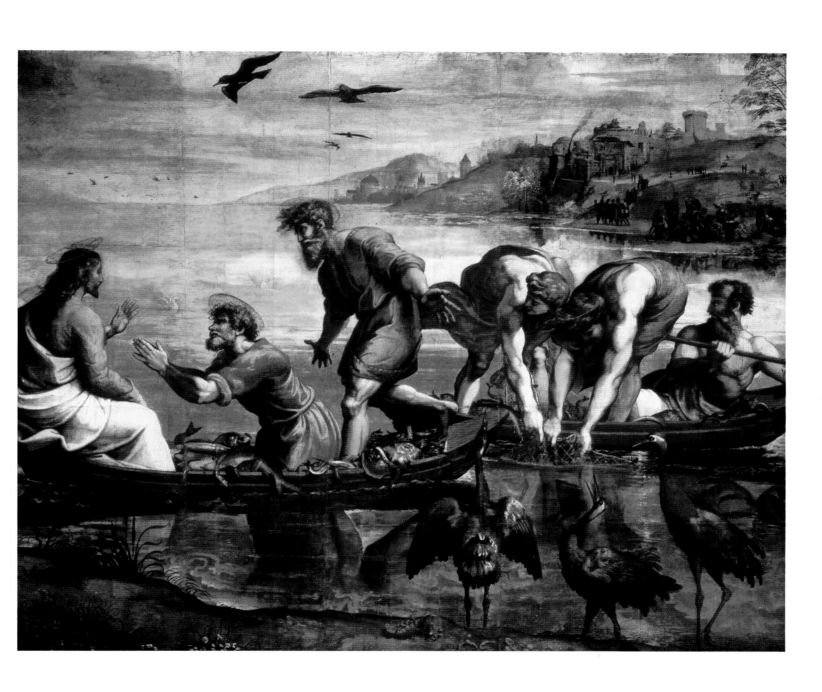

PORTRAIT OF BALDASSARE CASTIGLIONE

c. 1515
Oil on canvas, 32¼ × 26"
The Louvre, Paris

The portrait, originally painted on a wooden panel, was transferred to canvas and was probably cut down a few inches at the base, judging from seventeenth-century copies where the hands of the famous writer were fully shown. Castiglione's *Book of the Courtier,* finished in 1516 but published a decade later, is devoted to life and manners at the court of Urbino; Raphael is mentioned in it more than once. To be sure, Castiglione's list of great painters is revealing; he observes, "Consider that in painting Leonardo da Vinci, Mantegna, Raphael, Michelangelo and Giorgio da Castelfranco [Giorgione] are most excellent," and perceptively adds, "and yet they are all unlike one another in their work." As Baldassare himself is in many ways a perfect model of a High Renaissance writer and gentleman, so Raphael's portrait of him is equally exemplary of High Renaissance portraiture. Grace, seriousness, penetrating intellect, a balanced temperament, bridled self-control, these attributes all may be deduced from this portrait, which was mentioned in a letter of 1516 but most likely finished the year before.

The overall restraint and easy dignity of the pose is further underscored by the color: nearly neutral tonalities with umbers, ochers, and sonorous grays. Nothing is exaggerated; each element, every part functions to emphasize the nobility of the total image, and it is no wonder that two of the greatest painters of the next century, the Baroque masters Rubens and Rembrandt, both of whom knew the picture firsthand, saw fit to make studies from it. But the dramatic qualities that the later masters injected into their versions of the image are nowhere found in Raphael's original, which is characterized by a sobering, generalized light.

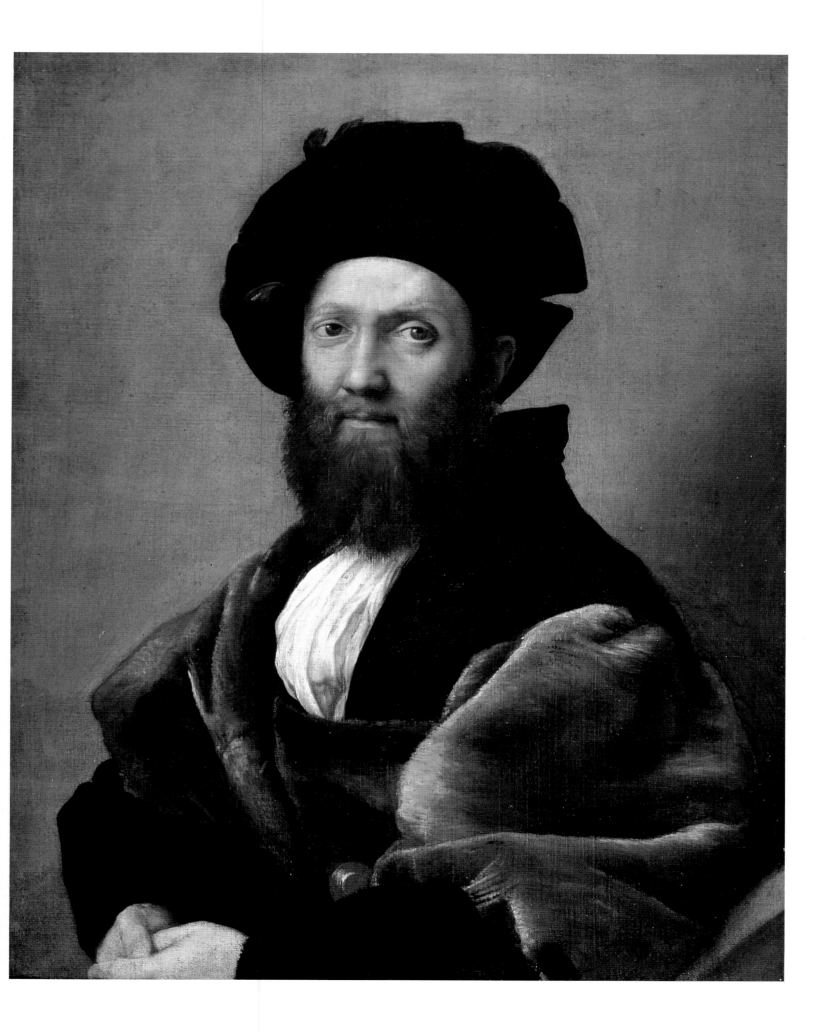

THE WAY TO CALVARY (LO SPASIMO)

1516–17
Oil on canvas, 10'½" × 7'6½"
The Prado, Madrid

Among the more difficult paintings to "read" from Raphael's hand is this one, executed for the Church of S. Maria dello Spasimo in Palermo, Sicily. Almost from the beginning of its existence, the altarpiece became especially prized because it miraculously survived a devastating storm at sea when it was being shipped to its owners, the Olivetan monks. The subject has been interpreted by the artist to have two principal thrusts: the agonized Christ, who has stumbled under the weight of his burden, and the desperate Mary, whose mournful expression and pleading outstretched arms betray her helplessness. The importance of Mary's function in the painting is fitting for this commission since it was made to be placed in a church dedicated to Mary in precisely such a suffering role.

In Italian art, the Carrying of the Cross was usually relegated to a predella, where the compositional framework inevitably had a horizontal orientation. Because of the increased importance of the subject and the painting's function as an altarpiece, Raphael constructed the composition vertically, and so departed from the traditional rendering of the subject. Christ is portrayed as pausing as he moves out of the pictorial space to the left; the path he will soon take can be seen bending back into the picture, finally leading to the hill where two crosses are already set up in the central distance.

The figures in the foreground plane are arranged around Christ, with the lash-bearing soldier and the lancer at the left prodding the fallen Christ onward, in violent opposition to the bereaved Marys at the other side. In the center, Joseph of Arimathea, a vigorous, majestic figure who is an adaptation of the Aristotle from *The School of Athens,* supports the weight of the cross; in the plane behind, soldiers on horseback solemnly observe the scene.

Although the composition has often been related to German prints, and particularly to Dürer, the arrangement owes more to North Italian and especially Ferrarese developments; Raphael has also called upon several of his own previous inventions, like the kneeling figure on the right, known from drawings and, in reverse, from a figure in *The Expulsion of Heliodorus from the Temple.* The flickering light effects, with pockets of dramatic bright and dark areas, foreshadow the final stage of Raphael's artistic evolution. Such is also the case with the shifting logic within the planes, so that the figures might appear to be piled one on top of another, if hastily read. The painting was executed in large measure by Raphael himself and is among the most adventuresome of his entire career.

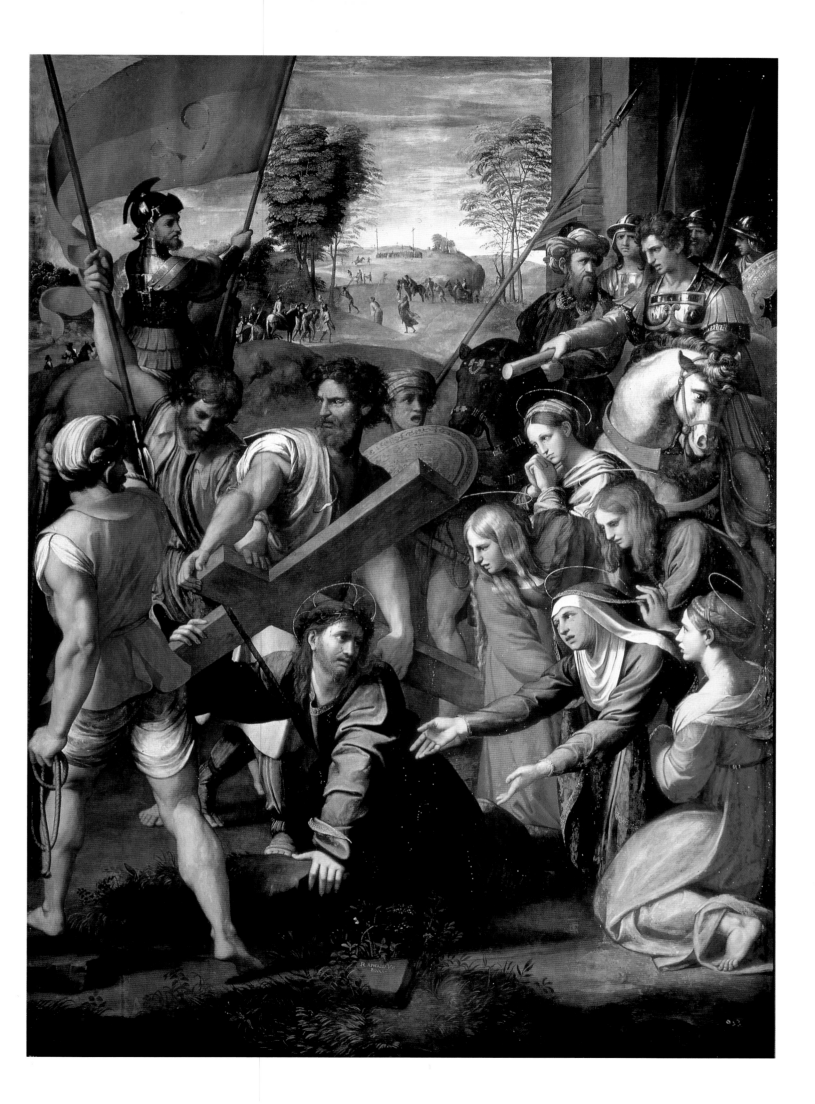

PORTRAIT OF LEO X AND TWO CARDINALS

1517–18
Oil on panel, 60⅛ × 46⅞"
Uffizi Gallery, Florence

Considering the importance of the subject matter alone, not to mention the superior quality of execution of this group portrait of Pope Leo X (Medici) and his cousin Giulio de' Medici—the future Clement VII—on the left and Luigi de' Rossi on the right, the main share of this painting must have been by Raphael, and whatever assistance he may have had was very slight. All three portraits appear to be presented in a straightforward, direct manner, each with its own highly individualized physiognomic attributes; some intangible common denominator points to the subjects' being of the same family, then the most powerful in Italy. All three are close to the same age and, despite Leo's corpulence, a resemblance persists. Cardinal Giulio was already an important patron of Raphael, having commissioned the painter to execute *The Transfiguration* in 1517. The likeness of Cardinal Luigi de' Rossi on the right, a son of the pope's sister, is thin-lipped and silent as he looks out openly at the spectator. He was raised to the cardinalate on July 6, 1517, giving a *post quem* for the painting, which was exhibited in Florence in 1518.

In style and execution Raphael demonstrates his breadth of vision toward the end of his career. It would appear that the contacts with Northern and especially Flemish art he first experienced as a youth in Urbino continued to have meaning for him. The attention to detail, for example, in the silver-and-gold bell or the illuminated manuscript the myopic Leo had been examining with a magnifying glass, could hardly be more exacting. Unexpected in Italian art is the reflection of a window painted on the luminous knob of the chair in front of Cardinal de' Rossi. Surface qualities are captured in Leo's velvety cape and biretta, as well as in the variously textured cloths. The coloristic achievement is particularly noteworthy; on this level the *Portrait of Leo X and Two Cardinals* might be considered an abstract study in reds, with nuances from the more orange side to deep, raking, sonorous crimson tones.

None of these aspects of the painting should be seen as diminishing its monumental structure: the figures are solid and permanent, massive as columns, while the somewhat obscured architrave in the background stresses the architectonic justice within the painting. There is no picture quite able to match this group portrait, among the most successful of Raphael's career, until the next century and Rembrandt's *Syndics*.

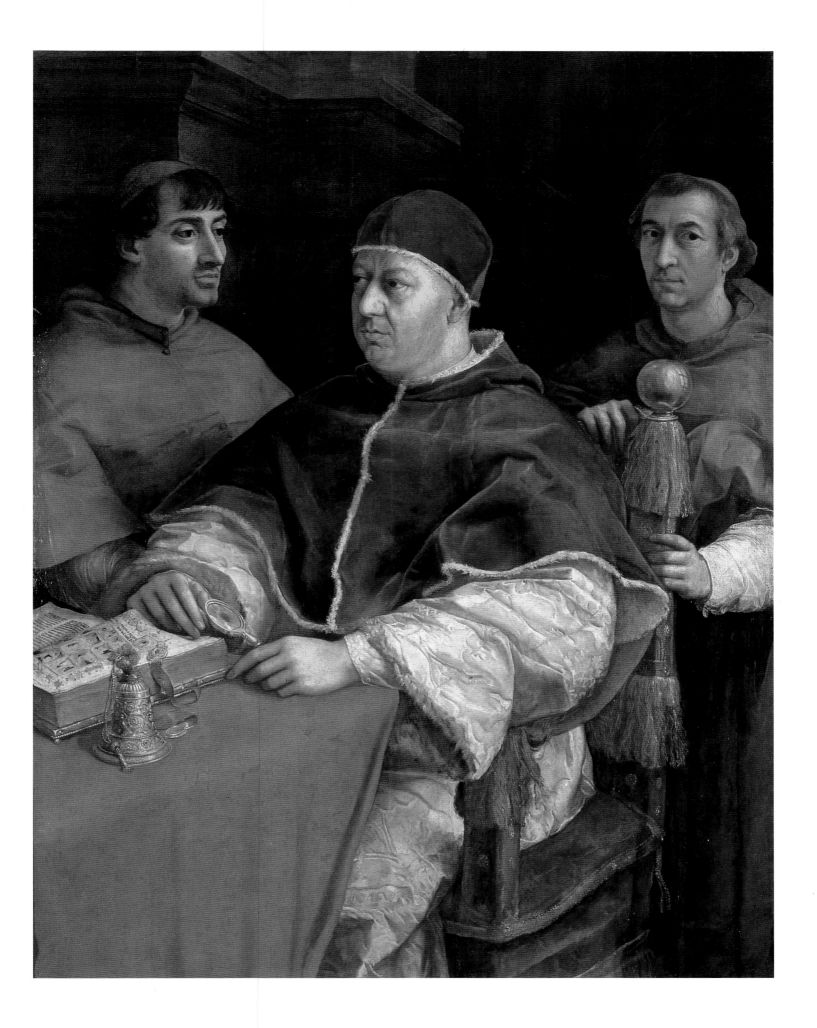

COLORPLATE 38

THE HOLY FAMILY OF FRANCIS I

1518
Oil on canvas, 81½ × 55⅛"
The Louvre, Paris

Although the king's name has traditionally formed part of this painting's title, it was made in conjunction with the *Saint Michael Vanquishing the Devil* and shipped with it to Fontainebleau for the queen. As with the *Saint Michael,* the poor state of preservation, in part caused by its transferral from a wood support to canvas, has made the connoisseur's task more difficult. Raphael, it appears, had taken a lesser part in the painting of this picture than in its companion piece. Even the cartoon may have been the work of his chief studio assistant, Giulio Romano, who must have done the greater part of the painting as well, though it is signed by Raphael and dated 1518. The subject, really a conflation of two traditional themes—the Madonna and Child with Saint Joseph and the Madonna and Child with Saint John the Baptist and his mother, Saint Elizabeth—recalls *The Canigiani Holy Family* of a decade earlier, although the charm of the outdoor setting has given way to a crowded marble-floored interior.

The attitude and expression of the figures fail to attain the customary dignified level of Raphael's works, nor does the painting offer any psychological insights into human behavior. For example, the anxious child leaps awkwardly into his mother's arms from his cradle, which incidentally bears the French lily. What is most evident is a kind of artistic exercise in which a number of Raphaelesque motives, poses, and types are almost helter-skelter thrown together into the same composition so that almost any given detail speaks more eloquently than the whole. There is also, as Sebastiano del Piombo related to Michelangelo, the interaction of chiaroscuro elements so that the figures are either "all light or all dark." Such experiments, surely part of Raphael's vocabulary at this time, were never fully explored until the end of the sixteenth century, but here, in the hands of his shop assistants, the painting on all levels falls short of expectation.

The two altarpieces, completed in a short period, compare quite unfavorably in the quality of execution with the contemporary *Portrait of Leo X and Two Cardinals.* Although the invention is high, especially for the *Saint Michael,* Raphael's personal touch is virtually absent in *The Holy Family,* and it is sorely missed.

122

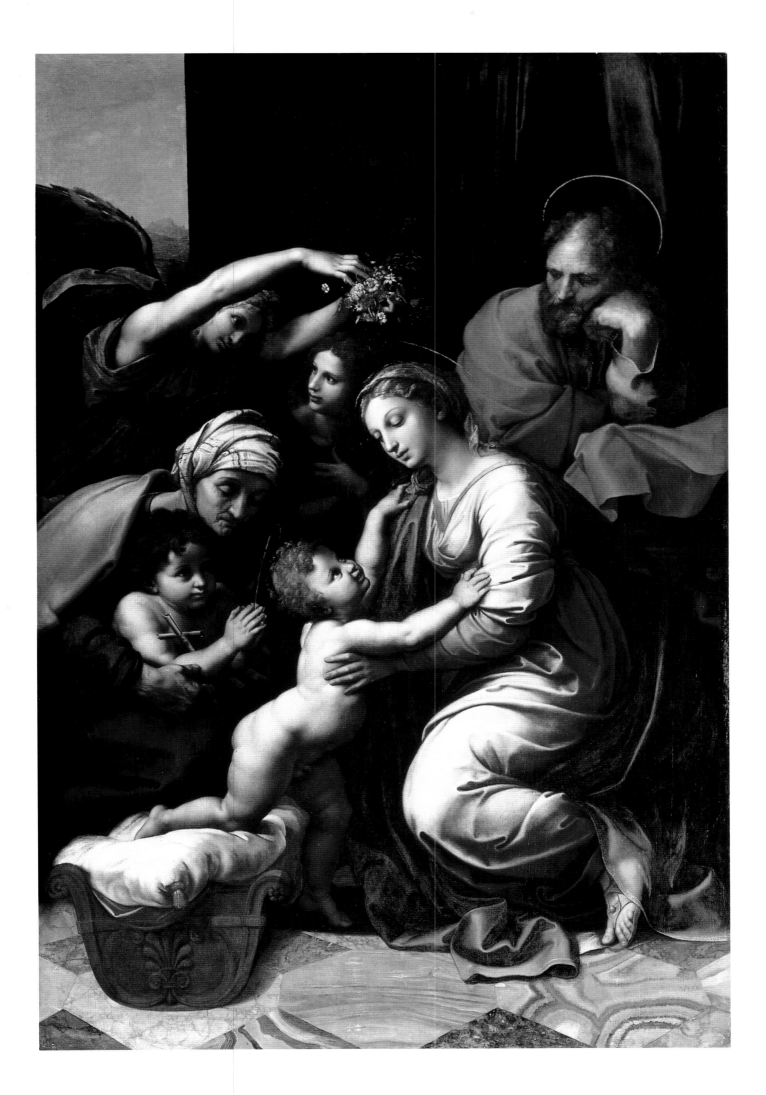

THE CREATION OF EVE

1518–19
Fresco
Logge, Vatican, Rome

The series of small scenes known collectively as the "Bible of Raphael" is painted in thirteen vaults of a gallery planned by Bramante but carried to completion by Raphael, his successor as papal architect. The frescoes and other decoration, including skillful, refined stucco reliefs, have suffered from weathering, since the gallery was not glass-enclosed until the nineteenth century. Raphael's part was primarily that of director of the entire operation, but he may have supplied a few drawings and some of the basic ideas behind the decorative program together with a limited number of specific motives. All of the actual work, possibly under the guidance of Giovanni da Udine, appears to have been done by Raphael's shop, a long list of assistants probably having a share. After Raphael's death they played a significant part in the evolution of Italian painting of the next generation. Among them were Giulio Romano, Giovan Francesco Penni, Perino del Vaga, and Polidoro da Caravaggio.

Although called *The Creation of Eve,* it more accurately represents the moment when God the Father presented Eve to Adam and Adam said, while touching his rib cage, "This is now bone of my bones, and flesh of my flesh." Beneath the leaning Adam is a rabbit, an allusion, no doubt, to the reproductive role of the first parents.

It cannot be said that these small-scale frescoes, located in an open loggia, were conceived in direct competition with the Old Testament frescoes on the Sistine Chapel ceiling; the authors of the vaults were, however, quite conscious of Michelangelo's pictorial solutions, and in many cases the "Bible of Raphael" is a commentary on them by Raphael's pupils. God the Father in *The Creation of Eve* parallels Michelangelo's figure from the same scene, with its massive form wrapped in full draperies. Also Michelangelesque is the musculature of the nude Adam, although the pose is derived not from the Florentine master but from antiquity. Entirely unlike Michelangelo's example is the sparkling landscape that forms a fundamental part of both the mood and the setting of *The Creation.* Michelangelo, so thoroughly a figural artist, seems to disdain landscape, and in his *Creation of Eve* there is but the barest suggestion of Paradise, except for a barren tree stump. The strength of the landscape here must derive from Raphael's continuous concern with this element almost from the beginning of his Umbrian training.

The painting combines the expressive power of the figure, a new iconographical turn of the theme, and a remarkable landscape. Unfortunately, frequent repainting has resulted in rather insipid facial expressions on the figures, and these should be discounted by the modern viewer. The conception, in the last analysis, is worthy of Raphael; it shows how closely a member of his studio could assimilate not only individual motives and figure types of the master but an entire approach.

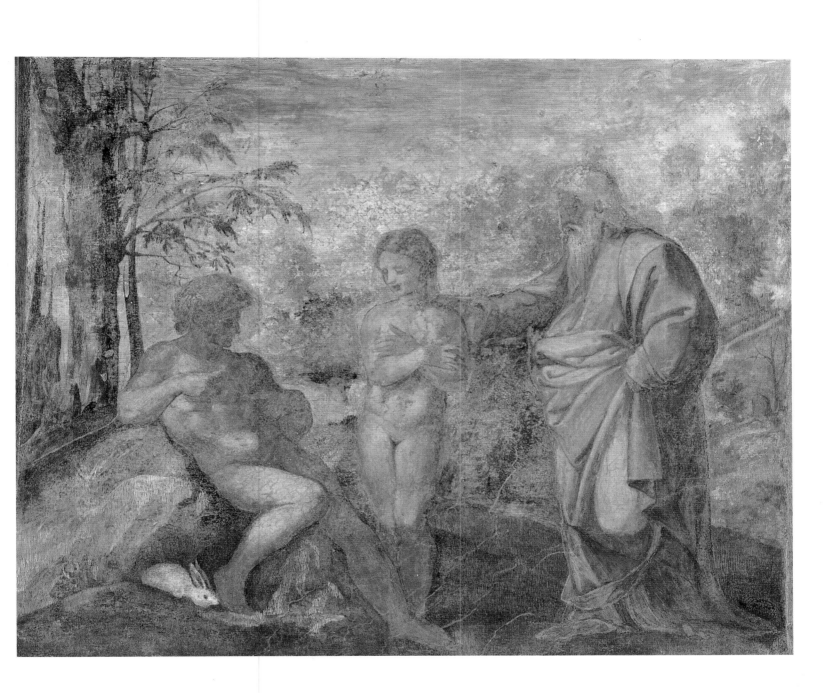

THE TRANSFIGURATION

1518–20
Oil on panel, 13' 3¾" × 9' 1½"
Pinacoteca, Vatican, Rome

Raphael died while painting *The Transfiguration,* although it was largely finished by that April day in 1520; it stands at the very end of a career that was brief by the standards of a Giambellino, a Titian, or a Michelangelo. *The Transfiguration* and the drawings connected with it are crucial for understanding his final style (see fig. 51, for example). Commissioned by Cardinal Giulio de' Medici for the Cathedral of Narbonne, the painting was put on display at Raphael's funeral in the Pantheon. Sebastiano del Piombo was also commissioned to do a large altarpiece, *The Raising of Lazarus* (fig. 49), for the same church, and the two works were executed in direct competition. The confrontation, to some degree, was actually between Raphael and Michelangelo, who encouraged and guided Sebastiano and who was kept in close touch with the circumstances. In fact, the letters by Sebastiano to his mentor, then in Florence, are the primary source for the progress of Raphael's picture.

The determination of the share Raphael's studio had in its execution is one of the very controversial, challenging problems connected with this painting and most of his later work. In 1522, after the master's death, Giulio Romano requested a sum for this picture that has been used as proof that after 1520 Giulio had painted large sections. As a counter to this reasoning is the interpretation that the monies sought by Giulio represented a balance owed to Raphael. Since Giulio was Raphael's heir, he could correctly claim an outstanding debt, which was to be used as a dowry for his sister, whose betrothed was getting restless. Still, shop participation during Raphael's lifetime cannot be denied. Raphael's working procedure, in fact, almost demanded it, but the invention, the many drawings, and much of the actual execution were by the master himself, who closely supervised all the operations.

The earliest ideas for the painting reveal a far more limited plan, with only the actual Transfiguration when Christ appears above Mount Tabor between Moses and Elijah with the three Apostles below. Raphael expanded the content by including the biblical account that immediately follows. A lunatic child, son of one of the multitude, is possessed by a devil, but the Apostles have failed to liberate him. Only after coming down from the mountain will Christ heal the lad, who is shown in a frantic pose at the lower right in the picture.

Pivotal for understanding the complicated composition is the realization that the Transfiguration is located not only above the excited scene but also considerably *behind* it, in the middle distance. In that zone on the left, two observers, identified as patron saints of Narbonne Cathedral, climb the mountain.

Light and its effects are a dominant pictorial theme of *The Transfiguration.* Its blinding force overwhelms Peter, James, and John on the mountaintop, but a second light picks out heads and hands, a gesture or a bit of garment, from deep black recesses. *The Transfiguration,* with its exceptional and complicated light, was for Caravaggio and his enormous following in the seventeenth century what Michelangelo's *Cascina* and Leonardo's *Anghiari* cartoons had been for sixteenth-century painters.

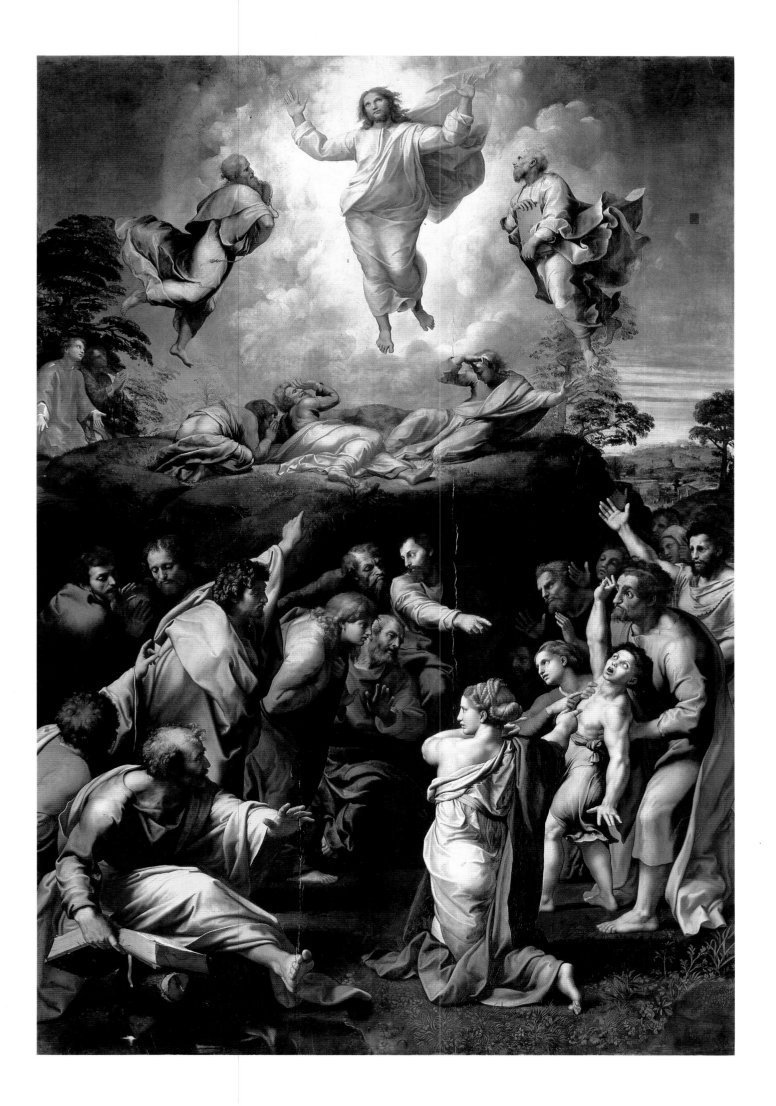

INDEX

Abimelech Spying on Isaac and Rebecca, fig. 52
Aeneas, Anchises, and Ascanius Fleeing Troy (Bernini), 35; fig. 42
Agony in the Garden, 56; figs. 13, 14
Alba Madonna, 94, 112; cpl. 24
Alberti, Leon Battista, 8
Albizzini family, 54
Aldobrandini Madonna, see *Garvagh Madonna*
Alexander VI, pope, 46, 58
Alidosi, Francesco, Cardinal, 92
Altoviti, Bindo, portrait of, 43; fig. 56
Angelico, Fra, 8, 82
Ansidei Altarpiece, 46, fig. 15
Apollo and Marsyas, 80
Ariosto, Ludovico, 88
Assumption of the Virgin (Vallombrosa Altarpiece) (Perugino), 11–12; fig. 3

Baglioni, Atalanta, 74
Baglioni, Grifonetto, 74
Battle of Ostia, study for, 46, fig. 47
Belle Jardinière, 22, 72, 76; cpl. 15
Bellini, Giovanni, 21
Bembo, Pietro, 46
Bernini, Gian Lorenzo, 38; *Aeneas, Anchises, and Ascanius Fleeing Troy*, 35; fig. 42
Bibbiena, Bernardo Dovizio da, Cardinal, fig. 57; Stufetta decoration, 38, 46; fig. 53
Bologna, Italy, 21, 106
Bonaventura, Saint, 24, 82
Borghese, Scipione, Cardinal, 74
Borgia, Cesare, 15, 58
Bosch, Hieronymus, 58
Botticelli, Sandro, 9, 19, 32; *Birth of Venus*, 96
Bramante, Donato, 23, 26, 31, 82, 84, 86, 110, 124
Bramantino, 24
Bridgewater Madonna, 90
Brunelleschi, Filippo, 8
Bugiardini, Giuliano, 24

Cambio, Perugia, 12
Canigiani Holy Family, 70, 72, 122; cpl. 12
Caravaggio, Michelangelo Merisi da, 42, 126; *Entombment*, 74
Caravaggio, Polidoro da, 37, 124
Cardinal Bibbiena Presenting His Niece to Raphael (Ingres), 43; fig. 57
Castiglione, Baldassare, 116; portrait of, 20, 46, 108, 112, 116; cpl. 35
Chigi, Agostino, 12, 27, 39, 45, 46, 96
Chigi chapels, 27, 46; fig. 46
Christ Handing the Keys to Saint Peter, 38
Ciarla, Simone, 22, 46
Città di Castello, 11, 12, 13, 15, 36, 42, 48, 50
Clement VII, *see under* Medici family
Colonna Altarpiece, 56, 62; fig. 13, cpl. 5
Colonna, Sigismondo de', 26
Conti, Sigismondo de', 26
Coronation of S. Niccolò da Tolentino, 11, 12, 48; cpl. 1
Coronation of the Virgin, 13–15, 52; cpl. 3
Creation of Eve (banner), 15
Creation of Eve (Logge fresco), 124; cpl. 39
Credi, Lorenzo di, 19, 20
Crucifixion (banner), 15
Crucifixion (Gavari Altarpiece; Mond Crucifixion), 12, 13, 50, 54; cpl. 2

Dante, 82, 88; study for head of, fig. 30
David, Jacques-Louis, 74
Dei family chapel, S. Spirito, Florence, 78
Delivery of the Keys to Saint Peter (Perugino), 15; fig. 9
Della Robbia, Luca, 21, 68, 78
Departure of Enea Silvio Piccolomini for the Council of Basel (Pintoricchio), 20; figs. 7, 8
Deposition, see *Entombment*
Desiderio da Settignano, 8
Disputation over the Sacrament (Disputa), 13, 24, 25, 52, 82, 84, 88; fig. 28, cpl. 18
Dolci, Carlo, 68
Donatello, 8, 21, 43, 68
Doni Holy Family (Michelangelo), 64, 70, 74; fig. 19
Doni portraits, 19, 64, 66, 92; cpls. 9, 10
Donna Velata (Woman with a Veil), 108, 112; cpl. 31
Dream of a Knight, 62; fig. 12
Duke Federigo da Montefeltro (Piero della Francesca), fig. 2
Dürer, Albrecht, 46, 118

Entombment (Deposition), 22, 46, 74; cpl. 14; studies for, 22, 74; figs. 36, 37
Evangelista da Pian di Meleto, 8, 11, 12, 46, 48

Expulsion of Heliodorus from the Temple, 25–26, 98, 110, 118; fig. 39, cpl. 26

Fall, 80; cpl. 17
Ferdinand III, grand duke of Tuscany, 68
Ferrara, Italy, 21, 43, 118
Fire in the Borgo, 33–35, 110; fig. 41, cpl. 32
Flood (Michelangelo), 33–35; fig. 43
Florence, 8, 9, 15, 19, 20, 21, 22–23, 42, 43, 54, 56, 64, 72, 76
Francesco di Giorgio Martini, 8
Francia, Francesco, 21, 46

Galatea, 27, 76, 96; cpl. 25
Garvagh Madonna (Aldobrandini Madonna), 90; cpl. 22
Gavari Altarpiece, see *Crucifixion*
Ghiberti, Lorenzo, 68
Ghirlandaio, Domenico, 9, 32, 64
Giocondo, Fra Giovanni, 31
Giambellino, 126
Giorgione, 108, 116
Giotto, 8
Giovanni da Udine, 37, 38, 106, 124
Giulio Romano, 37, 38, 42, 122, 124, 126
Gonzaga family, 8
Granacci, Francesco, 24

Half-Length Study of a Woman, fig. 18
Heads of Dante, Homer, and Virgil, fig. 30
Holy Family of Francis I, 40–41, 46, 122; cpl. 38
Holy Family with Saints Elizabeth and John (Canigiani Holy Family), 70, 72, 122; cpl. 12
Holy Family with the Lamb, 70
Homer, 88; study for head of, fig. 30

Inghirami, see *Portrait of Tommaso Inghirami*
Ingres, Jean-Auguste-Dominique, 43; *Cardinal Bibbiena Presenting His Niece to Raphael*, 43; fig. 57
Innocent III, pope, 82

Jonah (Lorenzo Lotti), fig. 54
Judgment of Solomon, 80
Julius II (Giuliano della Rovere), pope, 19, 23–24, 25, 26, 28, 29, 43, 46, 82, 98, 100, 102, 104, 110; portrait of, 26; fig. 40; Tomb of, 23, 36, 102

Lamentation over the Dead Christ (Signorelli), 22, 74; fig. 35
Laocoön (head), fig. 31
Large Cowper Madonna, 22, 46; fig. 26
Laurana, Luciano, 8
Leda and the Swan (after Leonardo), 76; fig. 16
Leo III, pope, 110
Leo IV, pope, 110
Leo X (Giovanni de' Medici), pope, 25, 28–29, 32, 33, 36, 38, 40, 43, 45, 110, 114, 120; see also *Portrait of Leo X and Two Cardinals*
Leonardo da Vinci, 7–8, 9, 15, 19, 20, 22, 23, 24, 29–31, 43, 45, 56, 60, 64, 66, 68, 70, 74, 86, 90, 92, 94, 104, 116; *Battle of Anghiari*, 19, 60, 126; *Leda and the Swan*, 76, 80; *Madonna of the Rocks*, 22, 72, 90; fig. 25; *Mona Lisa*, 19–20, 21, 66, 92; fig. 17
Liberation of Saint Peter from Prison, 25–26, 46, 102, 104; cpl. 28
Lippi, Fra Filippo, 8
Logge, Vatican, frescoes, 37, 38; fig. 52, cpl. 39
Lotti, Lorenzo (Lorenzetto): *Jonah*, fig. 54
Lotto, Lorenzo, 24
Louis XII, king of France, 98
Luther, Martin, 45

Mackintosh Madonna, 22
Madonna and Child Enthroned with Five Saints (Colonna Altarpiece), 56, 62; cpl. 5; predella panel, see *Agony in the Garden*
Madonna and Child Enthroned with Two Saints (Ansidei Altarpiece), 46, fig. 15
Madonna and Child with an Angel, fig. 32
Madonna and Child with Book, figs. 5, 6
Madonna of Foligno, 26, 104, 106
Madonna of the Baldacchino, 78; cpl. 16
Madonna of the Chair, 112; cpl. 33
Madonna of the Goldfinch, 22, 72, 76; cpl. 13
Madonna of the Granduca, 21–22, 68; cpl. 11
Madonna of the Meadow, 72
Madonna of the Rocks (Leonardo), 22, 72, 90; fig. 25
Mantegna, Andrea, 8, 43, 116; *Battle of the Sea Gods*, 96
Mantua, Italy, 8, 43
Marriage of the Virgin, 13, 15, 19, 46, 54, 62, 76; fig. 10, cpl. 4

Masaccio, 8, 43, 56
Mass of Bolsena, 25–26, 46, 100, 102; cpl. 27
Medici family, 29, 39, 40; Giovanni, *see* Leo X; Giuliano, duke of Nemours, 29, 39, 45; Giulio (later Clement VII), 29, 39, 41, 46, 120, 126; Lorenzo, duke of Urbino, 29, 39, 40, 45, 46; Lorenzo the Magnificent, 29
Meleager, Roman sarcophagus figure, fig. 34
Michelangelo, 7–8, 15, 19, 22, 23, 24, 27–28, 29–31, 38, 42, 43, 45, 46, 56, 64, 70, 74, 80, 86, 88, 114, 116, 122, 126; *Battle of Cascina*, 19, 114, 126; *Bruges Madonna*, 72, 76; *David*, 8, 15; *Doni Holy Family*, 64, 70, 74; fig. 19; Medici tombs, 39; *Pietà*, 15, 74; fig. 33; *Saint Matthew*, fig. 21; Sistine Chapel ceiling frescoes, 24–25, 28, 32, 33, 36, 46, 100, 124; *Creation of Eve*, 80; *Fall*, 80; *Flood*, 33–35; fig. 43; *Jonah*, 36; *Prophet Isaiah*, 28; fig. 45; Prophets and Sibyls, 27, 36; Tomb of Julius II, 23, 36, 102
Miraculous Draught of Fishes, 38, 114; cpl. 34
Mona Lisa (Leonardo), 19–20, 21, 66, 92; fig. 17
Mond Crucifixion, see *Crucifixion*
Montefeltro family, 8; Federigo, 8, 19; fig. 2; Giovanna, 15–19, 46; Guidobaldo, 46, 58
Muta, La (Woman in Green), 21, 64

Narbonne Cathedral, 126
Netherlandish influences, 58, 92

Oath of Leo III, 46, fig. 48
Oddi family, 52; Maddalena, 13
Orvieto, Italy, 22; Cathedral, 25, 100

Palazzo della Signoria, Florence, 19, 23, 72
Pantheon, 23, 36, 42, 126; tomb of Raphael, fig. 55
Parnassus, 24, 88, 94, 102; fig. 29, cpl. 21
Paul V, pope, 74
Penni, Giovan Francesco (Il Fattore), 37, 124
Perugia, Italy, 11, 12, 20, 22, 42, 74
Perugino, Pietro, 8–11, 12, 13, 15, 19, 22, 24, 32, 42, 43, 45, 46, 48, 50, 52, 54, 56, 62, 66, 86, 110; *Delivery of the Keys to Saint Peter*, 15; fig. 9; *Marriage of the Virgin*, 15; *Vallombrosa Altarpiece (Assumption of the Virgin)*, 11; fig. 3
Peruzzi, Baldassare, 27, 43, 96
Piccolomini Library, Siena, frescoes, 20
Piero della Francesca, 8, 9, 43, 54, 100; *Duke Federigo da Montefeltro*, fig. 2
Piero di Cosimo, 19
Pietà (Michelangelo), 15, 74; fig. 33
Pintoricchio, Bernardino, 20, 24, 32, 52, 80; *Departure of Enea Silvio Piccolomini for the Council of Basel*, 20; figs. 7, 8
Pius II, pope, 20
Poliziano, Angelo, 96
Portrait of Angelo Doni, 19, 64, 92; cpl. 9
Portrait of a Young Cardinal, 92; cpl. 23
Portrait of Baldassare Castiglione, 20, 46, 108, 112, 116; cpl. 35
Portrait of Bindo Altoviti, 43; fig. 56
Portrait of Julius II, 26; fig. 40
Portrait of Leo X and Two Cardinals, 39, 40, 41, 46, 120, 122; cpl. 37
Portrait of Lorenzo de' Medici, Duke of Urbino, 46
Portrait of Maddalena Doni, 19, 64, 66, 92; cpl. 10
Portrait of Tommaso Inghirami, 26–27; fig. 38
Portrait of Two Men, frontispiece
Prime Mover, 80
Prophet Isaiah, 28; fig. 44
Prophet Isaiah (Michelangelo), 28; fig. 45
Psyche frescoes, Villa Farnesina, 37, 39, 46
Pucci, Bp. Antonio, 106
Pucci, Lorenzo, Cardinal, 106

Quercia, Jacopo della, 8

Raising of Lazarus (Sebastiano del Piombo), 42, 46, 126; fig. 49
Raphael: as an architect, 26, 31–32, 35–36, 46, 110; "Bible of," 38, 124; biographical outline, 46; as director of antiquities, 31–32, 33, 46; phases: early, 11–15, 42, 43; Florentine, 15–23, 42–43, 56, 64; Julian, 23–28, 43; Leonine, 29–42, 43; portraits of, 43, 82, 86; fig. 1; tomb of, fig. 55; workshop of, 11, 36–38, 39, 40, 41, 48, 106, 110, 114, 122, 124, 126
Raphael and the Fencing Master, frontispiece
Rembrandt, 116; *Syndics*, 120
Repulse of Attila by Leo the Great, 25, 28

Rome, 20, 23–24, 32, 35, 43
Rossi, Luigi de', Cardinal, 39, 120
Rovere family, 104; Francesco, *see* Sixtus IV; Francesco Maria, duke of Urbino, 46; Giovanni, 46; Giuliano, *see* Julius II
Rubens, Peter Paul, 38, 116

S. Agostino, Città di Castello, 46, 48
S. Agostino, Rome, fresco, 28; fig. 44
Saint Catherine of Alexandria, figs. 23, 24
S. Cecilia Altarpiece, 106; cpl. 30
S. Domenico, Città di Castello, 12
S. Francesco, Città di Castello, 46, 54
S. Francesco, Perugia, 13, 52
S. Francesco al Prato, Perugia, 74
Saint George and the Dragon, 58, 60; cpl. 7
S. Giovanni in Monte, Bologna, 106
S. Maria della Pace, Rome, 27; fig. 46
S. Maria dello Spasimo, Palermo, 118
S. Maria del Popolo, Rome, 27, 46
S. Maria in Aracoeli, Rome, 26
Saint Matthew (Michelangelo), fig. 21
Saint Michael and the Dragon, 58, 60; cpl. 6
Saint Michael Vanquishing the Devil, 40–41, 46, 122
S. Niccolò da Tolentino Altarpiece, 11, 12, 46, 48; cpl. 1
Saint Peter's, Rome, 23, 31, 35, 36, 46, 74, 82, 84, 110
S. Pietro, Perugia, 13
S. Pietro in Vincoli, Rome, 102
Saint Sebastian, fig. 4
S. Sisto, Piacenza, 104
S. Spirito, Florence, 78
Santi, Giovanni, 8, 11, 46, 48
School of Athens, 24, 26, 82, 84, 86, 88, 98, 118; cpls. 19, 20
Sebastiano del Piombo, 27, 42, 46, 96, 122; *Polyphemus*, 96; *Raising of Lazarus*, 42, 126; fig. 49
Sibyls, 27; fig. 46
Siena, 9, 20, 27, 80, 96; Cathedral, 20, 62
Signorelli, Luca, 8, 24, 43, 50, 100; *Lamentation over the Dead Christ*, 22, 74; fig. 35
Sistine Chapel, Vatican: ceiling frescoes, *see under* Michelangelo; tapestry cartoons, 32–33, 37, 38, 46, 114; cpl. 34; wall frescoes, 9, 15, 32; fig. 9
Sistine Madonna, 22, 26, 78, 104, 106, 108, 112; cpl. 29
Sixtus II (Saint Sisto), pope, 104
Sixtus IV (Francesco della Rovere), pope, 24, 82, 100, 102, 104
Small Cowper Madonna, 22
Soderini, Piero, 19, 22, 46
Sodoma, 27, 86, 96
Spasimo, Lo, see *Way to Calvary*
Standing Figure (after Michelangelo), fig. 22
Stanze, Vatican, frescoes, 92, 106, 108; Eliodoro, 25–26, 28, 46, 98, 110; fig. 39, cpls. 26–28; Incendio, 33, 37, 46, 110; figs. 41, 48, cpl. 32; Segnatura, 24–25, 46, 52, 78, 80, 86, 92, 94, 98, 110; figs. 20, 27–29, cpls. 17–21
Strength, Prudence, and Temperance, fig. 20
Stufetta of Cardinal Bibbiena, Vatican, decoration, 38, 46; fig. 53

Tenebrists, 42
Three Graces, 62; cpl. 8
Titian, 108, 126
Transfiguration, 41–42, 46, 120, 126; figs. 50, 51, cpl. 40

Uccello, Paolo, 8
Urbino, dukes of: Francesco Maria della Rovere, 46; Guidobaldo da Montefeltro, 46, 58; Lorenzo de' Medici, 29, 39, 40, 45, 46
Urbino, Italy, 8, 20, 22, 42, 46, 54, 58, 116

Vaga, Perino del, 37, 38, 124
Vallombrosa Altarpiece (Assumption of the Virgin) (Perugino), 11–12; fig. 3
Vasari, Giorgio, 12, 45, 50, 76
Vatican frescoes, *see* Logge; Sistine Chapel; Stanze; Stufetta
Velázquez, Diego de, 100
Venice/Venetian painting, 20–21, 43, 108
Venus and Adonis, 38; fig. 53
Verrocchio, Andrea del, 9, 20
Villa Farnesina, Rome, frescoes, 27, 37, 39, 46, 76; cpl. 25
Virgil, 88; study for head of, fig. 30

Way to Calvary (Lo Spasimo), 40, 118; cpl. 36
Woman in Green (La Muta), 21, 64
Woman with a Veil, see *Donna Velata*